STAINED GLASS OF
CANTERBURY CATHEDRAL

SCALA

STAINED GLASS OF CANTERBURY CATHEDRAL

M. A. MICHAEL

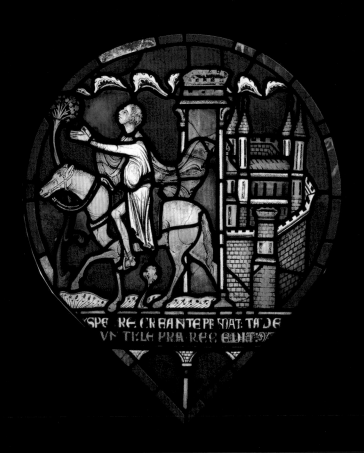

With a chapter by Sebastian Strobl

Contents

Foreword *by* Michael Archer **7**

Introduction 8

Innovation and Communication in Stained Glass 10
 Southwest Transept Window (S. XXVIII) 11

Reading Stained Glass 26

Stained Glass of Canterbury Cathedral 30

The Genealogy of Christ 32

Early Canterbury Saints 42
 Life of St Alphege window (Nt. IX) 44

Iconography of Redemption 46
 Second Typological Window (n. XV) 48
 Third Typological Window (n. XIV) 64
 Fourth Typological Window (n. XIV) 70
 Sixth Typological Window (n. XV) 76
 Corona Redemption Window (Corona I) 86
 Tree of Jesse (Corona n. III) 100

The Becket Miracles 102
 North Ambulatory Window (n. IV) 104, 106
 South Ambulatory Windows (s. II and s. VII) 104, 118
 Becket Miracle Window 5 (n. III) 124
 Becket Miracle Window 6 (n. II) 140

Saints, Prophets and Kings 162
 West Window (W) 164
 Royal Window (N. XXVIII) 176

Modern Stained Glass 188
 Chapterhouse East Window (I) 190
 Chapterhouse West Window (W) 192
 Christopher Whall Window (s. XVII) 196
 Freemasons of Kent Window (n. XVII) 200
 St Anselm's Window (III) 202
 Ervin Bossanyi Windows (s. XI, s. XII and s. XIII) 204

Restoring and Conserving the Stained Glass
 by Sebastian Strobl **208**

Bibliography 220
Index 222

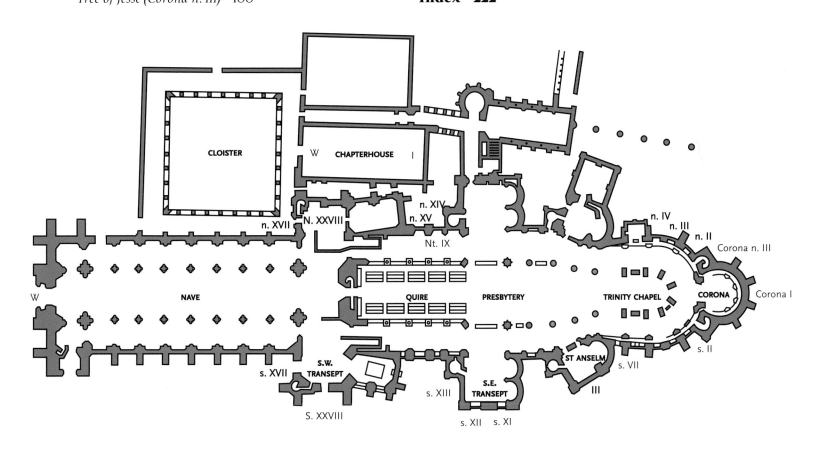

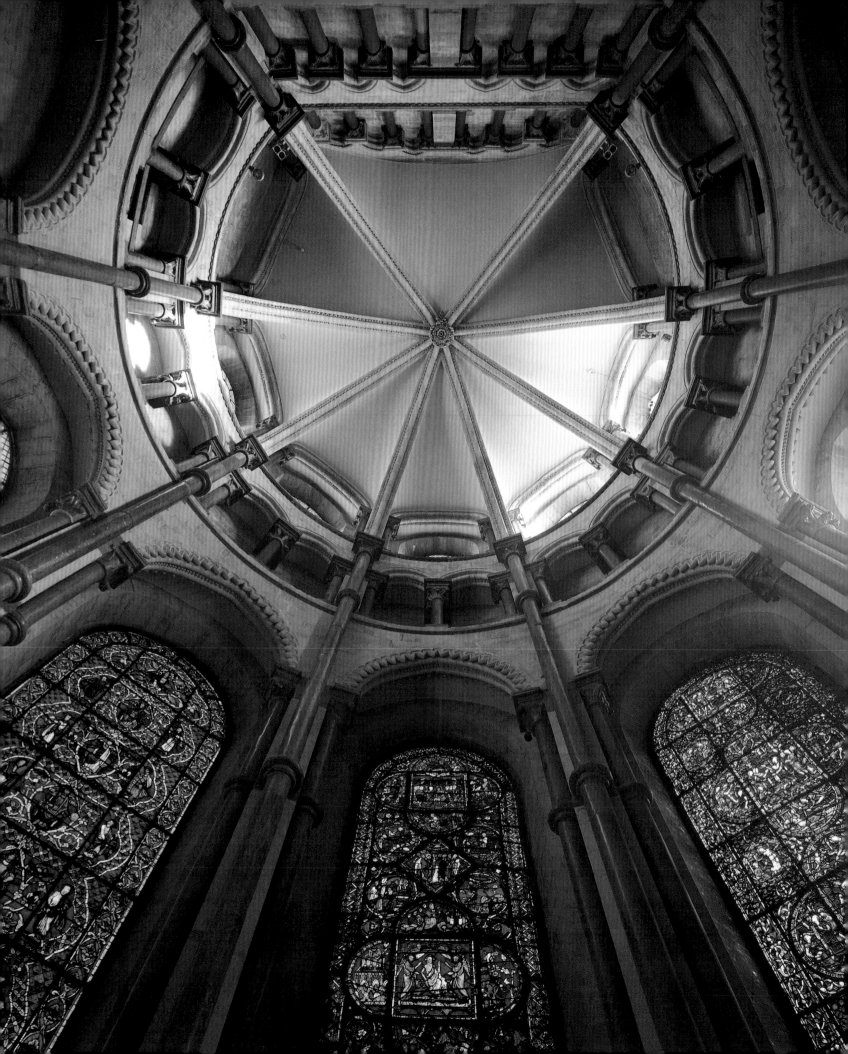

Foreword

The early stained glass of Canterbury Cathedral is one of the greatest achievements of medieval European art. The visitor's eye is immediately drawn to the windows: their brilliant colours, the fascination of their subject matter and the vigour of their draughtsmanship dominate the interior of the great building. Although the initial aesthetic experience needs no guiding intermediary, few nowadays are likely to appreciate the significance of what they are looking at. Dr M. A. Michael, the author of this book, is a distinguished scholar specialising in painting and illuminated manuscripts of the Middle Ages. He explains not only the history of every window in the Cathedral but also its subject matter, purpose and underlying religious meaning. He also describes how stained glass was made and examines the influence of contemporary painting (in Continental as well as English windows, frescoes and manuscripts) on the glass produced by the artists at Canterbury.

The earliest windows were made over a considerable period in the late twelfth and early thirteenth centuries. The construction of the Cathedral itself proceeded intermittently due to setbacks, such as the fire of 1174, and political events, notably the death of Archbishop Thomas Becket in 1170, which had an important effect on iconographic programmes and the setting in which they were placed. Within a week of Becket's death, reports about the miraculous quality of his blood began to circulate. His canonisation three years later fuelled the cult of St Thomas, which made Canterbury one of the most important pilgrimage centres in Europe. His shrine (set up in the Trinity Chapel in 1220) was surrounded by a superb series of miracle windows showing the cures he was said to have brought about, and these are particularly interesting for the fascinating glimpses they give into aspects of daily life in medieval England.

The Becket glass was not the only programme carried out in the Cathedral during the late Romanesque and early Gothic period. The high clerestory was filled with majestic figures representing the genealogy of Christ. At a lower level there were originally 12 typological windows showing scenes from the Old Testament that were thought to have prefigured New Testament events. Dr Michael points out that these windows, which were essentially didactic with a deep theological meaning, have a strong graphic impact intended to arouse curiosity. Other early windows include a Jesse Tree, a Redemption window and glass associated with the relics of Saints Dunstan and Alphege.

The nave and transepts survived the fire of 1174 untouched, but in the fourteenth century it was decided these should be rebuilt, beginning with the nave and the west wall. The most important glazing took place between the late fourteenth and the late fifteenth centuries, and it was concentrated on two great perpendicular windows at the start and end of this period. The earlier was the West Window, which was filled with standing figures of the kings of England. It seems to have been glazed in honour of Richard II, and the very high quality of the painting shows the influence of court artists. It is probable that the king was involved with the rebuilding programme, and therefore the choice of royal subject matter is not surprising, particularly as the west door was used as a processional entrance where the Prior received royal visitors. Very little survives of the later of the two great perpendicular windows, which is in the northwest transept, and it is only the presence of Edward IV, his Queen and their children that has led to it being known as the Royal Window. From Richard Culmer's description of what was destroyed during the 1642 campaign against idolatry we know that this window was originally filled with religious subjects.

Dr Michael concludes his survey with the stained glass commissioned in the nineteenth and twentieth centuries. Apart from copies of medieval glass made by George Austin in 1861–62, the earliest of the surviving glass from this period are two large windows in the chapterhouse by Hemmings and Company, which show the history of the Cathedral and its archbishops. Slightly later is the superb west window in the southwest transept by Christopher Whall, arguably the best and most influential designer of the Arts and Crafts movement. In a related tradition are windows by Christopher Webb, Hugh Easton and Sir Ninian Comper, who supplied the remarkable neo-medieval glass commemorating the coronation of Queen Elizabeth II. In a more modern idiom are work by Henry Stammers of York and the four powerful windows by Ervin Bossanyi.

Over the centuries the Cathedral's glass has been subjected to decay and destruction for many reasons, and much has been lost. Many panels are no longer in their original settings, others are altered, and all have been repaired at one time or another. The largest and most consistent period of thorough restoration began in 1819 with the appointment of George Austin Sr as Surveyor to the Fabric and continued, with members of the Austin and Caldwell families as successive Cathedral Glaziers, until 1952. The former distinguished Director of the Cathedral Studios, Dr Sebastian Strobl, has contributed a final chapter that covers this period and brings the history of restoration and conservation up to the present day. His research not only supplies a fascinating insight into past techniques but also examines the ethical arguments and explains present-day methodology.

Michael Archer, O. B. E.

Opposite: Designed by William the Englishman who succeeded the French William of Sens, the Corona (or 'crown') later housed the relic of the head of St Thomas Becket and contains the redemption window (Corona, I) and a fragment of the tree of Jesse (Corona, n.III).

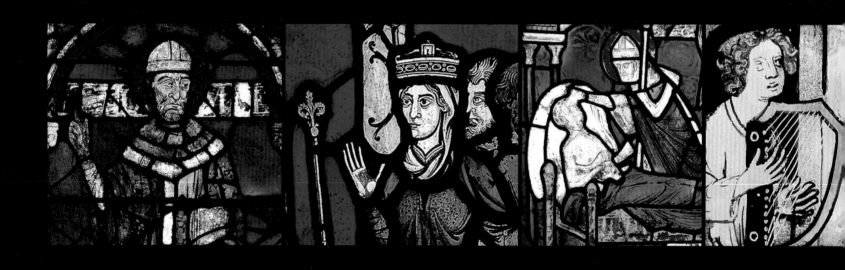

Introduction

Innovation and Communication in Stained Glass

Stained glass makes an impact on the senses unlike any other art form because of its brilliance and ever-changing movement as it responds to the light of the sun. Reaching many people simultaneously through the use of light to power the generation of bright colours, it was arguably the first modern medium of communication. Not until the invention of cinematography could a greater number of people view images transmitted by light, and not until the invention of television could more people view the same images simultaneously, as in a medieval cathedral. Wall paintings use reflected light to illuminate a mixed palette and have never been able to rival the brilliance of glass. Stained glass uses a technological breakthrough whereby oxides held in clear glass can absorb the light waves of one colour to create another. Natural colours cannot rival the arresting power of stained glass because it is a filter that produces a frequency of light that has been isolated in a pure form. Stained glass was the ideal mode of expression for the complex ideological messages that the community at Canterbury wanted to promote about itself at the end of the twelfth century. The international reputation of the Cathedral was enhanced by its stained-glass windows, and despite the depredations of time, iconoclasm and war, the glass remains one of the cultural treasures of Europe. A living tradition of stained glass at Canterbury, inspired by the past, has also produced some of the most important windows of the past two centuries. The creation, care and conservation of stained glass, as an essential part of the fabric of the Cathedral, started in the twelfth century and has remained at its heart.

The History of the Stained Glass at Canterbury

The stained glass at Canterbury Cathedral is inexorably linked both to international disputes and local events. The fire that gutted the quire in 1174 came soon after the murder of Archbishop Thomas Becket in 1170 and his canonisation in 1173. The disputes between church and state that led to Henry II's retainers murdering Archbishop Becket in the northwest transept (now known as the 'Martyrdom') in 1170 created a period of instability and loss of prestige for the community at Canterbury. To the monks the murder and the fire must have seemed like divine retribution, but not for their actions. The fire allowed them to link the canonisation of St Thomas with a refurbishment of the Cathedral that re-established Canterbury as a force to be reckoned with by the secular authorities.[1]

The programme for the replacement of the glass can be traced quite clearly because the monk Gervase of Canterbury was asked by Archbishop Baldwin to write a history for the Cathedral in the late 1180s.[2] Although the fire had gutted the inside of the quire, the community at Canterbury hoped that a refurbishment of the east end would suffice, as the walls were generally intact. The Cathedral was not an old one – it was consecrated in 1130, and building in the cloister was still going on in the 1160s. The architect William of Sens, in France, was called in to supervise the works. He persuaded the community that, although they could keep the crypt and the lower walls, the upper walls needed to be re-built. This decision was made easier because the monks must have realised, even at this stage, that the body of St Thomas could not remain in its grave in the crypt but would need to be translated into a shrine behind the high altar. William of Sens fell from the scaffolding during the building of the new quire in 1179 and was forced to abandon work and return to Sens, where he died. He must have already considered the layout of the shrine and the ambulatory before his fall. It is to him that we owe the vision behind the creation of an ambulatory walk that is made a blaze of colour with windows depicting the miracles of St Thomas. Its form owes a great deal to the modernisation of the east end of St Denis outside Paris (consecrated in 1140), under Abbot Suger. William's successor as architect, known enigmatically as 'William the Englishman', appears to have elaborated somewhat on his predecessor's initial vision, but not altered it significantly.[3]

Opposite: the Southwest Transept Window (S. XXVIII) displaying the seated ancestors of Christ, which were originally placed in the quire clerestory and moved here after 1780. Only the remains of a few shields at the very top survive from the original glazing campaign, which may have taken place at the time of Archbishop Chichele (1415–43).

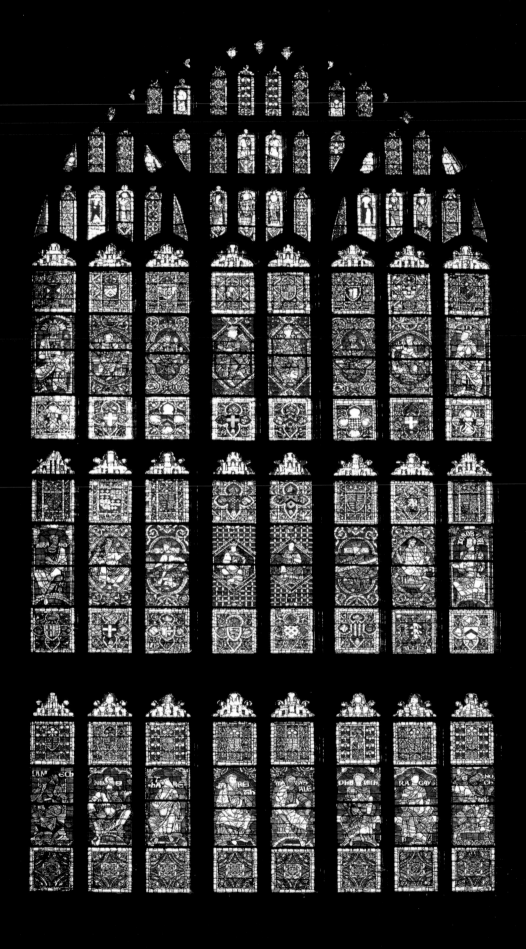

Above: St Thomas Becket at the Bedside of Robert of Lilford (n. IV 57, detail). St Thomas is reputed to have touched the wounds of Robert, who had been attacked. Robert was then cured on the application of 'St Thomas' water'.
Right: View of the Trinity Chapel and its ambulatory.

Glazing in the Twelfth Century

Gervase of Canterbury indicates that the new quire was re-instated at Easter 1180 but that a temporary screen was placed across it (between windows N./S. XI and N./S. X). This means that those windows depicting figures from the genealogy of Christ in the upper parts of the clerestory, placed to the west of N./S. IX, must date to 1174–80. Those placed to the east of N./S. X (see pages 36–37) must date to after 1180. Madeline Caviness has also noted that the armatures holding the leaded glass in place are original in this part of the building and that they differ at this point, suggesting that a lapse in time may have occurred during the glazing around 1180.[4] The relics of the great sainted Canterbury archbishops Dunstan and Alphege (see pages 42–45) were also translated into altars in the presbytery in 1180, and glass associated with them in the north quire aisle gallery probably also antedates the temporary screen. A series of 12 biblical windows were placed where they could be easily seen in the quire aisles. These must also have been completed before 1180.

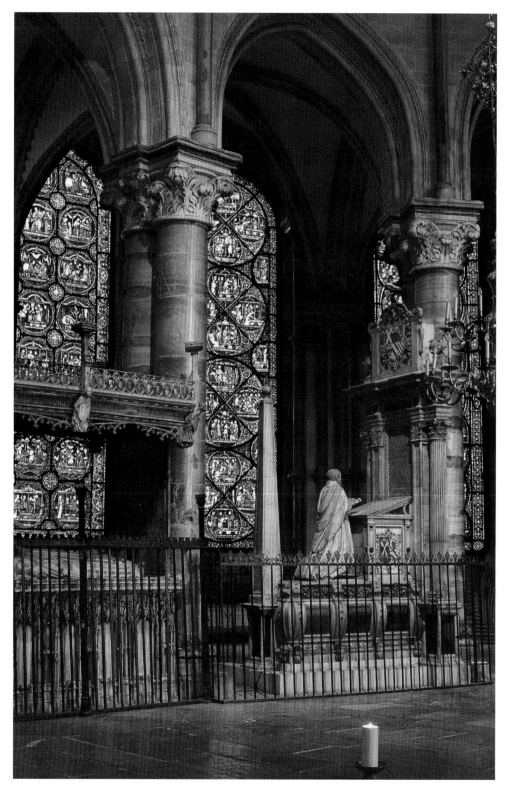

The Genealogy of Christ

In order to understand the stained-glass windows at Canterbury something of what they have come to symbolise, as much as what they were intended to mean, needs to be appreciated. The ancestors, who form the genealogy of Christ (see pages 32–41), were intended to fill the topmost windows of the quire (the clerestory). Their removal in the late eighteenth century has enabled most of the remaining figures (43 in all) to be displayed where they can be seen to great advantage: in the south-west transept (see page 11) and in the West Window (see page 164), although nine of them are still displayed in the clerestory. Behind the pragmatic decision to move them, no doubt for reasons of expediency owing to their condition, lies a desire to display the remains of the glazing in a way that can be enjoyed. The re-use of glass from previous building campaigns, or after damage from fire or natural disaster, is as old as the medium of stained glass itself. As a mark of respect it was even called *belles-verrières* (literally 'beautiful glass') in the Middle Ages.[5]

The ancestors displayed high up in the quire had the function of stressing the incarnation of Christ as God's son on earth. Christ's direct link with the first man, Adam, would have been seen as a verification of His humanity and an affirmation of the hope for everlasting life. The survival of a fragment of the *Last Judgement* from the East Window, now in the Richmond Museum, Virginia, USA, suggests that the ancestors were, in effect, witnessing the Second Coming. A cosmological eschatology is created by the position of the windows themselves, forming a cross in the clerestory crowned by the *Last Judgement* in the east. It is probable that the placing of these figures over the most holy part of the church had an apotropaic meaning – they act as guardians seated near the vault, which itself symbolises heaven.

The Typological Windows

Typology is the study of the prefiguration in the Old Testament of events that will occur in the New Testament.[6] It is a literary practice as old as Christianity itself. A classic example of its use can be seen in this passage from the New Testament: 'For as Jonas was three days and three nights in the whale's belly; so shall the Son of Man be three days and three nights in the heart of the earth' (Matthew 12: 40). This was seen as prefigurative of the fact that Christ would remain in the tomb for the same amount of time. Jonah's story as related in the Old Testament (Jonah 1–4) suggested a proof, not least because of the number symbolism, that Christ was buried and thought dead but actually resurrected on the third day. A deeper meaning was also understood – those who believe in Christ and pray to him, just as Jonah prayed to God, will be saved, even though they have sinned.

The survival of the two typological windows from the north quire aisle (n. XV and n. XIV, made up from *in situ* glass and glass from two other damaged windows from the same series) allows us to glimpse a type of stained glass with a function completely different from that of the Genealogy of Christ series. Originally there were 12 windows, placed low down so that all could see and read them visually, which were probably designed by the monks themselves to have a didactic purpose. Abbot Suger, in his book on what was done during his administration of St Denis Abbey, lists a similar series of windows in his own church.[7] The Canterbury windows display a detailed knowledge of the Old and New Testaments and the use of pictorial 'figures' to suggest connections between the two texts. That the windows were regarded, in some ways, as models of this type of iconographical programme is demonstrated by the survival of three manuscript records of their subjects from the thirteenth to the fifteenth century.[8] The copy still at Canterbury takes the form of a scroll, which some scholars have thought may have acted as a guide for the public. It seems that a guide may well have been required by the fifteenth century when

an anonymous imitator of Geoffrey Chaucer, who had completed most of his *Canterbury Tales* by 1395, poked fun at those pilgrims who tried to 'read' the iconography of the windows at Canterbury:

> The Pardoner and the Miller and other lewde sotes [ignorant fools]
> Sought hemselff in the chirch, right as lewd gotes [ignorant guttersnipes],
> Pyred fast and poured highe oppon the glase,
> Counterfeiting [Portraits of] gentilmen, the armes for to blase,
> Diskyveryng fast the peyntour, and for the story mourned
> And ared [erred] also – right as rammes horned!
> 'He bereth a balstaff', quod the toon, ['He holds a quarterstaff', said the dunderhead]
> 'and els a rakes ende.'
> 'Thow faillest', quod the Miller, 'thowe hast nat wel thy mynde [you don't know your mind].
> It is a spere, yf thowe canst se, with a prik tofore
> To bussh [push] adown his enmy and thurh [through] the sholder bore.'
> 'Pese!' quod the Hoost of Southwork.
> 'Let stond the wyndow glased …
> Prologue to the *Tale of Beryn* [9]

The confusion as to who the figure might be – is he carrying a rake, a spear or a staff? – leads to a dispute that could not easily be resolved (it seems possible they were looking at the newly installed figures in the West Window (see pages 162–75). This kind of confusion among the laity may have been quite common. This is certainly the fear of the author of a painters' handbook called *Pictor in Carmine*, which survives in many copies from *c*. 1200 onward. It outlines the typological system of interpretation in order to advise artists on the best way to make didactic biblical pictures, but the author is concerned about the way the public interacts with these pictures. He states in a shockingly disdainful introduction:

> … I wished if possible to occupy the minds and eyes of the faithful in a more comely and useful fashion. For since the eyes of our contemporaries are apt to be caught by a pleasure that is not only vain, but even profane, and since I did not think it would be easy to do away altogether with the meaningless paintings in churches, especially in cathedral and parish churches, where the public stations take place, I think it an excusable concession that they should enjoy at least that class of pictures which, as being the books of the laity, can suggest divine things to the unlearned, and stir up the learned to the love of the scriptures [10]

This extract demonstrates the function of the typological windows at Canterbury. They may be compared, in modern terms, with the essentially didactic principles that lay behind the British Broadcasting Corporation in its early days under Lord Reith, when entertainment was used as an educational tool. Similarly, on a basic level, the visual impact of typological windows is what arrests the viewer, but they also carry deeper theological meanings. In each pairing of biblical scenes, the 'type' (die or mould) is represented by the Old Testament and prefigures the 'anti-type' (the impression the die or mould leaves in clay or wax), represented by the New Testament.[11] A typical visual 'figure' found in the typological windows is the 'gifts' of the Queen of Sheba to Solomon, compared with the 'gifts' of the Magi to Christ. Solomon is both a prefiguration and an ancestor of Christ. The Queen of Sheba, through testing Solomon with questions and then offering him gifts, represents the Gentiles who were converted to Christianity. Sheba herself was sometimes identified with Ecclesia (the Church), so here Solomon is a type of Christ as *sponsus* (groom) and Sheba the *sponsa* (bride) from the Song of Songs.[12]

At least as interesting as these prefigurations are the moralisations – which do not relate directly to the Bible but appear to have been created by iconographers and artists and used, in place of an Old Testament type, to make a paradigmatic point. A

good example of this is *Christ leading the Gentiles away from Pagan Gods* (n. XV, 34). This prefigures the Magi being warned not to return to Herod to tell him where the Christ child is. Christ becomes the *figura* for the star, that leads the Magi toward Christ and away from Herod. As in many of the typological windows the message is also one about how the Gentiles (the Magi) recognise Christ and put paganism behind them (in a literal visual metaphor).

The Trinity Chapel Ambulatory

The political crisis of 1170, which led to Thomas Becket's murder, was followed by another turning point between 1207–13 when King John forced the archbishop and monks into exile. In response to this, John was censured by a papal interdict in 1208 and excommunicated in 1209. Pope Innocent III's candidate, Archbishop Stephen Langton, returned to England in 1213 in an attempt to find reconciliation, but he subsequently also fell under papal censure. On returning to Rome for the fourth Lateran Council in 1215 he was suspended for two years and did not return to England until 1218. It is difficult to see how continuous activity on the glass could have been maintained under these circumstances, but work does appear to have been going on between 1180 and 1207, and then from 1213 until the translation of the relics of St Thomas into his shrine behind the high altar in 1220.

Many of the figures from the Genealogy of Christ (formerly in the quire clerestory and now mostly placed in S. XVIII and W) came from east of the temporary screen of 1180 and must date to the period before and after 1207–13. The windows of the Trinity Chapel ambulatory (see pages 104–23), which depict the miracles of St Thomas, and the Corona, with its Tree of Jesse and Redemption Window (see pages 100 and 86), were glazed between 1184, when Gervase indicates that the Corona was completed, and 7 July 1220, when the relics of St Thomas were translated into his shrine. The stylistic changes which can be seen, particularly in the work of the Jesse Master in the Corona,

indicate that Canterbury was one of the first places in England to absorb the new humanistic values of Gothic art in the thirteenth century. This sense of modernity is also conveyed in the way narrative is depicted in the Becket Miracle Windows, in contrast to the Typological Windows.

Above: King Solomon and the Queen of Sheeba (n. XV, 27, detail) were regarded as prefigurations of Christ and the Virgin Mary. In the Canterbury glass the exotic Sheba was given the attributes of an Arabian queen.

Reading the Becket Miracle Windows

The disputes between church and state that lead to the death of St Thomas Becket on 29 December 1170 were nothing new in the political life of England.

Within one week of Becket's murder near the altar of St Benedict in the southwest transept,

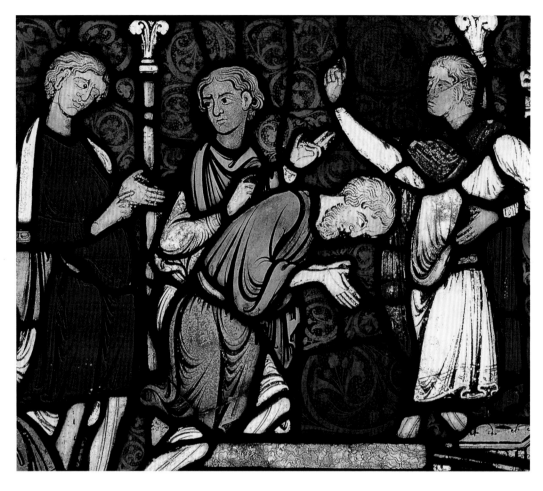

Left: Robert of Cricklade, Prior of St Frideswide's in Oxford, became lame while he was on pilgrimage in Sicily. He was cured on returning to Oxford, after he had stopped at Canterbury to pray at the tomb of St Thomas (n. IV 29, detail).

reports of a cure attributed to his blood began to circulate. Whether or not King Henry II could be held directly responsible for Becket's death, it was rightly interpreted as a symbol of the clergy's refusal to accept secular jurisdiction. Perhaps realising the strength of popular feeling that surrounded the event, Henry submitted to penance for Becket's death in May 1172, paving the way for a quick canonisation by Pope Alexander III on 21 February 1173. St Thomas' cult was promoted by the church all over Europe. A reliquary pendant, close in style to the Jesse Master's work and containing fragments of Becket's blood from his vestments, cloak, belt, hood, shoes and shirt, was made for Bishop Reginald of Bath for presentation to Queen Margaret of Sicily as early as *c.* 1174–83 (New York, Metropolitan Museum of Art, 63.160, Joseph Pulizer Bequest, 1963). This gift may have been occasioned by the marriage of Joan, daughter of Henry II to the Norman King William II of Sicily in 1177. Becket's image was already being made by Byzantine craftsmen working in the apse of William's Great Basilica at Monreale *c.* 1172–76, and soon a proliferation of caskets, embroideries and other objects showing St Thomas' image was being traded all over Europe.

The Becket Windows themselves represent a different type of artistic expression to the didactic explanation of the Incarnation and the Redemption of Man offered by the Typological Windows. In the Becket Windows the experiences of men and women who lived and died in twelfth-century England are depicted. Their stories were recounted verbally and in letters written by their

priests to those compiling a dossier of information with a view to promoting Archbishop Thomas Becket to sainthood. Where the Typological Windows explore an essentially academic programme of theological justifications and didactic manipulations of biblical imagery, the Becket Miracle Windows are about popular belief and devotion. They antedate the more famous fresco cycles at St Frances' Church at Assisi by at least 20 years, but they form part of the same phenomenon of popular religious fervour known throughout thirteenth-century Europe. The images at Canterbury are, however, radically different from most hagiographical imagery in emphasising the events surrounding the everyday lives of the people who believe in St Thomas and are cured by him. The image of the saint seldom appears in the surviving glass, although his tomb is ever present.

The Becket Miracle Windows are closely related to the accounts of St Thomas' life written down in two versions by the monks of Canterbury, William (prior of Canterbury from 1175) and Benedict (abbot of Peterborough from 1177). (The two texts were written and revised between 1172 and 1180 and do not always agree with each other in detail.) The fact that the images in the glass do not always follow the texts suggests that the stories may also have been known through oral tradition and were interpreted by the glassmakers in their own medium.[13] Two surviving pilgrim souvenirs in the form of *ampullae* (holy water containers) have survived, with unidentified scenes based on the designs of Becket Miracle Window 5 (n.III, see page 125), but none of the scenes in the glass has ever been recorded elsewhere.[14] This suggests that the iconography of the miracles in the glass was invented specifically for the windows and did not exist in manuscripts or wall paintings from which the glass makers could borrow imagery.

The subject matter of the windows reads like a hospital waiting list of the twelfth century, from stomach pains and toothache to epilepsy, leprosy and accidents at work (see pages 104–23). Doctors are not shown to be healers of such ailments but

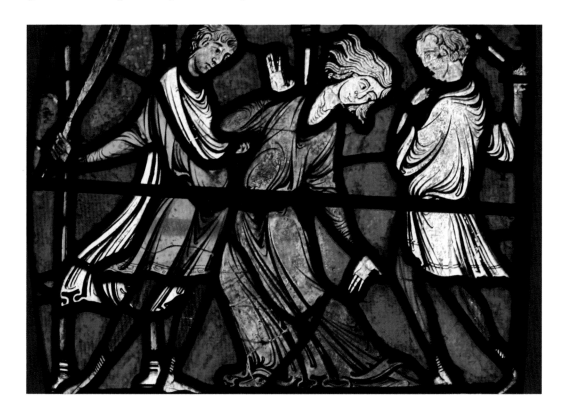

Left: Mary of Rouen suffered from a nervous affliction which caused her violent mood swings. Here she is seen during one of her demented states (n. II, 33, detail).

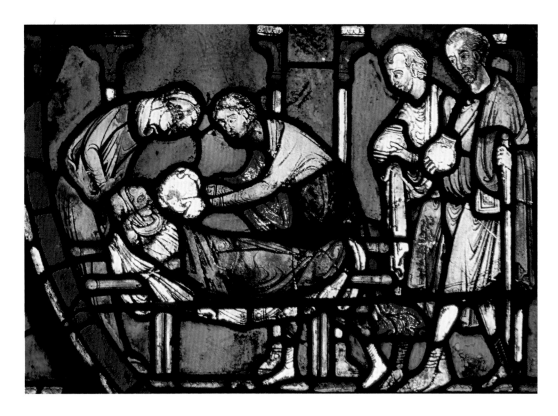

Left: Jordan Fitz-Eisulf insists that his dead son's head is lifted and his jaw prised apart so that the 'water of St Thomas' can be poured into his mouth (n. II, 11, detail) – the boy later recovers and asks why everyone is making such a fuss.

ridiculed for failing to cure patients. The only person who can heal them is St Thomas (see page 116, for example). By emphasising cures the images tell their stories with a remarkable egalitarianism. People from all walks of life are encountered and put on centre stage, usually in the final scene of thanksgiving at the original low tomb of the saint – this has distinctive oval openings at the side similar to those on the surviving tomb-shrine of St Osmund at Salisbury. The grave was certainly level with the ground, but a structure was built over it. Benedict explains that the *fenestre* (openings) at the side were designed so that pilgrims could get their heads inside and kiss the tomb slab.[15]

Often the story seems sufficiently straightforward to be read as a sequence of events that occurred to individuals from all walks of society and led to either their cure or the cure of their loved ones. There are fascinating images showing brutality against so-called mad men and women, such as Henry of Fordwich who is 'dragged by his friends to the tomb' (see page 112).[17] Less obvious to

a modern audience is the emphasis in these images on the 'votive' value of everyday objects, which are often placed at the tomb in fulfilment of a vow or because they have been used during a cure. The sticks and rope used to bind and beat mad Henry of Fordwich become central to the scene of thanks. Robert of Cricklade's crutch, cloak and boots receive the same treatment, as does Juliana Puintel's coil of precious wire and the Leper Godwin of Boxgrove's shirt (see pages 111, 115 and 128).

It is not just their attention to detail that makes the Becket Miracle Windows so realistic; it is the knowledge that the people who are depicted went through experiences that anybody visiting the tomb could have shared. The images can be graphic, such as the punishment of Eilward of Westoning (see page 135), but the context of the graphic content is central to its inclusion. For example, Eilward became drunk in a tavern and demanded money that was owed to him legally. Because of his condition he was falsely condemned. The realism of his situation creates a

believability that is echoed by the brutality of his punishment. This is a remarkable artistic achievement for the time.

The compassion seen in the scene of the blind Juliana of Rochester (see page 142–43), tenderly led by her father to the tomb, also has a darker side that is not obvious. Juliana sits with her father at home, and only then is her sight restored. Being made to wait for the cure is a repeated theme that implies a test of faith for those who visit the tomb but are not cured immediately. The *Plague in the House of Jordan Fitz-Eisulf* (see pages 154–61) emphasises this point further in an elaborate narrative of nine scenes where Jordan is punished for promising to make the pilgrimage to the tomb of St Thomas, in thanks for the cure of his son, and forgetting to do so – St Thomas swoops, sword in hand, to take the life of another son and re-visits the plague on his house. The plague is only lifted when the money promised to the saint has been given.

Artists of the Early Glass

A number of distinctive artists working on the early glass have been identified by Madeline Caviness.[18] The most important artist of the Genealogy of Christ series has been named the Methuselah Master after the eponymous figure (see page 34), now placed in the Southwest Transept Window. The figures of Adam, Lamech (not illustrated), Enoch and Noah, and the design of the Second Typological Window (see pages 33, 35, 40 and 49) have all been attributed to him. His work bears a striking resemblance to that of the artist of the Morgan leaf of the Winchester Bible and may be linked to wall paintings at Sigena in Catalonia, Spain.[19] At least three other artists were working at the same time as the Methuselah Master on the *Public life of Christ* (n. XIV) and the *Parable of the Sower* (see page 79), as well as on larger figures such as the prophet Johanna, often depicted under innovative canopies (for example, the figure of Shem, N. XIII, 11, 13). The Jesse Tree Master, named after the window in the Corona depicting this subject (see page 100),

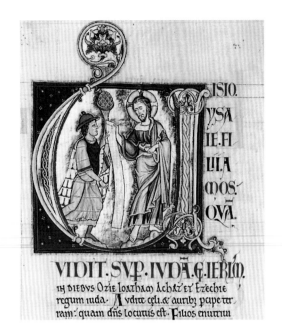

Left: the Winchester Bible from the Winchester Cathedral Library, showing the initial to the Book of Isaiah: The Calling of Isaiah (f.131). The head types and sophisticated drawing of this artist, who worked on the Bible *c.* 1180, are closely related to the work of the Methuselah Master of the Canterbury Glass.

developed the style of the Methuselah Master by creating more delicate figures. The similarity between his work and stained glass at Sens has led to the suggestion that he was trained in France, but his figures may be compared with the seated king from Richard I's second Great Seal of 1195, indicating both a date for this glass and the origins of the artist.[20] He worked side-by-side with a number of other artists who collaborated on the creation of the Corona Redemption Window (see page 86). The troughed-fold style, which characterises their work, is ultimately derived from continental models such as that provided by the work of the Mosan metal-worker Nicholas of Verdun.[21] This style is practised with great aplomb by the so-called Petronella Master, named after his scenes depicting the nun of Polesworth, who was cured of epilepsy by St Thomas (see page 106–07). His figures of Aminadab and his son Nahsson (see pages 36 and 39) are beautifully preserved examples of this grand and humanising style. Finally the Fitz-Eisulf Master, named after the unfortunate Jordan Fitz-Eisulf (see page 154), belongs to the phase immediately before the translation of the relics of St Thomas in 1220. His work has been convincingly linked to the Joseph Window at Chartres, but, as Caviness has

pointed out, work at Sens, Chartres and Canterbury in the first quarter of the thirteenth century is linked by an almost competitive desire to keep up with the best and most innovative modes of expression available.[22]

Techniques of the Early Glass Painters

Glass was made from sand, potash and lime.[23] It was coloured through and through by different metallic oxides, which were added to it during the heating process. This so-called 'pot-metal' glass could only display one colour at a time. Each colour had to be leaded in separately, but it could be painted with a thick black paint made up of a mixture of ground glass and binders. The restrictions that this placed on the glass makers helped to create the familiar lead lines of medieval glass that define it as an artistic medium. A good example of this is the figure of Adam – the lead lines follow his head and arms and the contours of his chest. Only later breakages, which have been leaded in, disrupt the clear lines of

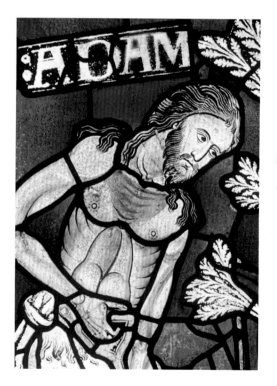

Left: Adam, from the Genealogy of Christ series (formerly N. XXV, W d 3, detail), showing the sensitive use of lead lines to reinforce the drawing and structure of the body
Above: The Destruction of Sodom and Gomorrah (n. XV, 22, detail), showing the use of streaky red glass in the flames.

the glass. Our view of what stained glass should look like is, unfortunately, often governed more by the proliferation of such mending, than the original intentions of the maker.

In contrast to all other colours, red or ruby glass was never coloured through and through, as the intensity of the colorant would otherwise render the glass black. To counteract this phenomenon, the early glass makers swirled together molten red and colourless glasses to create a 'streaky' glass. This can be seen most clearly in the fire that rages in Sodom (shown here), where the red 'streaky' glass has been chosen to give the impression of moving flames. Later glass makers fused ('flashed') only a thin film of red glass over white glass during the manufacturing process. This also allowed the glass painter to create white and red effects on the same piece of glass by abrading the red away. The richness of detail could also be enhanced by painting the 'pot-metal' glass on the back as well as the front (so-called back painting). This gives an added three-dimensionality to the image and is used throughout the Second Typological Window (see page 49), for instance on the dappled horse's rump or on the blue mantle of the Pharaoh in the scene of the Exodus (see pages 50 and 52).

By 1300, glass painters had begun to utilise a technique that had been known to Byzantine glass makers but never used by them on window glass. Silver nitrate held in a solution was painted on to clear glass and then re-fired. This produced a beautiful golden 'yellow stain' which could be brushed on to hair, crowns and embroidered robes of figures without the necessity for putting in an extra lead. This can be seen in the figure of St John the Evangelist (shown here), where silver stain is used for the hair and neckband, and around King Canute, where architectural details are rendered in 'yellow stain' (see page 166).

Glazing in the Fourteenth Century

The Gothic glass of the Cathedral from between the great period of re-building and glazing (c. 1174–1220)

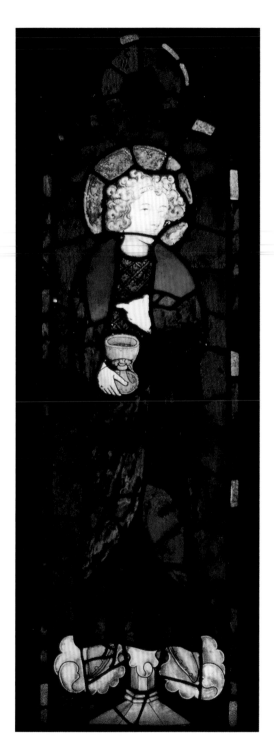

Above: St John the Evangelist (W, C 14), shown carrying a chalice that symbolises his survival after drinking from a poisoned cup handed to him by the high priest at Ephesus.

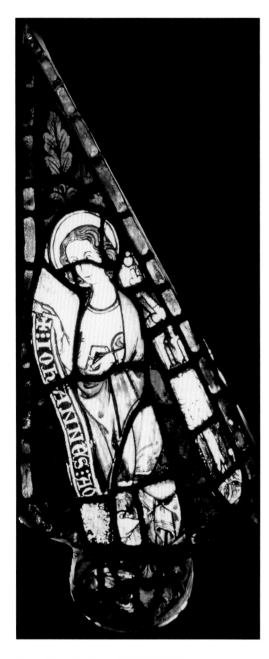

Above: St John the Evangelist (S.XXVIII, H 15), a precious survival from the early fourteenth-century glazing of the Cathedral.

and the fifteenth century has only survived in a few windows. From the early fourteenth century there remains an archbishop, a Christ in Pity, a pilgrim and St John the Evangelist. This relatively unknown glass may have been made for the East Window of St Anselm's Chapel (formerly known as the Chapel of Saints Peter and Paul), as a payment was made by the priory in 1336 for the newly designed East Window.[24] The figure of St John the Evangelist (shown here) is in a similar style to that found in the Latin Chapel at St Frideswides' in Oxford, which can be dated slightly earlier. It is typical of the style of painting popular in England and found in manuscript illumination such as the *Vaux Psalter* (shown here).[25] No other glass from Canterbury falls into this category, but a few fragments such as the musicians now found in the Music Room (also shown here) suggest that other, more intimate, glass continued to be made for smaller windows into the fifteenth century.

In its display of the Kings of England, the Great West Window (see page 165) contains some of the finest glass produced in the late fourteenth century. It also now displays 12 of the figures from the Genealogy of Christ series that was originally placed in the quire clerestory. Richard II's armorials and those of his two wives, Anne of Bohemia and Isabelle of France, were recorded in 1777 at the top of the window and are displayed in their original positions (w D 20, B 18 and F 18). This suggests that the window must have been made between his marriage by proxy to Isabelle in 1396 and his death in 1399, although a later inscription (now lost) suggests that the project was unfinished at his death and Prior Chillenden (1391–1411) had it completed. The glass has also been linked to the stained-glass makers William and John Burgh, who worked for both Richard II and Henry IV.[26]

The images of standing kings used in the West Window form yet another mode of expression in stained glass. The west end of the Cathedral was used as a processional entrance, and it had become an accepted norm that such an area could have displays of a secular nature in the form of kings of the realm. Both the church and the crown had a vested interest

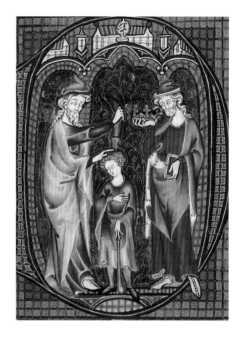

Above: the *Vaux Psalter* from Lambeth Palace Library, showing the depiction of the Anointing of Saul, *c.* 1320 (MS 233, f.44).

Below: three musicians playing a lute and two harps, *c.* 1420? (Music Room V, possibly originally from the West Window or the nave).

in such public displays, and it comes as no surprise that Richard II appears to have been involved in the project of re-building the nave after *c.* 1378. The inscriptions of some of the kings were recorded in the eighteenth century and, as would be expected, William the Conqueror and Edward the Confessor were included, although subsequent removal and replacement of the figures has made it difficult to identify now exactly which one is which. The figures are of monumental size, standing approximately 162.5cm in height, and dominate the space in front of them. There is no complex narrative and no compromise with authority as they stand, with their swords and sceptres, in state robes. The quality of the images' exec-ution and the care that went into their production also send out signals of wealth and power, which befit the setting but also assert a secular authority that gains immeasurably from the association with Canterbury and the church. The remarkable similarity of approach between the heads of Canute and Edward the Confessor (see pages 163 and 167) and the head of Edward the Confessor depicted on Richard II's own devotional panel, the *Wilton Diptych* (shown here and in detail on page 162), suggests that the glass painters behind this series were familiar with the work of court painters during the lifetime of Richard II.

Glazing in the Fifteenth Century

The most important window commissioned in the fifteenth century is the Great Royal Window in the northwest transept (or Martyrdom, usually now dated *c.* 1482–87). The figures that remain are those of the donors, Edward IV, his wife Elizabeth Woodville and their children. Some idea of what the configuration of this window would have been like originally can be gleaned from comparing it with the Joys of the Virgin or *Magnificat* window at Great Malvern Priory (*c.* 1509), also in the northwest transept. It depicts Henry VII and his wife Elizabeth (one of the daughters of Edward IV and Elizabeth Woodville). The style of painting in the Canterbury window is of particular importance. It

represents a complete modernisation of the pictorial space in line with the developments that had occurred in the early-Renaissance painting of the Low Countries – it is especially close to the work of the great Flemish painter Hugo van der Goes. This reflects the interests of Edward IV, who was a keen patron of Flemish manuscript illuminators and ordered manuscripts directly from Flanders in many cases.[27] The regality and coolness of the West Window is less pronounced in Edward IV's Royal Window. Here the creation of illusionistic space, through the conceit of the 'Royal Box', combined with the presentation of the Royal family kneeling in devotion, suggests a political agenda that is completely different from that of the West Window.

A description of the Royal Window exists from the man who caused the most destruction to it during the seventeenth century, Richard Culmer, known as 'Blue Dick' because of his habit of wearing a dark blue cloak rather than a black one. Appointed as a commissioner in 1643, he wrote contemptuously of the glass he was charged to

Above: the *Wilton Diptych*, showing King Richard II (1367–99) presented to the Virgin and Child by St John the Baptist, St Edward the Confessor and St Edmund, by an anonymous court artist (London, National Gallery). Richard II is closely associated with the glazing of the West Window, and artists employed by him at court almost certainly provided designs for the figures of English Kings displayed in this window.

destroy in a tract that he called *Cathedrall Newes from Canterbury*. It was almost certainly Culmer who climbed up 60 steps on a ladder to use a long pike to '[rattle] down proud Becket's glassy bones'. It says much for the townspeople of Canterbury that they surrounded the Cathedral in protest at the actions of a man who appears to have been disliked by all except those who appointed him.

Re-glazing and Repair in the Post-Medieval Period

By 1660 the diarist John Evelyn noted that windows had been repaired with extraneous panels soon after the destruction of the 1640s. In 1640 William Somner had already published an account of the inscriptions found on the Typological Redemption Windows, which were recorded in a fourteenth-century roll manuscript, still kept at the Cathedral to this day, but he did not refer to any specific panels of stained glass in the Cathedral.[28] A detailed account of the glass was finally published by William Gostling in 1744 and revised in 1777.[29] We know that the German stained-glass panels of Charlemagne and St Maurice, together with the arms of St Augustine's Abbey, were inserted between the images of Edward IV and Elizabeth Woodville, where they remain today, some time after Culmer's destruction of the main body of the window, as Gostling refers to them in his first edition of 1744.[30] Between 1780 and 1800 nearly all the large figures from the Genealogy of Christ series in the quire clerestory were removed and placed where we see them now, in the Southwest Transept Window and the West Window (see page 11 and 165).[31]

The Nineteenth and Twentieth Centuries

By 1819 George Austin Senior began work on the restoration of the Cathedral, including some of its glass. Between 1861 and 1862 George Austin Junior placed new figures in the clerestory to form a restored Genealogy of Christ series made from copies based on surviving figures now in the Southwest Transept and West Windows. These figures were all but destroyed by enemy action in 1942 (four figures in S. XXI and S. XXII survive) but were replaced again by Samuel Caldwell. Austin also contributed glass to the South Oculus Window and to the chapels of St John and St Gregory. Concerted efforts were made in the nineteenth and twentieth century to glaze the chapterhouse and the cloister. Glass by Christopher Webb, of St Gregory the Great and the early archbishops of Canterbury (*c.* 1934), can be found here, as can Hugh Easton's window of the Adoration of the Shepherds. A memorial to Dean H. R. L. Sheppard (d. 1937), who was one of the founders of the Peace Pledge, Easton's window displays unusual humour in using a portrait of the dean as a shepherd in a play on his name. The talented Arts and Crafts stained-glass maker Christopher Whall contributed windows in St Andrew's Chapel (now lost) and opposite St Michael's Chapel in the southwest transept.[32] The latter chapel now boasts glass by William Wilson commemorating the East Kent Regiment, as well as work by the prolific London firm of C. E. Kempe & Co. Clayton and Bell contributed a window to the north aisle of the nave (n. XVIII). George Easton, assistant and successor to Samuel Caldwell, re-set glass in the south quire aisle (s. XIV, s. XV and s. XVI, formerly twelfth-century typological windows) with French medieval glass bought by the Cathedral from the collection of the great philanthropist and news-paper magnate, William Randolf Hearst, which was held at St Donat's Castle in Glamorgan. The great Scottish stained-glass maker Sir J. Ninian Comper provided the modern 'Royal' Window, depicting the current Royal family, immediately after the Coronation in 1953. This symbolised the new impetus after the Second World War to produce work that that spoke of the future.

In the late 1950s the émigré artist Ervin Bossanyi seemed the ideal man to provide glass in a style that broke with the traditions of Comper – continuity with the past had been emphasised in the Victorian period in both style and iconography, and this is seen also in Comper's work. Bossanyi was as committed to the medium of stained glass as Christopher Whall had been before him, but he wanted it to show an entirely modern face. He relished the commission to create the Peace and Salvation Windows in the southeast transept, and produced some of the most striking windows in the British Isles. They are not based on historicism but on a vision of universal unity, peace and salvation that was, in some ways, ahead of its time. His work is only now being re-assessed in the light of his contribution to glass-making internationally.[33]

Notes

1 Margaret Gibson, 'Normans and Angevins, 1070–1220' in, *A History of Canterbury Cathedral*, edited by Patrick Collinson, Nigel Ramsay and Margaret Sparks, Oxford, 1995, pp.38–68, esp. pp.63–67

2 Gervase of Canterbury, 'Tractatus de combustione et reparatione Cantuariensis Eccelesiae', translated by R. Willis in, *Architectural History of Canterbury Cathedral*, London, 1845, pp.36–62

3 Christopher Wilson, *The Gothic Cathedral. The Architecture of the Great Church*, London, 1990, pp.84–90

4 Madeline H. Caviness, *The Windows of Canterbury Cathedral, Corpus Vitrearum Medii Aevi, Great Britain, vol. 2, Christ Church Canterbury*, London 1981, pp.13–14

5 Madeline H. Caviness, 'Romanesque belles-verrières in Canterbury' in *Romanesque and Gothic: Essays for George Zannecki*, edited by Neil Stretford, Woodbridge, 1987, pp.35–38, suggests that some of the pre-1180s figures from the Genealogy of Christ series may also fall into the category of re-used glass from before the fire of 1174

6 See C. M. Kauffmann, *Biblical Imagery in Medieval England 700–1550*, London, 2003, pp.79–84

7 Erwin Panofsky, *Abbot Suger on the Abbey of St. Denis and its Art Treasures*, Second Edition, edited by Gerda Panofsky-Soergel, Princeton, 1979, pp.73–77

8 Cambridge, Corpus Christi College MS 400, part iv, ff. 121r –127r, Canterbury Cathedral DCc / Charta Antiqua C 246 and Oxford Corpus Christi College MS 256, ff. 185v – 188r

9 Passage first quoted in a shorter form by G. G. Coulton, *Stained Glass of the XIIth and XIIIth Centuries from French Cathedrals*, London, Paris and Berne, 1947, p.7., here quoted from *The Canterbury Tales: Fifteenth-Century Continuations and Additions, The Canterbury Interlude and Merchant's Tale of Beryn*, edited by John M. Bowers, Kalamazoo, 1992, lines 148–58

10 Quoted from the translation given by M. R. James, 'Pictor in Carmine', *Archaeologia*, vol. XCIV, 1951, pp.141–66

11 Erich Auerbach, 'Figura', in *Scenes from the drama of European Literature. 6 Essays by Erich Auerbach*, translated by Ralph Manheim, New York, 1957, pp.11–76, esp. 55–60

12 Gertrude Schiller, *Iconography of Christian Art*, vol. 1, London, 1971, p.24

13 Edwin A. Abbott, *St. Thomas of Canterbury. His Death and Miracles*, London, 2 vols, 1898

14 Sarah Blick, 'Comparing Pilgrim Souvenirs and the Trinity Chapel Windows at Canterbury. An Exploration of Context, Copying, and the Recovery of Lost Stained Glass', *Mirator Syyskuu*, 2001, pp.1–27 (E-Journal)

15 John Crook, 'The Typology of Early Medieval Shrines – a Previously Misidentified Tomb Shrine panel from Winchester Cathedral', the *Antiquaries Journal*, vol. 70, 1990, pp.49–65, esp. 51, plate X b; John Crook, *The Architectural Setting of the Cult of Saints in the Early Christian West c. 300-c.1200*, Oxford, 2000

16 Abbott, 1898, vol. 1, p.314 no.558

17 Abbott, 1898, vol. 1, p.263

18 Madeline H. Caviness, *The Early Glass of Canterbury Cathedral circa 1175–1220*, Princeton, 1977, pp.50–99

19 Walter Oakeshott, *Sigena. Romanesque Paintings in Spain and the Winchester Bible Artists*, London, 1972

20 See Louis Grodecki and Catherine Brisac, *Gothic Stained Glass 1200–1300*, London, 1985, p.182

21 Floridus Röhrig, *Der Verduner Altar*, Vienna, 1955

22 Caviness, 1977, pp.84–100

23 Sarah Brown, *Stained Glass: An illustrated History*, London, 1992, pp.7–25 and pp.172–73

24 Caviness, 1981, p.290

25 London, Lambeth Palace Library MS 233, f.44

26 David E. O'Connor and Jeremy Haselock, 'The Stained and Painted Glass' in G. E. Aylmer and Reginald Cant, *A History of York Minster*, Oxford, 1977, pp.313–94, p.272

27 *Gothic Art for England 1400–1547*, exhibition catalogue, Victoria and Albert Museum, edited by Richard Marks and Paul Williamson, assisted by Eleanor Townsend, London, 2003, no.38 and pp.76–85

28 William Somner, *The Antiquities of Canterbury*, London, 1640

29 William Gostling, *A Walk in and About the City of Canterbury*, Canterbury, 2nd edition, 1777

30 Caviness, 1981, p.321

31 Caviness, 1977, p.5

32 Peter Cormack, *The Stained Glass Work of Christopher Whall, 1849–1924*, Boston Public Library, 1999

33 *Ervin Bossanyi: Paintings & Works in Stained Glass*, exhibition catalogue, Ashmolean Museum, Oxford, 1979

Reading Stained Glass

Understanding the imagery of the past is, in some ways, like learning a foreign language; many of the words and some of the syntax may be the same as one's mother tongue, but the overall meaning can be quite different. Misunderstandings can occur because the images may have resonances that are not obvious to a modern reader.

Often it is the small things that lie at the peripheries of the stories told through stained glass that give us insights into the social contexts in which artists worked. The blocks used by a crippled man, a hockey stick, a carpenter's trestle table – all reveal aspects of daily life that were recorded in the minds of artists because of the strong impressions they made. Transmitted through the work of artists, these impressions are still powerful today and reveal more about the past than a written document can ever do.

Adam's Spade (see page 35)

When held by Adam, the spade directs our thoughts to the toil man has to endure because of the Fall. It is accurately depicted and identifiable as a typical spade of its time. The symbolism of daily work as the lot of all men is strengthened by the realism of its depiction.

Ark of the Covenant (see page 62)

The chest was made of acacia wood and gilded. As a replacement for the Golden Calf it represented the agreement (Covenant) between the Israelites and God in a visible form that was not an idol. The Tablets of the Law obtained by Moses were contained within it, as was Aaron's rod, chosen by God from the 12 rods of the tribes of Israel to blossom with almonds. It was thereafter placed in the ark with manna, a bread from heaven given to the Israelites each morning except the Sabbath, while they were in the wilderness for 40 years.

Blood Sacrifice of Jeroboam (see page 61)

The killing of the calf signifies the animal sacrifice associated with the Old Testament. Sacrifice was not done just for the sake of killing; it was usually associated with a religious feast, during which the flesh would be eaten.

Boyhood (see page 71)

Youth is signified by the ball and stick. The curved end suggests a form of hockey stick, rather than a bat, perhaps for playing 'bandy ball' (a form of medieval hockey). The popularity of this game is indicated in a similar depiction of a youth with a curved stick in the stained glass of Gloucester Cathedral (*c.* 1350).

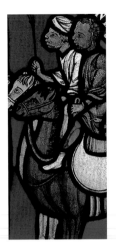

Camels of the Queen of Sheba (see page 56)

The camels and the camel riders are here indicators of the exoticism associated with the Queen of Sheba. She was popularly thought to come from Southern Arabia although some authors also suggest that she came from Ethiopia. This conflation of exotic locations is expressed through the use of the camels themselves, which signify Arabia, and the riders who are shown with the facial characteristics of Africans. The saddlebags and water bottles carried by the caravan are other indicators of travel through difficult and, perhaps, hot terrain.

Carpenter's Trestle Table (see page 118)

The table is presented in a typically realistic way with its trestles beneath an upper slab. It signifies the carpentry that is being practised.

Christ's Halo (see page 76)

The 'tripartite halo' or 'cross nimbus' was only used to depict Christ or God. It indicates a three-part nature – Father, Son and Holy Spirit.

Cripple with Blocks (see page 135)

The doubled-back legs of the cripple and the handblocks he uses for crawling along the ground are powerful indicators of the lot of disabled people in the Middle Ages. Here they signify not so much the helplessness of the man as his willingness to help himself, even before he has been helped by the donation of money by Eilward of Westoning.

Flock of Crows (see page 77)

The crows shown here signify the seed that went to waste in the Parable of the Sower, taken by the devil: 'then cometh the wicked one, and catcheth away that which was sown in his heart' (Matthew 13: 19). In Chaucer's *Manciple's Tale*, the treacherous crow is turned black by Apollo and despised. The symbol of the crow as a cursed bird that had lost its song was a powerful one and survives to the present day.

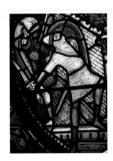

Danish Soldier (see page 45)

As a clue to whether an enemy or an ally is depicted, the knight's dress tells us nothing. Both defenders and attackers wore the same chain-mail armour and helmets of the twelfth century. The meaning of the depiction – evil attacker and good defender – is achieved through the context of the action and the mythology surrounding the life of St Alphege, who was captured by the Danes.

Destruction of Sodom (see page 60)

The fire depicted here symbolises a phrase in the Bible, which is still part of popular speech today. It is the 'brimstone and fire' that 'the Lord rained upon Sodom and Gomorrah'.

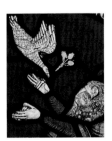

The Dove (see page 69)

As part of the story of Noah's ark the dove signifies proof of the waning of the waters – it is shown returning with an olive sprig. The white dove also signifies the Holy Spirit if placed in another context. Its connotation of peace – particularly with the olive branch – is an expansion of the notion that it symbolised God's forgiveness after the Flood.

The Grapes of Eschol (see page 99)

Grapes were a symbol for the blood of Christ because of His own analogy between the wine of the Last Supper and His own blood: 'for this is my blood of the New Testament, which is shed for many for the remission of sins' (Matthew 26: 28).

Guards at the Door (see page 94)

The guards have come to arrest Samson but wait until Delilah has cut his hair. They are armed and ready for a fight but signify the fear of Samson rather than their own ferociousness.

Holy Water (see page 107)

Water mixed with the blood of St Thomas was used to cure many ailments at Canterbury. It signifies not the washing of limbs, as might seem to be the case, but the cleansing of sin and removal of evil by the saint.

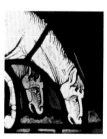

Horses Grazing (see page 144)

This scene is carefully observed and suggests the status attached to the care of horses within a feudal system of prestige (based on ownership of land and rents) but also duties, such as the care of animals.

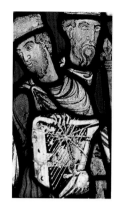

King David with his Harp (see page 72)

The harp was the attribute of King David, who played it to King Saul when he was troubled with violent outbursts. It was widely believed that King David had composed and sung the Psalms. The harp (or lyre) is particularly associated with archaeological finds in ancient Sumeria and Babylon. It comes as no surprise that the famous Lament of Psalm 137 should start with the lines 'By the rivers of Babylon, there we sat down, yea, we wept, when we remembered Zion. We hanged our harps upon the willows in the midst thereof.'

Lectern (see page 113)

This lectern with a book placed on it suggests that prayers were read at the tomb of St Thomas, indicating that the monks of Canterbury held a vigil over the tomb.

Net with Fish (see page 75)

Medieval nets were made of nettle hemp and constructed using specialised knots. Nets for sea fishing could also be used as storage bags or as traps. The oval, reinforced, upper edge of this net suggests that it was used in exactly this way.

Ploughed Field with Thorns (see page 79)

The field is shown as an angled row of furrows with seed scattered upon them. This symbol of fertility is broken up by thorns growing in its heart, signifying the deceitfulness of riches that 'choke the word' (Matthew 13: 22).

Riches (see page 79)

This bowl of money signifies the riches of the world. Crosses are visible on the coins, which also have inscribed edges. This was a common design for the reverse of coins in the reign of Henry II. Known as 'short cross' coinage it was used with little variation, other than changes to the head of the ruler on the obverse, until the middle of the reign of Henry III.

Shrine of St Thomas (see page 126)

This is a typical 'house shrine' of the *c.* 1200 period. These objects were made to house the relics of saints that had been translated (removed from their graves) and placed in gilded and enamelled boxes. There is great historical significance in this representation at Canterbury, because it occurs in glass that was probably made before St Thomas was translated in 1220. The monks had wanted to translate his relics from the crypt since soon after he was canonised in 1173. Therefore, this representation may have been made when designs for the real shrine were still being considered.

Sundial of Ahaz (see page 41)

Sundials were often inscribed on the south side of churches. This portable sundial signifies the power of God to make the dial ascend or descend at will – in effect to control time. It became the attribute of King Hezekiah because God made time run backward as proof of his power.

Tray of Food (see page 145)

The tray is longer than it might normally have been, as it is used to feed a leper. It is an indication of distance between giver and receiver, but also of care and compassion through the provision of food for the sick.

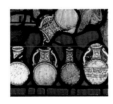

Wine Vases (see page 73)

Wine and beer were the staple drinks of the Middle Ages because water was often regarded as contaminated or not palatable enough to drink on its own. The vases seen here are carefully drawn to suggest grandeur through shape and decoration. They are somewhat archaic in appearance and resemble antique amphorae, which suggests they were intended to signal a time gone by, perhaps even the Roman period of Christ's own life.

Diagrams have only been provided where the interpretation of the glass is enhanced by knowledge of which parts of the glass have been replaced or re-painted. They are not intended to supplement or replace the detailed diagrams published by the *Corpus Vitrearum Medii Aevi* for Canterbury.

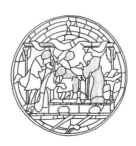

 Parts re-painted. In most cases, this involved the strengthening of original line, although some old glass could be cleaned with acid and then entirely re-painted – where this has happened, it is considered as replacement glass

Parts replaced. This includes glass replaced prior to the nineteenth century, as well as glass replaced by George Austin Jr (1848–62), Samuel Caldwell Sr (1862–1906), Samuel Caldwell Jr (1906–52) and George Easton (1952–72). See pages 210–14 for a detailed account of these men's work.

 Stop gaps. Pieces of medieval glass, and in some cases later glass, were sometimes inserted into windows in order to fill gaps in the glass. In some instances, decorative borders were made up from fragments of glass.

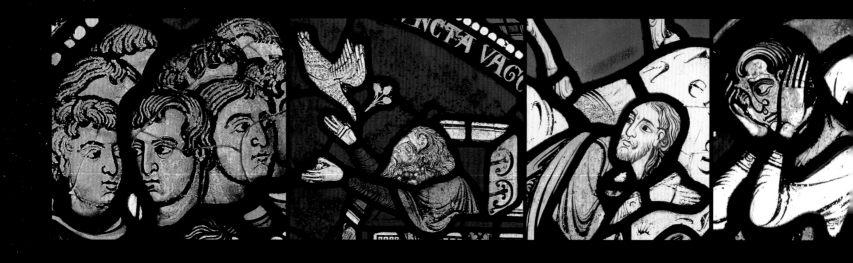

Stained Glass of Canterbury Cathedral

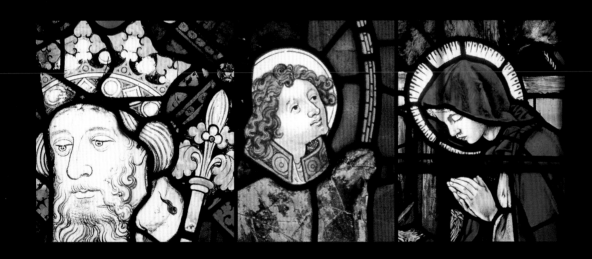

The Genealogy of Christ

The choice of subject matter for the clerestory of the quire (the uppermost windows) was particularly important after the fire of 1174. As many as 86 figures of at least 140cm in height, paired one above the other in each lancet, were planned to look down on the quire, like guardians seated above the area where the liturgy was sung daily. They formed a genealogy of Christ based largely on the list of 76 names contained in Luke (3: 23–38) and interpolated with additional figures from Matthew (1: 1–17), who gives 46 names. In total 43 figures survive. Nine are placed in the clerestory,

22 are placed in the Southwest Transept Window (S. XXVIII) and 12 in the West Window (W). The series started with scenes of the Creator and Adam on the north and finished with Christ and the Virgin on the south. At the east end a Last Judgement scene interrupted the paired figures, but underlined the eschatological purpose behind the iconography – the ancestors of Christ are ready to witness the Second Coming. The scheme used at Canterbury contains the largest number of figures of any Genealogy of Christ to have survived. The usual formula was to make an image of a tree stemming from Jesse (see page 100). At

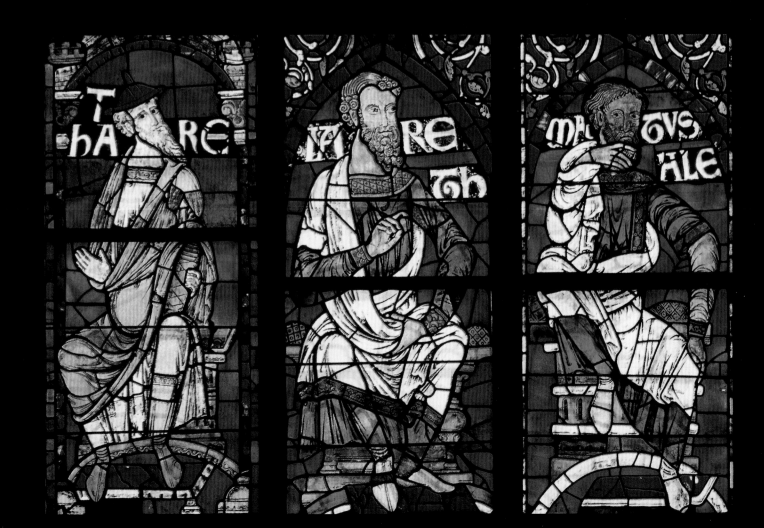

Canterbury a clear reference is made to the grand sculptural schemes which were appearing in the Isle-de-France in the late twelfth century in the arches over doorways at Senlis, Mantes and, later, at Chartres. The emphasis in these schemes is on the Coronation of the Virgin who, as the bride of Christ, is also identified with the Church (Ecclesia). At Canterbury the Genealogy of Christ would have been interrupted by windows of Christ and Ecclesia in the South Oculus Window and Moses and Synagoga in the north. Other sources of inspiration may have been the *Glossa Ordinaria*, a textbook that interpreted nearly every figure in the genealogy as having a significance based on Christ's life, as well as Anglo-Saxon commentaries.

Below: ancestors of Christ (Thara, Jared, Methuselah, Phalec, Reu and Enoch), now placed in S. XXVIII.

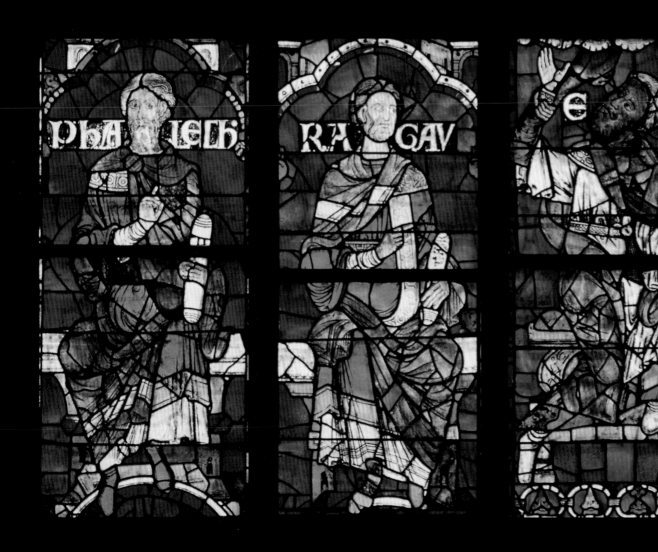

The Old Testament Patriarch Methuselah

S. XXVIII, e 2, i, ii (formerly N. XXI)

This imposing figure gives its name to the most important artist involved in the glazing of Canterbury Cathedral immediately after the great fire of 1174: the Methuselah Master. The Old Testament book of Genesis (5: 27) states that Methuselah lived 969 years, and 'as old as Methuselah' is a well-known simile for old age. The monumentality of the figure is appropriate to the high viewpoint at which it would have been seen. The precocious use of foreshortening on the right leg (drawn up to provide a rest for his arm) serves to emphasise its sculptural quality. The gesture of contemplation by raising the hand to the chin recalls antique sculpture depicting philosophers and writers.

Stylistically the figure forms part of a group of works by English artists that were at the forefront of European artistic innovation in the late twelfth century. Comparison between works by the Master of the Gothic Majesty, who worked as a manuscript illuminator on the Winchester Bible (see page 19), and the Methuselah Master shows many similarities. The drawing of the heads is clear and purposeful, but the figures maintain a humanity that gives the work a quality beyond the representational. Something of the mental struggle evoked by the pose of Methuselah, and signalled so effectively by the finger on his chin, is also found in the wall paintings in the chapterhouse at Sigena in Catalonia, which was also painted by English artists from the same group who worked at Winchester. The interest in antique models, transmitted through Byzantine art as well as through Roman sculpture, was shared by artists across Europe at this time, and evidence of it can also be found in metalwork from the Mosan region of Belgium and, later, in the sculpture at Rheims Cathedral.

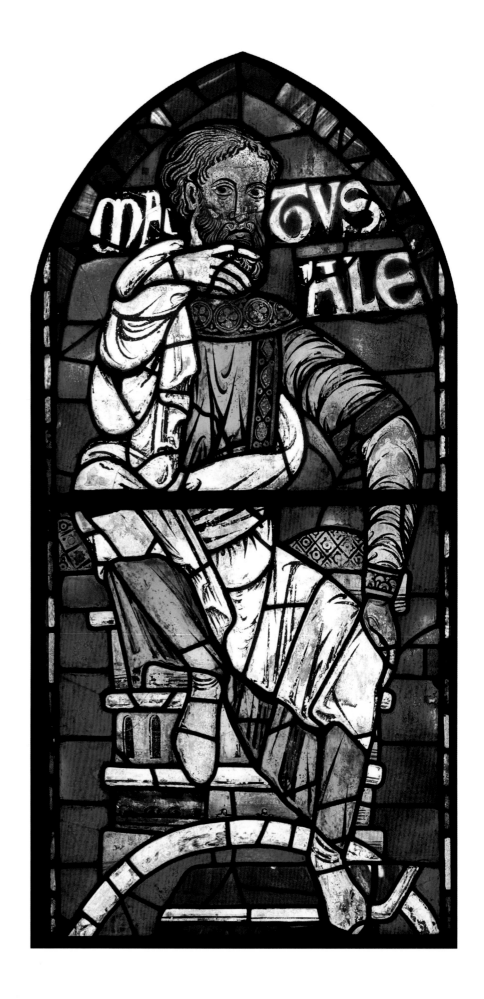

Adam Delving

W., d 3 (formerly N. XXV)

This image of Adam is one of the best preserved pieces of stained glass from the Middle Ages in England. Also executed by the Methusalah Master (see opposite), it marks the beginning of the genealogical cycle planned to explain the redemption of mankind through Christ, as God's son, being made flesh. The use of leading to reflect the musculature of the chest and the fullness of the arms is typical of the sensitivity of this artist to shape and colour. The audience for this cycle would have recognised the distinctive spade and appreciated the reference to primitive (almost 'Stone Age') attire made through the fleece loincloth. The absence of Eve is notable, but her image would not have been needed for the audience to appreciate that Adam was tilling the earth because of the original sin within the Garden of Eden. The emphasis on a single male toiling to cultivate the earth also fits in with the monastic context of the display of the glass in the quire of Canterbury. The message of the panel strikes to the very heart of belief in the Middle Ages: God manifested himself through His son in human form and was therefore related to Adam genealogically, just like the rest of mankind. This, almost subversive, message of equality can also be appreciated in the words attributed to John Ball during the Peasants' Revolt of 1381: 'When Adam delved and Eve span, who then was the gentleman?'

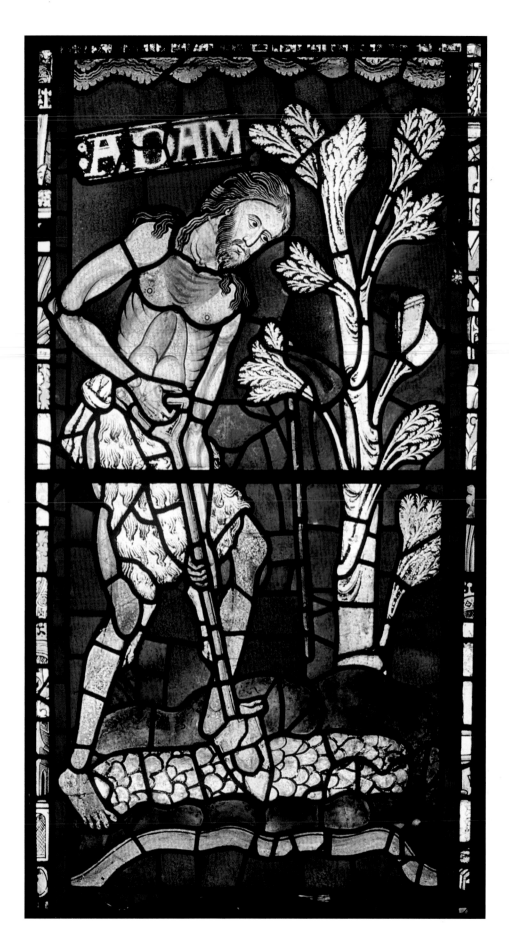

Aminadab

W., f 2 (formerly N. X)

Attributed to the Petronella Master, so called after the miracle scenes of the cure of Petronella, an epileptic nun (see page 106–07), Aminadab is paired with his son, Nahsson. The two represent the earliest stained glass to have been executed beyond the temporary screen that was erected in 1180 across the quire. The armatures of the glass beyond this point toward the east change, indicating a date perhaps between 1180 and 1207. Close stylistic resemblances can be found for this artist in the clerestory stained glass of St Remi, Rheims (Marne), and in windows of the life of St Peter at Troyes Cathedral (Aube).

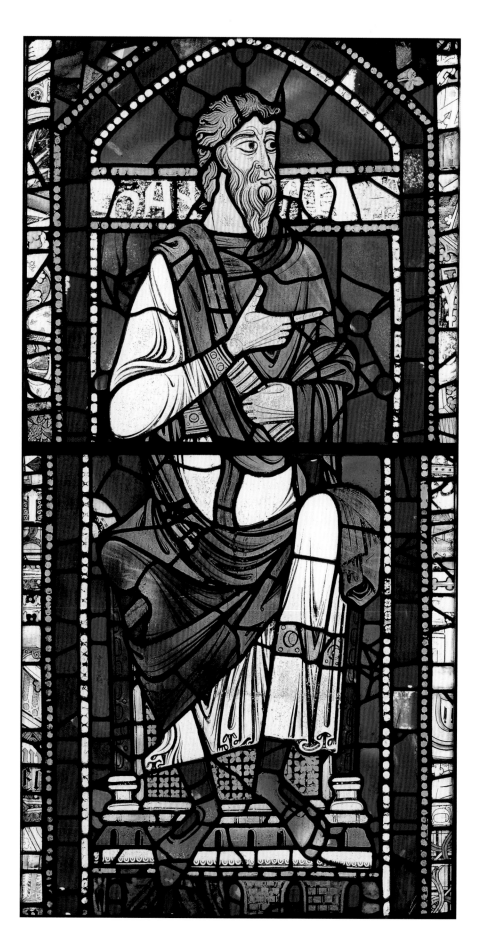

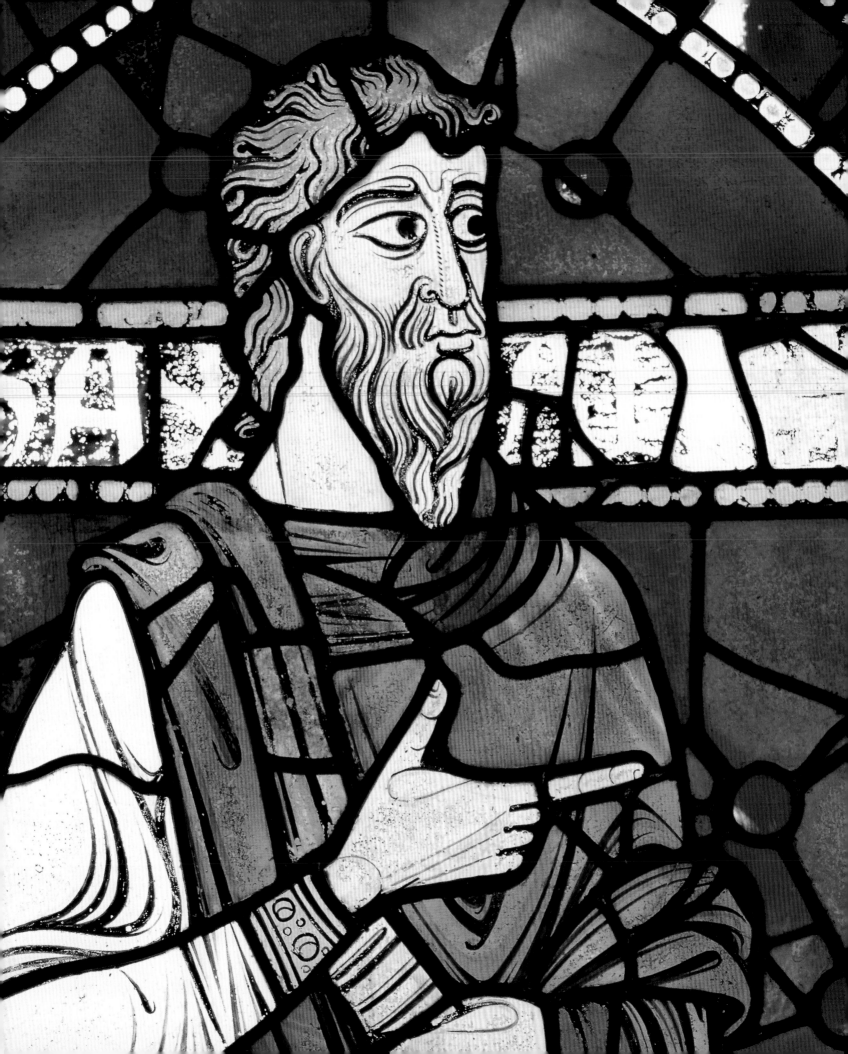

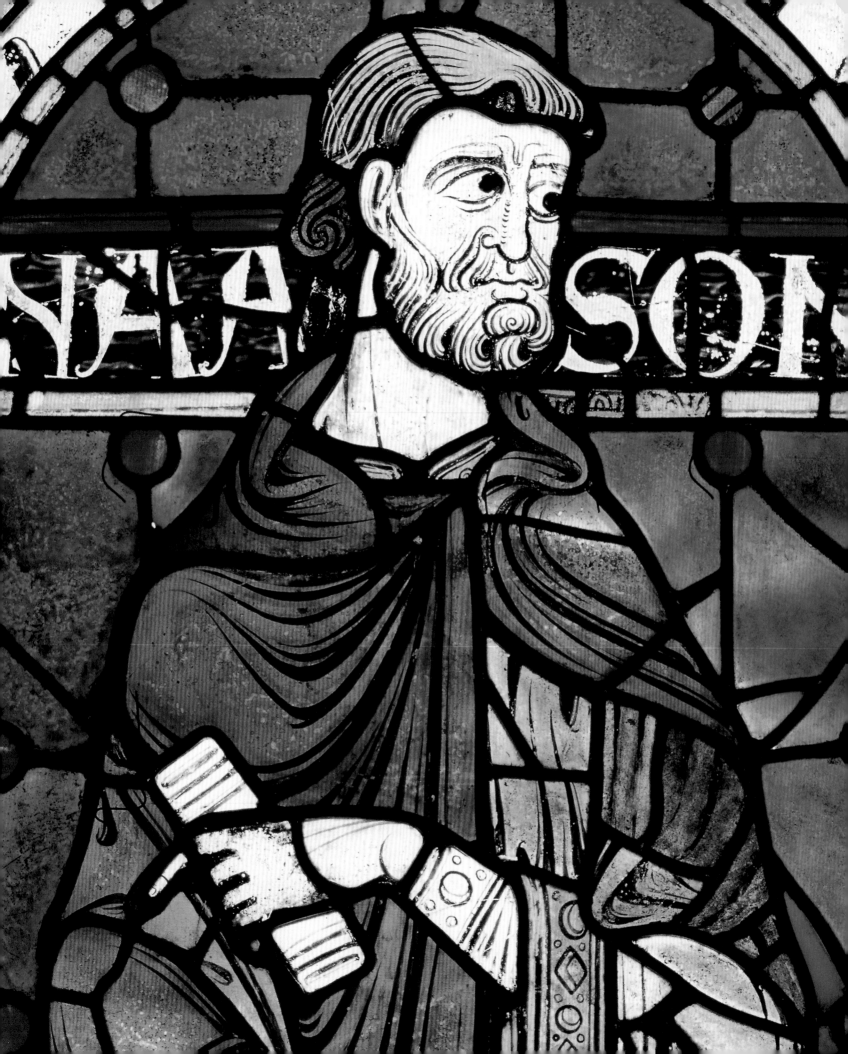

Nahsson (or Naasson)

W., b 2 (formerly N. X)

The obscure figure of Nahsson, Aminadab's son, is recalled in the Old Testament book of Numbers (1: 7) and by Saints Luke (3: 32) and Matthew (1: 4) as one of Christ's forebears. He sits erect pointing back down to his father, a prince of Judah. The distinctive purple drapery he holds elegantly in his right hand epitomises the developments in the handling of form seen in European painting *c.* 1200. The drapery may be compared with manuscript illumination such as that found in the Psalter of Queen Ingeborg of Denmark, who married the King of France Philippe II Augustus in 1193. The style is particularly associated with one of the most famous artists of his day, Nicholas of Verdun, who worked on the Shrine of the Three Kings at Cologne Cathedral and the Mary Shrine at Tournai *c.* 1200-1205. The elegant figures on the Mary Shrine show close parallels with the figure of Nahsson. The distinctive troughs of the folds sometimes create hairpin loops, which allow for flowing lines and liquid effects in the drapery.

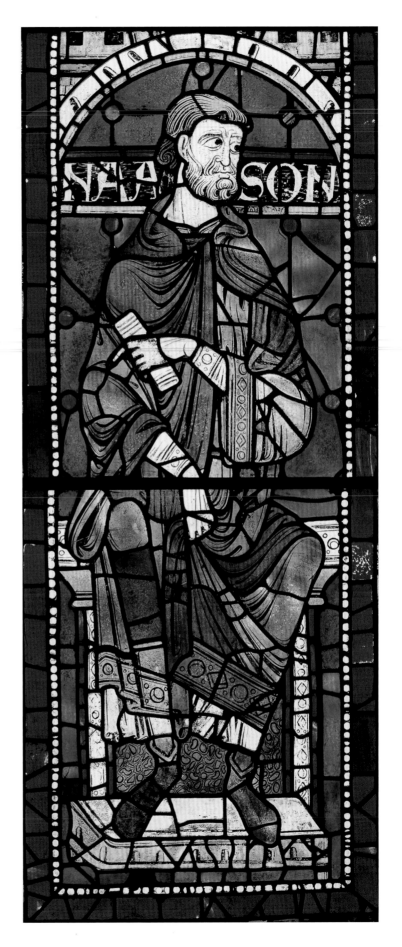

Noah

S. XXVIII, b 2 (formerly N. XX)

Noah is represented here gesticulating, as if in
conversation, as 'a just man … perfect in his
generations' who 'walked with God' (Genesis 6: 9).
He was regarded as tenth in line in the generations
from Adam, and was reputedly in his 600th year
at the time of the great deluge. He was forewarned
of this by God, who instructed him to build an
ark for himself, his family and two of each sort
of living thing. The lower half of his body is
reminiscent of Methuselah (see page 34). The
drapery reflects the more liquid approach seen
in figures of Aminadab and his son Nahsson, but
the design suggests the hand of the Methuselah
Master.

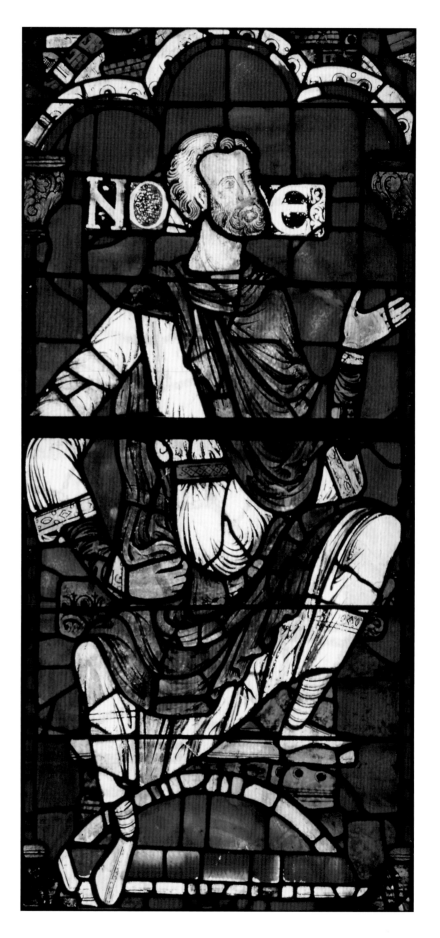

King Hezekiah (or Ezekias)

S. XXVIII, c 6 (formerly N. V)

The king is represented carrying the sundial of his father Ahaz on which God '… brought the shadow ten degrees backwards' (Vulgate 4 Kings 20: 11). This was the sign that Isaiah had told Hezekiah to look for. It showed him that his prayer, that he should not die before he had saved the city of Jerusalem, had been heard by God. Although sick, he was given another 15 years of life in order to defeat the King of Assyria. The sundial appears to have first been given as an attribute to Hezekiah in a New Testament and Psalter manuscript made for Winchcombe Abbey (Gloucestershire) in the twelfth century (Dublin Trinity College MS 53, f.7v). Hezekiah is also shown here in the crossed-legged pose of authority which was popular in thirteenth-century representations of kings, such as the image of The Coronation of David in the Glazier Psalter (New York, Pierpont Morgan Library MS G.25 f.4, *c.*1220–30). The tight-fitting sleeves and troughed folds at the waist also suggest comparisons with later English manuscript illumination such as the work found in the Rutland Psalter (London, British Library MS Additional 62925), especially the figure of Saul (f.55).

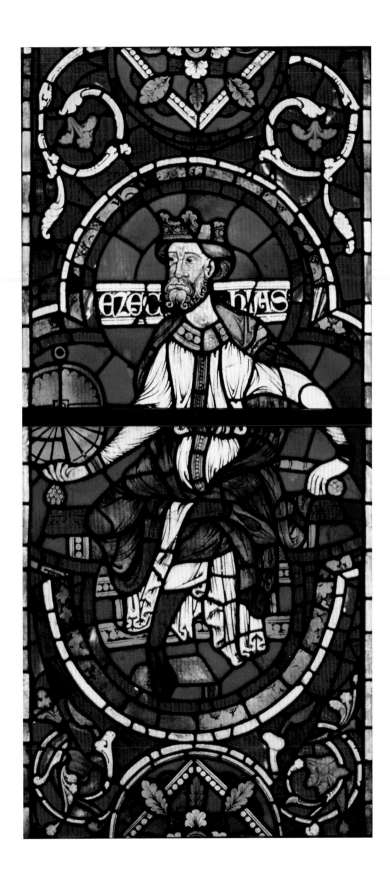

Early Canterbury Saints

The monk and chronicler of Canterbury, Gervase (*c.*1141–1210?) tells us that at Easter 1180, the prior and monks entered the quire to celebrate mass for the first time since the fire of 1174. The re-building of the quire had begun in 1175–76 and by 1178 the quire was completely vaulted as far as the crossing piers, when the architect, William of Sens, fell from the scaffolding and was mortally injured. By 1179, William the Englishman was able to vault the presbytery and high altar and put up a glazed temporary partition between the second and third bays beyond the east transept. The relics of Saints Dunstan and Alphege were also re-installed in 1180 in altars on the south and north side of the presbytery respectively. Both saints were highly venerated at Canterbury, Alphege (954–1012) as a martyr at the hands of the Danes, and Dunstan (*c.*909–88) as a great monastic reformer. After the canonisation of St Thomas Becket in 1173, the parallels between Dunstan's life and that of Becket were eagerly promoted. Dunstan had been banished under King Eadwig, but he returned under King Edgar to be made Archbishop of Canterbury and further promote the monastic reforms he had seen abroad in Flanders.

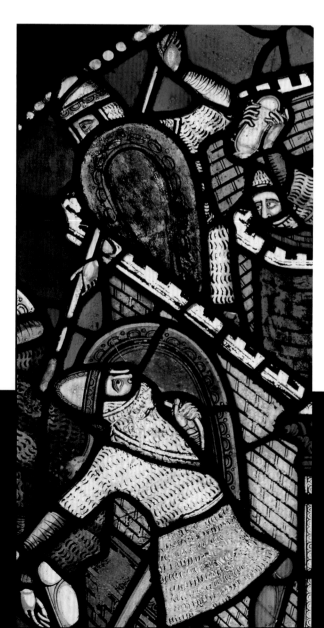

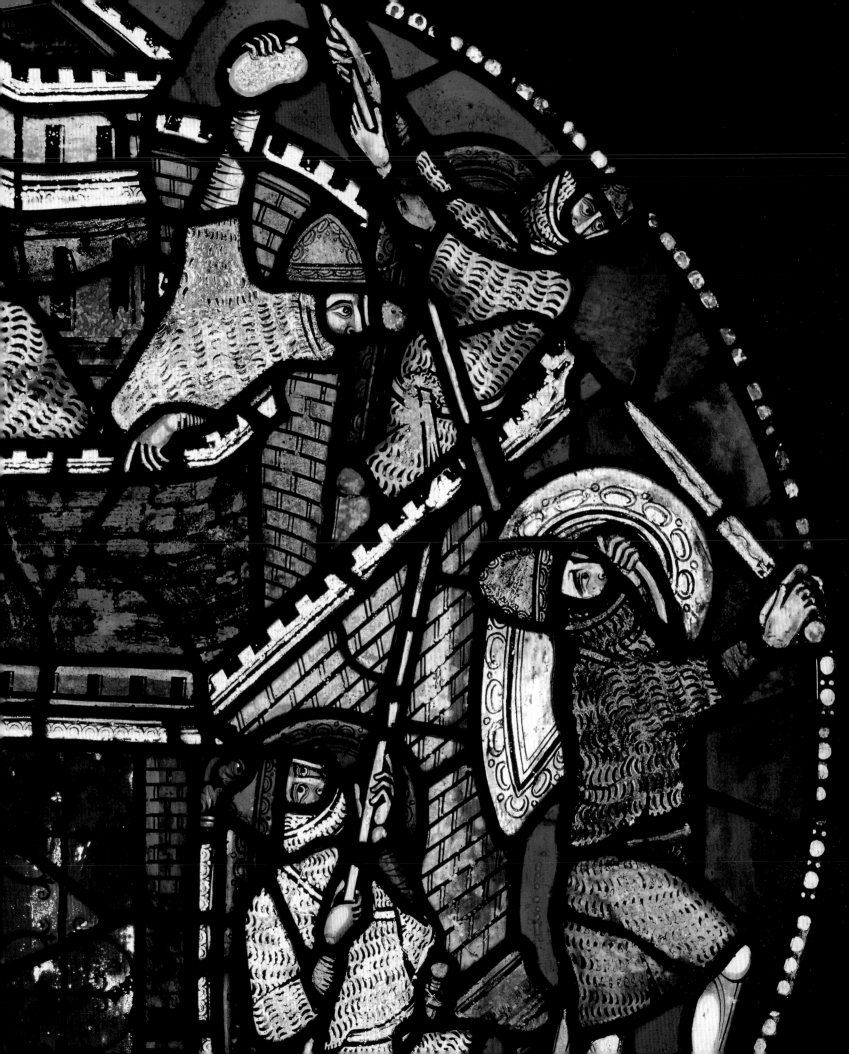

LIFE OF ST ALPHEGE WINDOW

North Quire Aisle Gallery, Nt. IX, 12, 4, 5

One of the earliest surviving windows at
Canterbury, it depicts events during the life of St
Alphege, who was Archbishop of Canterbury
1005–12. His life was recorded by Osbern, Prior of
Christ Church, Canterbury, c.1080, at a time when
there was a dispute over Alphege's sainthood. The
writing of the life and the support of St Anselm
(Archbishop of Canterbury 1093–1109) ensured
Alphege's sainthood was upheld despite
Archbishop Lanfranc's scepticism. Both St Alphege
and St Dunstan were highly honoured at
Canterbury before the martyrdom of St Thomas
Becket in 1170.

The top scene depicts the siege of Canterbury
by the Danes in alliance with Earl Edric in 1011.
The city fell and a massacre ensued, but Alphege is
said to have gone to the centre of the fighting and
tried to stop the Danes killing the innocent
citizens of Canterbury. He was arrested and
ransomed, but, according to Osbern's life, he
refused to let the people pay for his release. The
left-hand scene depicts his departure by boat for
Greenwich where he was taunted by the Danes
and eventually killed by a blow from an axe. He
was buried in St Paul's, London, but his body was
translated to Canterbury in 1023 during the reign
of King Canute.

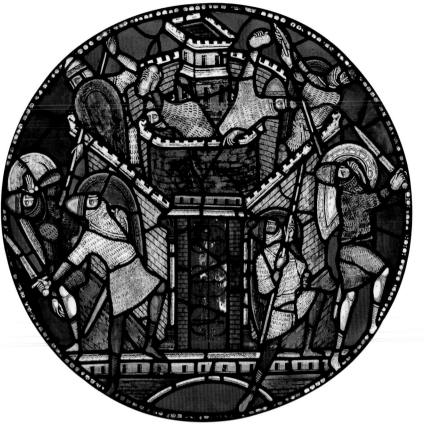

St Dunstan Saving King Eadwy from Hell

Nt. XI

Eadwy is seen below as Dunstan appears above attempting to rescue him from hell. Despite the fact that Eadwy had banished him from England, Dunstan had a vision of him suffering for his sins and wept and prayed for his soul. The parallel is with Christ's descent into purgatory, but the political message of a king who wrongs an archbishop of Canterbury, and then needs his help to stay out of hell, is also clear. St Thomas could easily be transposed for Dunstan and Henry II for Eadwy – both kings resisted their archbishops and needed forgiveness for their sins.

The Siege of Canterbury

Nt. IX

The city is depicted as a walled citadel with doors displaying contemporary wrought ironwork firmly closed. Chain-mailed and helmeted Danes attack with swords and pikes as the defenders rain stones on them. The payment of tax in the form of 'Danegeld' was supposed to prevent attack, but the Danes took the city and demanded a large ransom for Alphege. He refused to let the poor people of Canterbury pay and, it is said, was killed as much by accident as by design when a group of drunken Danes pelted him with bones and he was then hit by an axe.

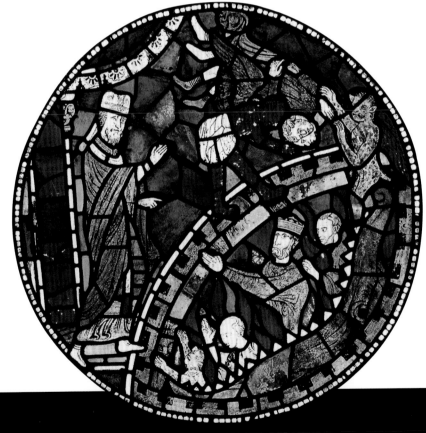

Iconography of Redemption

Of the 12 original biblical windows, known as the Typological Windows, displayed at Canterbury, glass from four precious windows survives. Following a liturgical scheme that spans the church year through Advent, Lent and Easter, they represent the most successful marriage of intellectual inventiveness and artistic expression found in any stained-glass scheme anywhere in Europe in the twelfth century. The audience for this display could have included the most learned theologians as well as pilgrims from all walks of life, yet it would have been accessible to all of them.

These windows demonstrated the redemption of mankind through Christ by placing the New Testament scenes of the life of Christ and His parables in the centre and Old Testament scenes, which medieval theologians believed predicted Christ's coming, on either side of them. The planners at Canterbury also went beyond the basic limits of comparison between the Old and New Testaments by introducing moralising themes, which were more common in the thirteenth century.

The windows started on the north side of the quire (n. XVI) with the Annunciation and continued into the northeast transept, presbytery and southeast transept (s. XII) ending in the south quire aisle (s. XV) with scenes from the Passion and Resurrection. The idea behind these windows is that the Old Testament provides an intellectual proof of Christ's incarnation, which is communicated through both verbal and visual signs. The message is often one which relies on visual comparison, so that the thieves with the grapes of Eschol (see page 97) arrange their bundle to make a 'tau' cross, reflecting Christ's sacrifice on the cross as well as His blood replaced by wine at the Eucharist (the grapes). Thus, a complex visual language is used, where both simile and metaphor demonstrate visually the inevitability of Christ's incarnation, death and resurrection. Similar schemes have survived on a group of Mosan enamelled liturgical bowls, know as *ciboria*, and also existed in paintings at Worcester and Peterborough. Prior Benedict of Canterbury, Abbot of Peterborough from 1177 to 1193, may have contributed to the transmission of these ideas. So complex are they visually, that no less than three separate manuscripts have survived describing the scenes from the thirteenth, fourteenth and fifteenth centuries respectively. This suggests that they were popular, but needed explanation even to the medieval viewer. They are easily visible from the ground and the inscriptions which frame each scene can be read in many cases without difficulty.

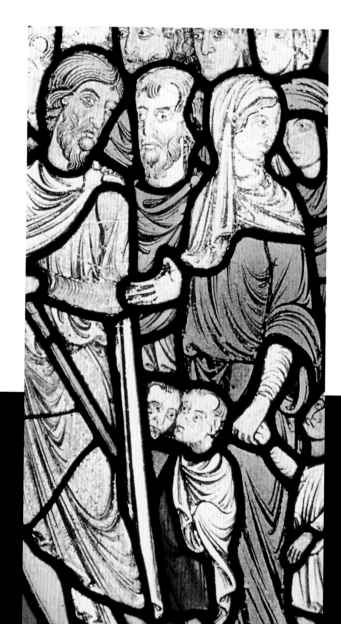

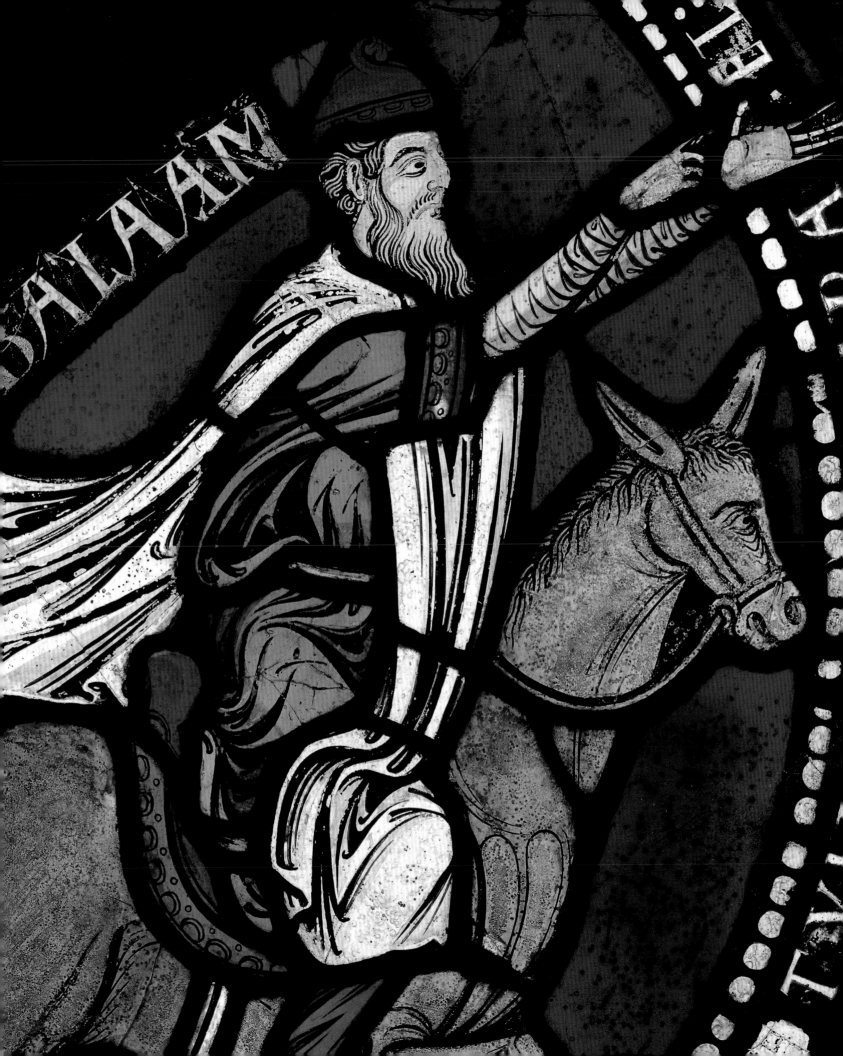

SECOND TYPOLOGICAL WINDOW

North Quire Aisle, n. XV

This is the best preserved of the typological windows and contains glass from two separate windows (the second and the sixth typological windows). It is stylistically related to the work of the Methuselah Master (see page 34) and may have been designed by him. In these smaller-scale scenes the Methuselah Master's work bears close resemblance to the later work on the Winchester Bible. Artists working in this style also completed wall paintings at Winchester and in the refectory of the monastery at Sigena in Spain (Catalonia). The fact that work in all three media is related stylistically suggests that a group of professional artists who were moving freely between England and Europe designed and executed these schemes. These artists retained, nevertheless, a strong connection with work that must have been produced in England. The compositions of all the Magi scenes in the glass at Canterbury, for instance, can be compared with the Great Canterbury Psalter (Paris Bibliothèque Nationale MS 8846, f.4.v), which was copied at Canterbury from an earlier exemplar in the last quarter of the twelfth century.

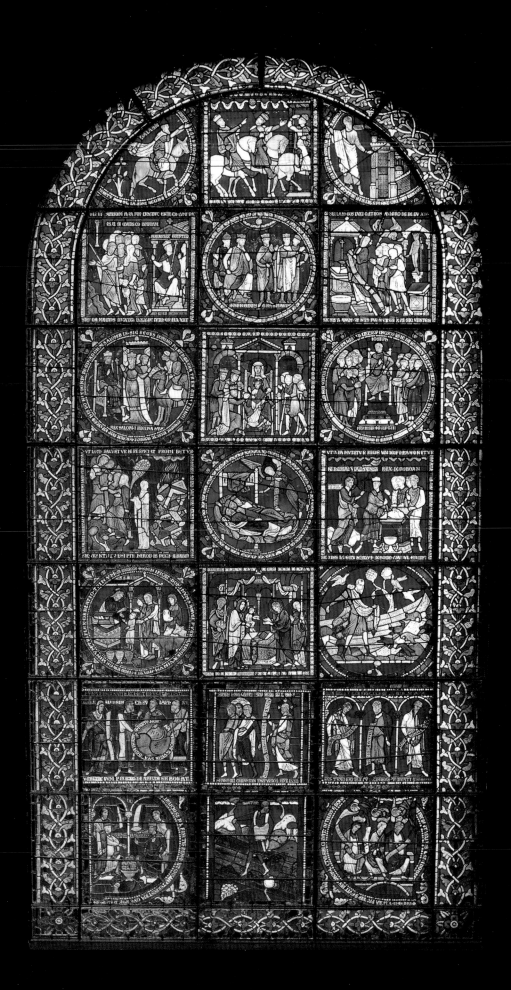

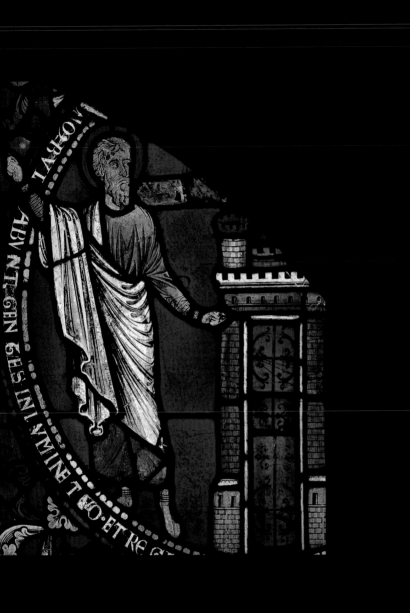

FIRST REGISTER

Balaam on his Ass

The Journey of the Magi

Isaiah

n. XV, 37, 38, 39

The window is read, like most English glass, from top to bottom. In the top centre the journey of the Magi following the star to Bethlehem is depicted, with all three on horseback, looking up, pointing and gesturing the way or straining to see the star. Either side are depicted Balaam on his ass and Isaiah prophesying.

Balaam was sent to curse the Israelites, but his ass refused to move despite being beaten. Eventually, to Balaam's amazement, the ass spoke, and an angel was revealed barring the way. Balaam blessed the Israelites and prophesied that 'there shall come a star out of Jacob and a sceptre shall rise out of Israel' (Numbers 24: 17). The story was seen as an allegory of the journey of the Magi and the star is a metaphor for Christ's coming. The inscription accompanying Isaiah suggests that a more literal prophesy was also intended: 'and the gentiles shall come to thy light, and kings to the brightness of thy rising' (Isaiah 60: 3).

SECOND REGISTER

Moses Leading the Israelites

Herod and the Magi

Christ Leading the Gentiles

n. XV, 32, 33, 34

The next central scene depicts the Magi before
Herod who is seated in purple and white robes. He
asks them to return, as he intends to kill the Christ
child. This is paralleled visually with the Israelites
escaping the clutches of the Pharaoh on the left.
They are led by God 'in a pillar of a cloud … and
by night in a pillar of fire' (Exodus 13: 21), here
visualised literally as a column of stone that guides
them in the same way as the star guides the Magi.
On the right, instead of a text from the Old
Testament, is an unusual scene based on the role
of Christ as redeemer. The allegory works visually
by showing us that Christ leads the Gentiles away
from pagan gods toward the true church. The
people are seen moving away from a naked pagan
statue, to an altar with a cross presided over by
Christ himself and a baptismal font waiting in the
foreground.

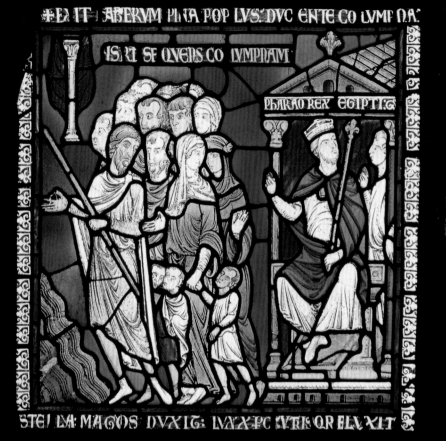

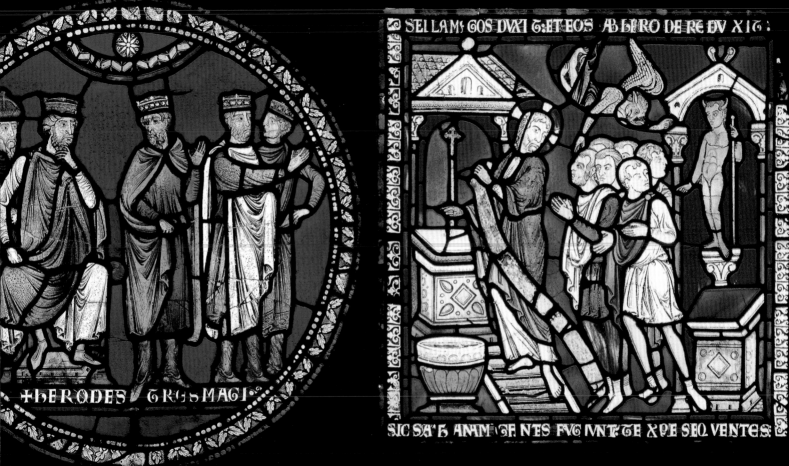

+ HERODES TRESMAGI

SEI LAM: GOS DVXI T: ET EOS AB ERO DE RE DV XIT:

SIC SATH ANAM CANTES FVGIVNT TE XPE SEQ VENTES:

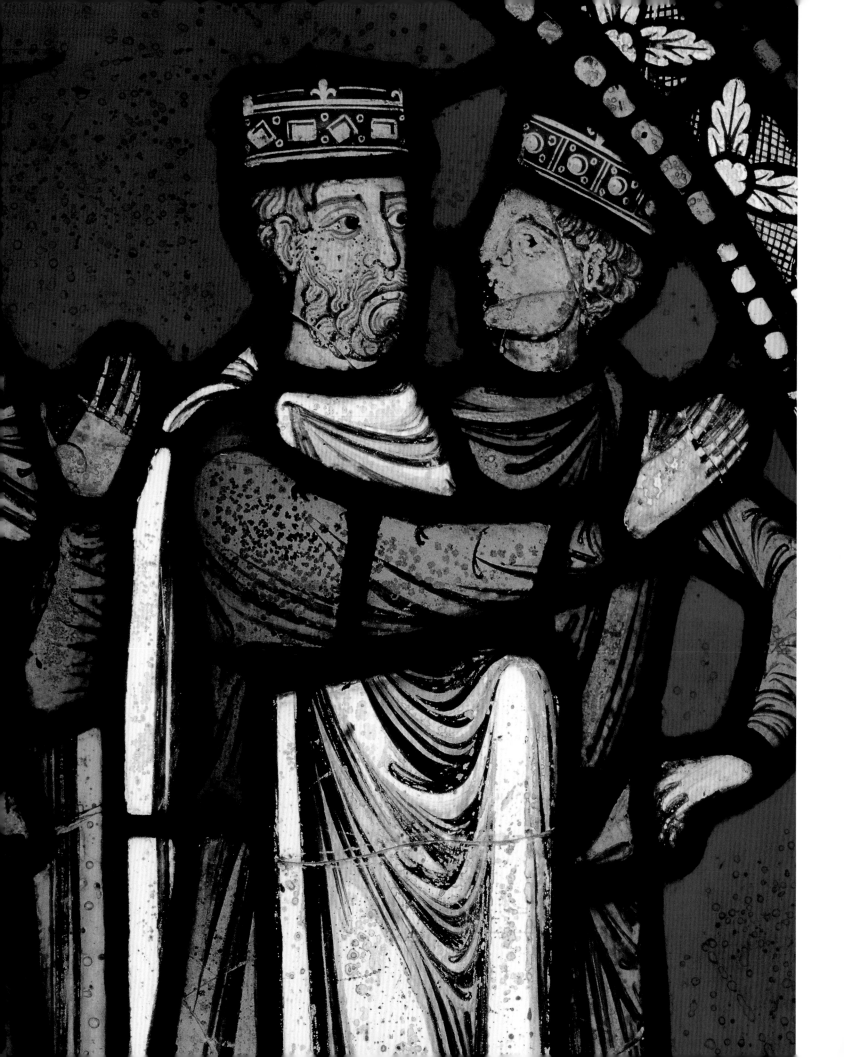

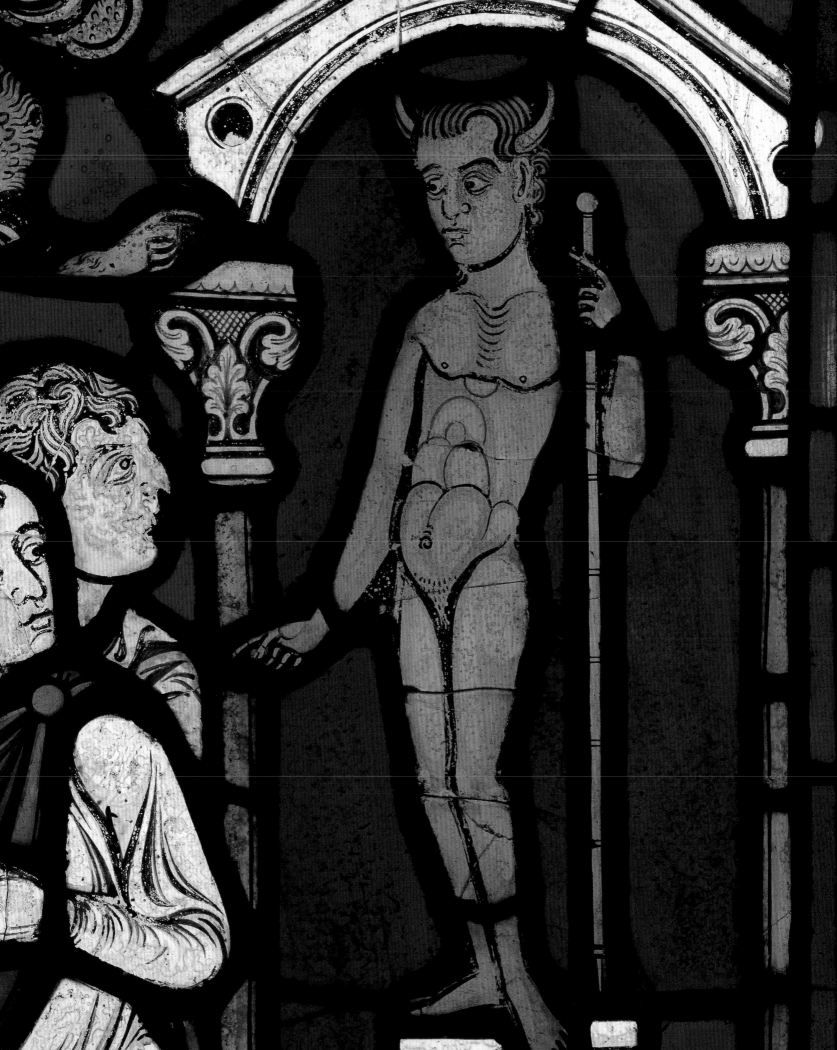

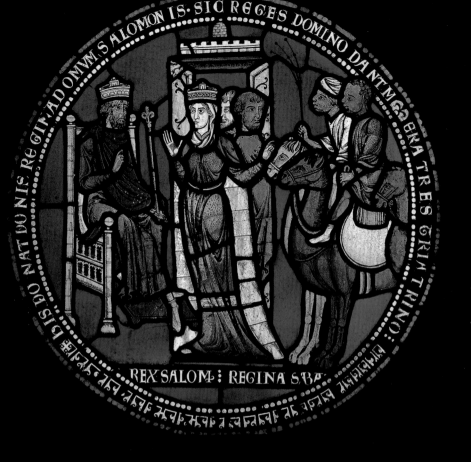

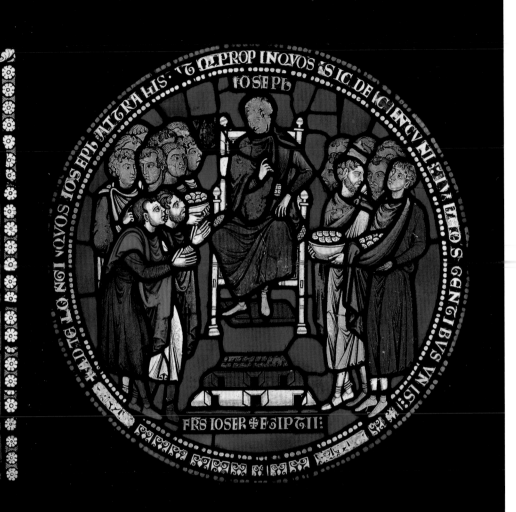

THIRD REGISTER

Solomon and the Queen of Sheba

Adoration of the Magi

Joseph and his Brothers

n. XV, 27, 28, 29

The central scene depicts two scenes simultaneously: *The Adoration of the Magi* and *The Adoration of the Shepherds*. The Magi arrive from the left and the shepherds from the right. The allegory here is of the recognition of Christ as saviour. Solomon is shown receiving the Queen of Sheba. She recognises his authority by giving him gifts in the same way as the Magi bring gifts to Christ. The unwitting recognition of Joseph's authority by his 12 brothers, who had sold him into slavery, suggests Christ among the Apostles. There are further layers of allegory here referring to the recognition of Joseph by the Egyptians, as opposed to the Israelites, and the recognition of Christ by the Gentiles and not the Jews. Nearly all the typological scenes in this window make constant reference to the conversion of the Gentiles suggesting a planned emphasis on this theme.

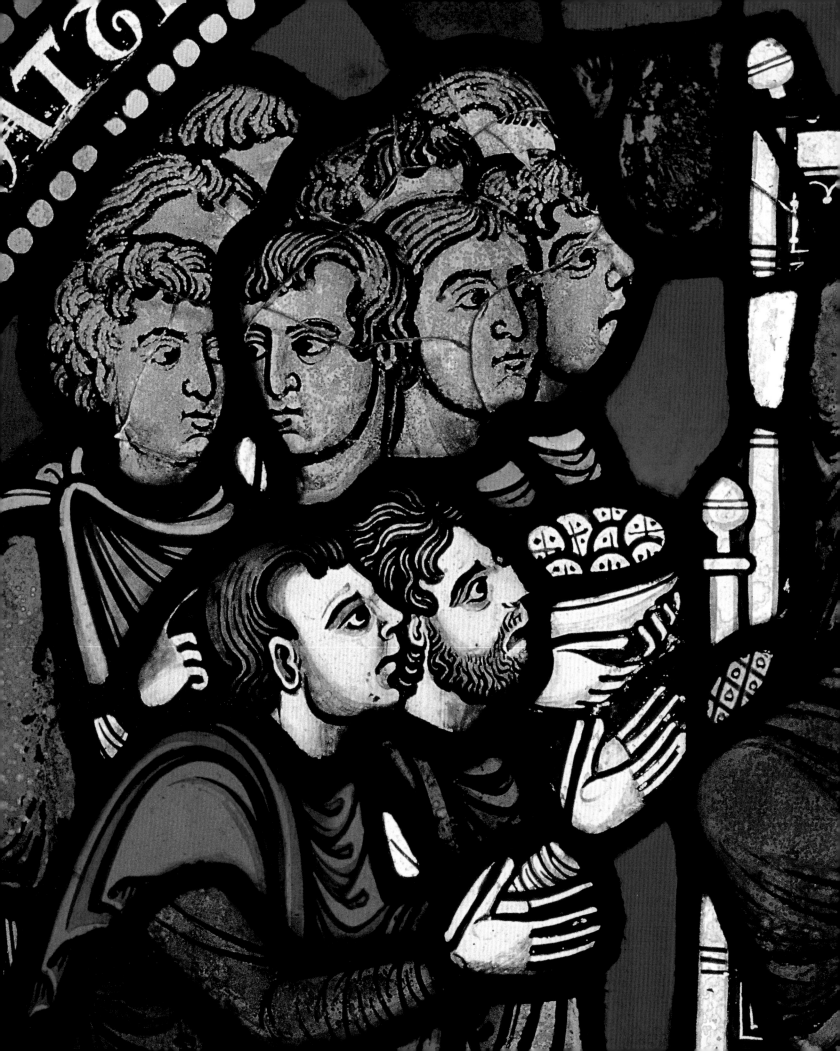

VT LOTH SALVET VR NE RE SPICI AT PROHI BET VR

SIO VIŁA NTIRS V EVI PER ḢEROD IS REGN A SABE I

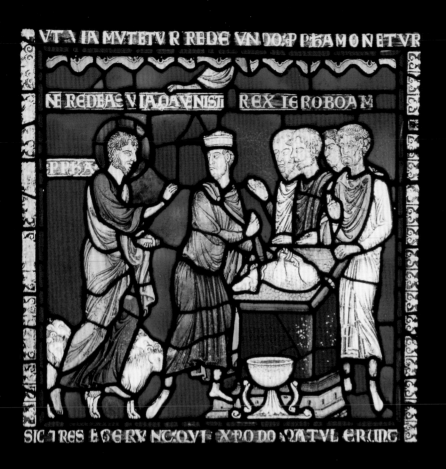

VT A IA MVTETVR REDE VN OO:P PHA MO N ET VR

NE REDEAS VIAQA VNIST REX IEROBOAM

PHA

SIC TRES EGGRV NCAQVI XPO DO MATVL ERUNG

FOURTH REGISTER

Lot's Wife

The Dream of the Magi

The Prophet in Bethel

n. XV, 22, 23, 24

The Magi are warned in a dream not to return to Herod to tell him where the child was to be found. The angel is shown approaching their communal bed (the sharing of beds by travellers was usual in the Middle Ages) while they sleep. This is paralleled by a warning of a different kind: Lot's wife is turned to a pillar of salt during the escape from God's destruction of Sodom and Gomorrah for not heeding the warning 'look not behind thee' (Genesis 19: 17–26). On the right the Prophet in Bethel is also warned not to return to Judah by the way he came (Vulgate 3 Kings 13: 1–9). The complexity of this allegory is such that it is necessary to know that the unnamed prophet prophesies against the altar set up with a golden calf at Bethel by King Jeroboam. He predicts that the altar 'shall be rent and the ashes that are upon it shall be poured out' – a parallel with the destruction of Sodom. He also predicts the coming of Christ by stating 'behold a child shall be born unto the house of David'. But he himself goes against God's instructions not to 'turn again by the same way that thou comest' on the advice of an older prophet and is slain by a lion for so doing. The visual signs used in this scene may also be interpreted through reference to the second register above: the stone pillar in the deliverance of the Israelites from Pharaoh is paralleled with Lot's wife turned to a pillar of salt and Christ's altar is paralleled with that of Jeroboam.

FIFTH REGISTER

The Presentation of Samuel

The Presentation of Christ

n. XV, 17, 18

The central scene depicts the Presentation of
Christ in the Temple at Jerusalem. It was conflated
as an event with the Purification of the Virgin
under Mosaic Law, and became known as the feast
of Candlemas as candles of beeswax were blessed
and the Canticle of Simeon was sung. Despite the
restoration of the Virgin and the High Priest
Simeon, the scene retains the tall candles
suggestive of the liturgical meaning of the scene –
that of the feast of Candlemas. It was once paired
with the scene of the Offering of Melchizadek on
the right (now lost and replaced with a scene of
the Parable of the Sower, see page 77). The
Presentation of Samuel in the Temple, shown on
the left, parallels that of Christ, but the allegorical
meaning of this scene is much deeper. The
unusual representation of the Ark of the
Covenant on the altar is a masked reference to the
Virgin Mary. The Ark was a gilded wooden box
created by Moses to replace the Golden Calf and
contained the Tablets of the Law, a pot of manna
and Aaron's rod. It was regarded as the only
necessary visible sign of the deity under Mosaic
Law. The wooden box of the Ark was interpreted
by Christian theologians as signifying the womb
and flesh of the Virgin who carried Christ.
It therefore represents the new Covenant that
God made with mankind through the sacrifice
of His son.

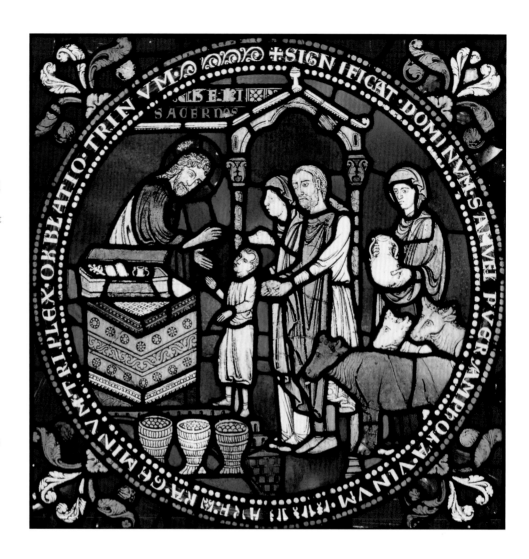

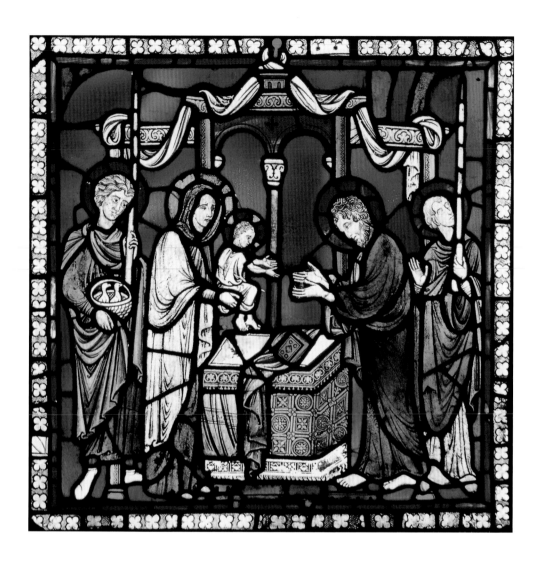

THIRD TYPOLOGICAL WINDOW

North Quire Aisle, n. XIV

This window is currently made up from well-preserved scenes from Typological Windows 3, 4 and 6 (n. XIV, n. XIII and n. XI). The scenes here originally introduced the Lenten theme to the glass and moved away from the more direct typology, based on the Old Testament, found in the Second Typological Window by introducing more moralising and theological comparisons. The uppermost three scenes, *Christ Among the Doctors, Moses and Jethro* and *Daniel Judging the Elders,* are still in their original settings and belong to this window. They appear to have been designed by the Methuselah Master who was also responsible for the Second Typological Window (see pages 34 and 48). Below are scenes of the *Miracle at Cana* flanked by *The Six Ages of Man* and *The Six Ages of the World,* which originally belonged to the Fourth Typological Window and need to be explained in terms of the writings of St Augustine (see page 72). The next three scenes also belonged to the Fourth Typological Window and depict the *Miraculous Draught of Fishes* and *Peter Preaching to the Jews* in the right-hand semicircle, and the rare scene of *The Calling of Nathaniel.* The latter is now flanked by *Noah in the Ark,* which belongs with this window but was originally paired with the lost *Baptism of Christ.* All of the scenes that once belonged to the Fourth Typological Window (see pages 70–75) have been attributed to an artist named after this cycle: the Master of the Public Life of Christ. His work is close to that attributed to the Methuselah Master, but he is less concerned with iconographical clarity and is more interested in combing movement and narrative within single panes of glass.

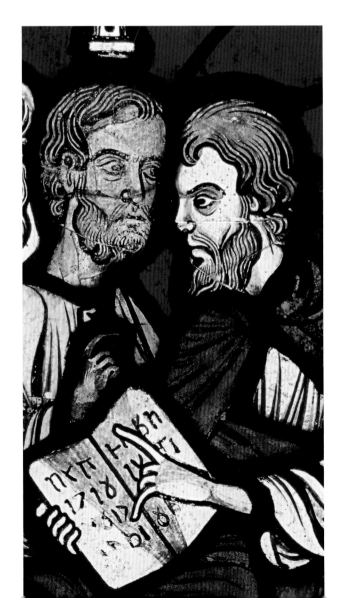

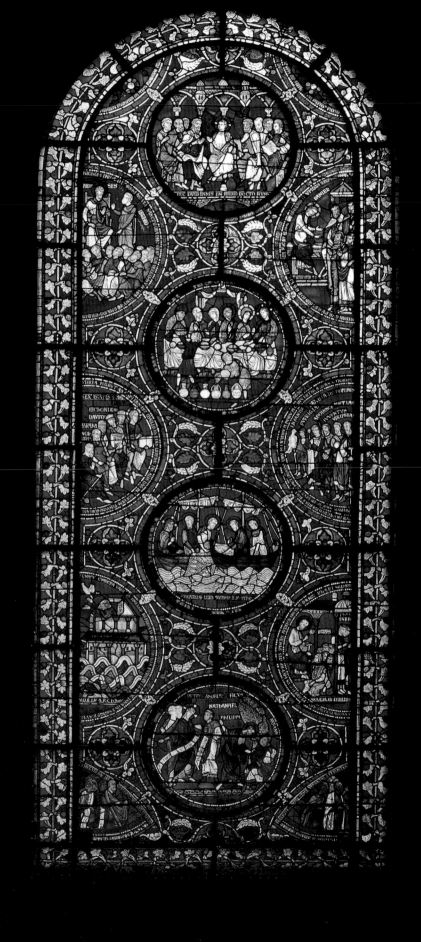

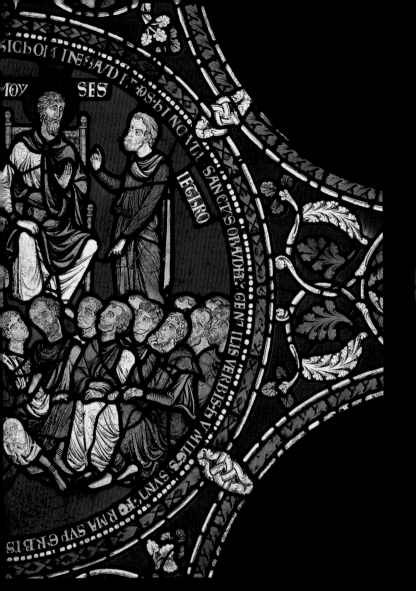

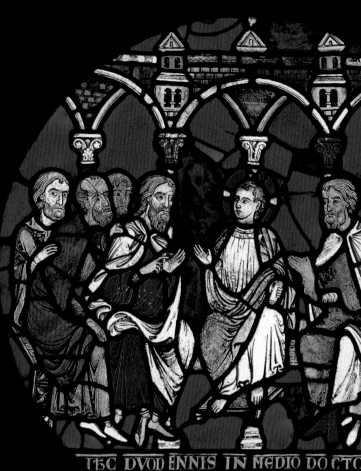

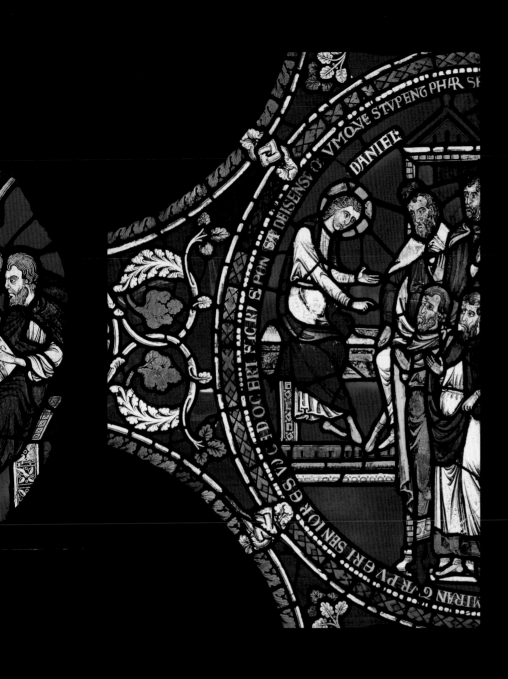

FIRST REGISTER

Moses and Jethro

Christ Among the Doctors

Daniel Judging the Elders

n. XIV, 25, 29, 26

The left-hand semicircle of glass depicts Moses receiving advice from Jethro, his father-in-law and a priest of Midian (Edodus 18: 1–26). This is seen as a parallel with Christ listening (*audientem illos*) to the doctors of the church at the early age of 12 (Luke 2: 42–46), depicted in the central roundel. The scene is inscribed: '…the Holy man (Moses) listens to the Gentile (Jethro)'. As Moses acted on Jethro's advice to create a council of advisers to help him rule, this inscription can be interpreted as a sanction for the institution of the Church with its officers (who are Gentiles). On the opposite side the semicircle is inscribed: 'The elders are surprised to be taught by … a boy'. Daniel's youth is obviously compared with that of Christ. He sits in judgement over the wicked elders who accused Susanna of adultery when she refused to lie with them, as recounted in the Vulgate Book of Daniel. The phrase 'God hath given thee the honour of an Elder' (Daniel 13: 50) suggests how Daniel might be regarded as a type of Christ in the central scene.

THIRD REGISTER (FORMERLY SECOND)

Noah in the Ark

n. XIV, 11 (formerly 18)

This beautifully preserved half-roundel depicts
Noah in a two-tier colonnaded ark floating in a
rough sea while a raven pecks at detritus in the
foreground. Noah leans out of a window in the
ark and welcomes the dove carrying an olive
branch. This refers to the narrative told in Genesis
(8: 6–12):

> And it came to pass at the end of forty days,
> that Noah opened the window of the ark
> which he had made: and he sent forth a raven,
> which went forth too and fro, until the waters
> were dried up from off the earth. Also he sent
> forth a dove … but the dove found no rest for
> the sole of her foot, and she returned unto
> him into the ark … and he stayed yet another
> seven days; and again he sent forth the dove
> out of the ark; and the dove came in to him in
> the evening; and, lo, in her mouth was an olive
> leaf pluckt [*sic*] off: so Noah knew that the
> waters were abated from off the earth.

This narrative is ignored by the text supplied
around the edge of the glass, which states: 'The
first flood, submerging everything in its sweeping
flow, purified everything and signified Baptism.'

The typological significance of the scene is
Baptism. This replaces the charm of the story with
a deeper meaning, hidden within the narrative,
which holds both a symbolic and allegorical
significance that can be extended beyond the
narrative. The ark itself, from the earliest
depictions in Jewish and Early Christian art, was
often represented as a casket rather than a boat, as
its meaning lay partly in its etymology (literally
casket in Greek and Hebrew – the same meaning it
has when the Ark of the Covenant is recalled). The
earliest depiction of the ark is on a coin from the
Hellenistic Jewish town of Apamea in Phrygia,
which was reputed to hold a relic from the ark
that was kept in a casket.

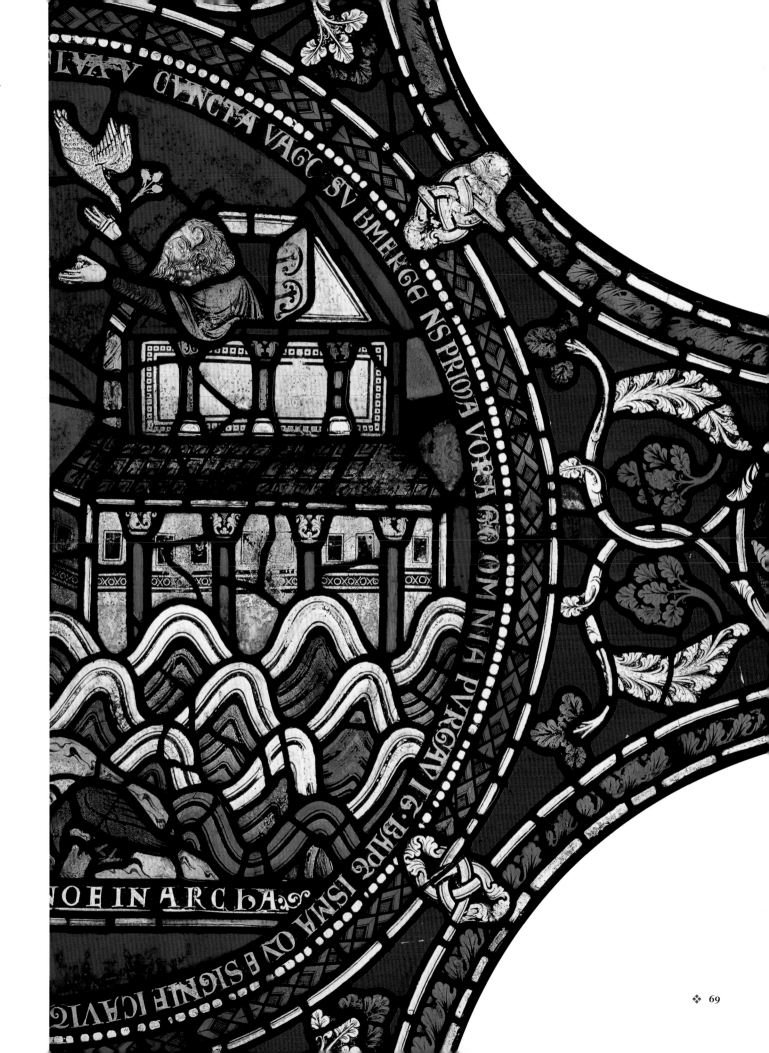

FOURTH TYPOLOGICAL WINDOW

North Choir Aisle, n. XIV (formerly n. XIII)

Executed by the Master of the Public Life of
Christ, so-called after the work he carried out on
these scenes, this window continued the liturgical
sequence through Lent in scenes starting with *The
Calling of Nathanael*, *The Miracle at Cana* and *The
Miraculous Draught of Fishes* (see pages 73 and 75)
and ending with scenes immediately before and
after The Sermon on the Mount.

The typological scenes which accompany
these central roundels are all placed in semi-
circles, just as in the Third Typological Window.
They represent an attempt to codify the
significance of the ageing process through a series
of personifications. This is first done as an
allegory of individual ageing and then as an
allegory of the ageing of the world leading to the
Second Coming of Christ in a final and Seventh
Age that is not depicted.

The intellectual basis for the juxtaposition of
the Ages of Man and the Ages of the World is
based on a long tradition. It goes back at least to
Pythogoras and the riddle of the Sphynx: 'What
animal is it that in the morning goes on four feet,
at noon on two feet, and in the evening on three
feet?' The three-part division of the answer,
(infant, grown adult and old man with a stick)
gradually grew to seven and even ten. It was St
Augustine who explained the cycle in terms of the
six days of creation and the seventh day of rest:
the first age of ten generations, from Adam to
Noah, as 'infancy'; the second age of ten
generations, from Noah to Abraham, as
'childhood'; the third age of fourteen generations,
from Abraham to David, as 'adolescence'; the
fourth age, ranging from David to the Babylonian
captivity, as the prime of life; the fifth age, with
the coming of Christ, as a transition to maturity
or older age; and the sixth age, or the period of
time since Christ's first coming, as old age – the
Seventh Age will only come when Christ returns
at the Second Coming.

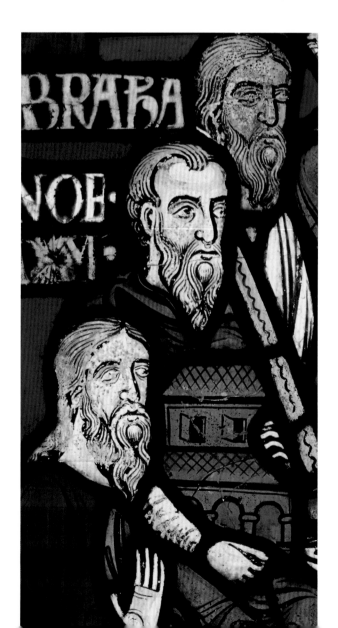

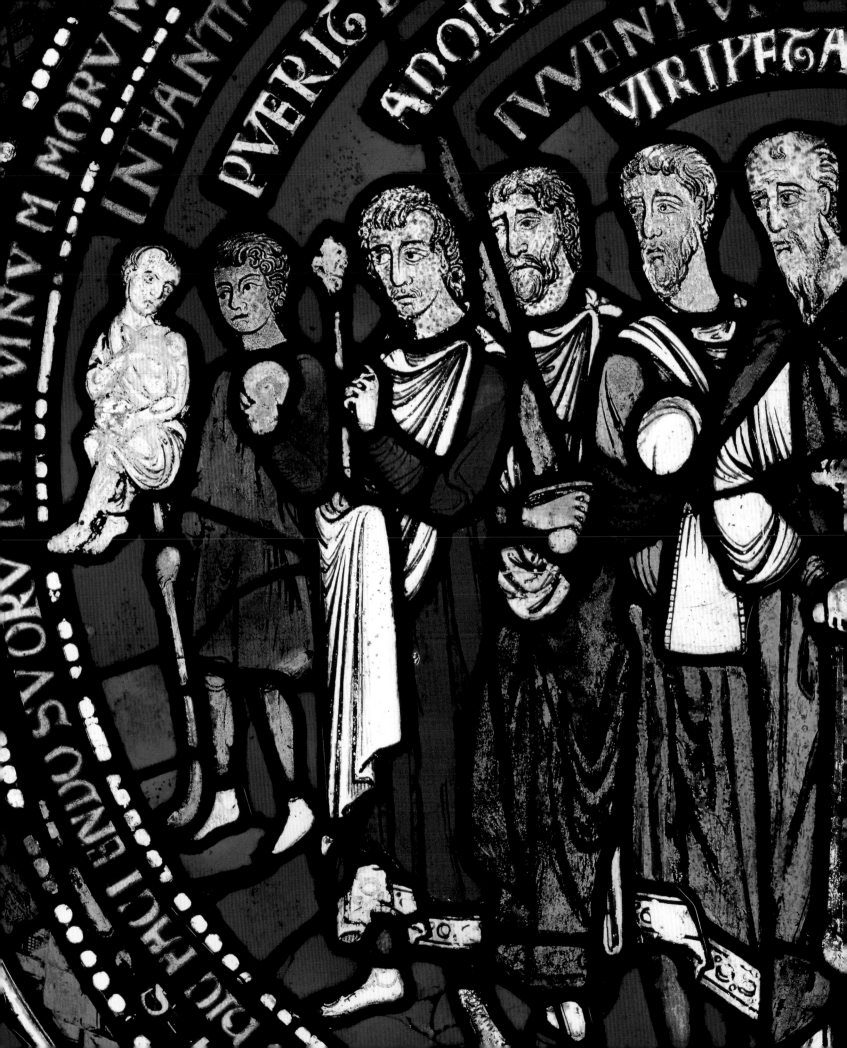

SECOND REGISTER

The Six Ages of the World

The Miracle at Cana

The Six Ages of Man

n. XIV, 18 i, 22 i, 19 i (formerly n. XIII, 35, 36, 37)

The significance of the number six lies at the heart of this visual comparison. The Gospel of St John states 'and there were set there six water pots of stone', and both St Augustine and other commentators linked this directly to the six ages of man. The water, by being transformed into wine, was a symbol of how belief in Christ would redeem sinners. On the left six men are seated, each bearing a clear label of identification. The first is Adam seated with a hoe, followed by Noah holding his ark, then Abraham holding a flame and a knife, which signify the sacrificial fire he lit and the knife he would have used on his son Isaac had not God intervened. King David is crowned and holds his harp, and Jechoniah, a king from the period of the Babylonian captivity (Matthew I: 11–12), holds a crown and sceptre. Christ follows with cross nimbus and book.

On the right-hand side a line of figures, increasing in size from left to right, represent the ages of a 'typical' man: infancy (*infantia*), a baby; childhood (*pueritia*), a boy in a short purple tunic; adolescence (*adolescentia*), a youth in red bearing a sceptre; prime (*iuventus*), a bearded man with a sword; maturity (*virilitas*), an older bearded man with a money pouch; and old age (*senectus*), an old man with a crutch.

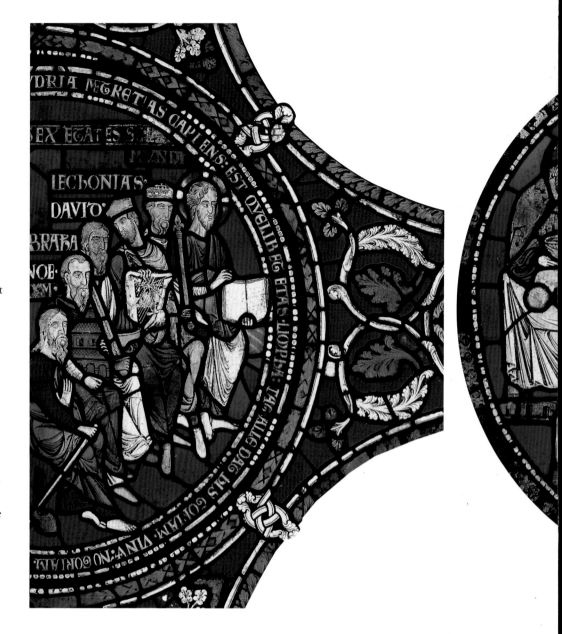

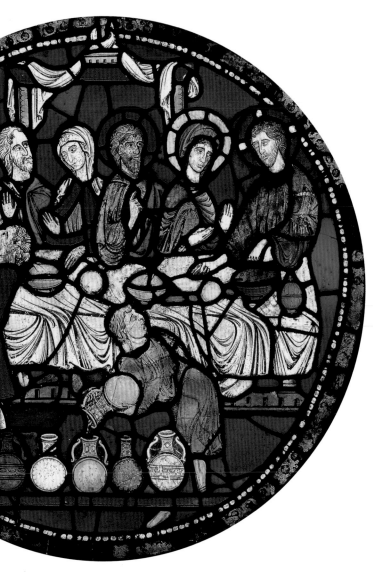

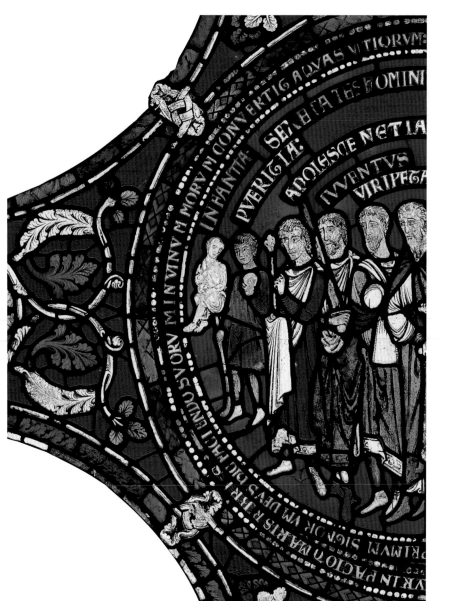

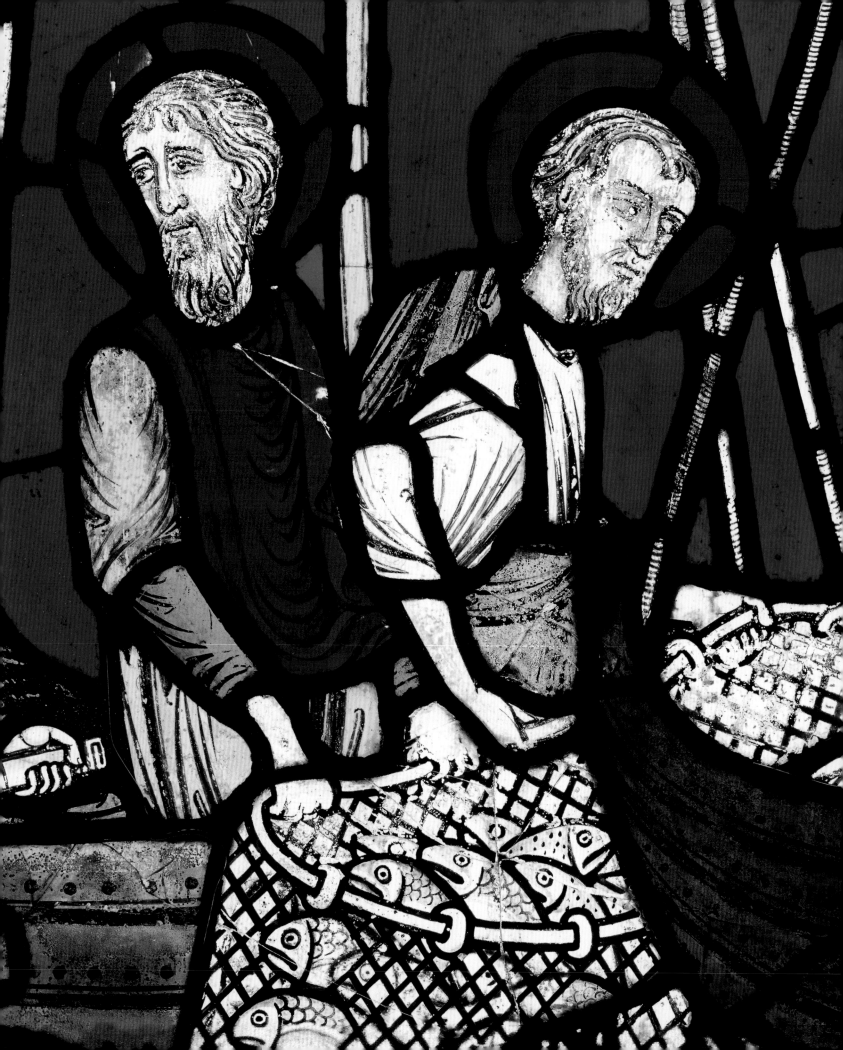

THIRD REGISTER

The Miraculous Draught of Fishes

n. XIV, 15 (formerly n. XIII, 29)

The scene is recounted in the Gospel of St Luke (5: 4–7):

> … he [Christ] said unto Simon, launch out into the deep, and let down your nets for a draught. And Simon answering said unto him, Master, we have toiled all the night, and we have taken nothing: nevertheless at thy word I will let down the net. And when they had this done, they inclosed a great multitude of fishes: and their net brake. And they beckoned unto their partners which were in the other ship, that they should come and help them. And they came, and they filled both ships, so that they began to sink.

Simon took on the name Peter after the miraculous draught, when Christ himself renamed him Peter ('rock' in Greek) and announced that 'upon this rock I will build my church' (Matthew 16: 18). Christ's concluding remarks could also be seen to announce Peter's ministry after Christ's death and resurrection, which is prefigured in the words 'fear not from henceforth thou shalt catch men' (Luke 5: 10).

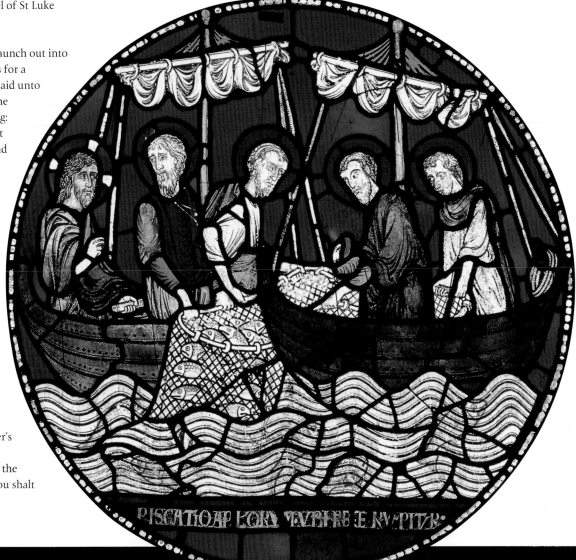

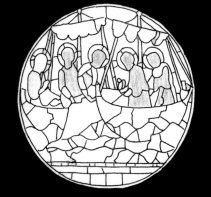

SIXTH TYPOLOGICAL WINDOW

North Quire Aisle, n. XV (formerly n. XI)

The distinctive 'flashed' reds which give a streaky appearance, the careful choice of leading and the spatial dynamics of the landscape in the *Parable of the Sower* scenes (see pages 77 and 80) has led to this artist being named The Master of the Parable of the Sower after these two extraordinary panels.

The original Sixth Typological Window contained seven New Testament subjects, which included the *Parable of the Sower* and the *Feeding of the Five Thousand*. The typological scenes chosen to compare with these scenes were much more moralising than in the earlier windows. They contained an eschatological message, that is, a message of possible salvation but also of damnation for the sinner. The parallels chosen for the 'types', which accompany the biblical scenes, sometimes refer to events that had yet to happen in Christ's life, such as the Pharisees turning away from Christ, or to historical characters who lived after His death, such as the Roman emperor Julian the Apostate, who turned away from Christianity in favour of paganism.

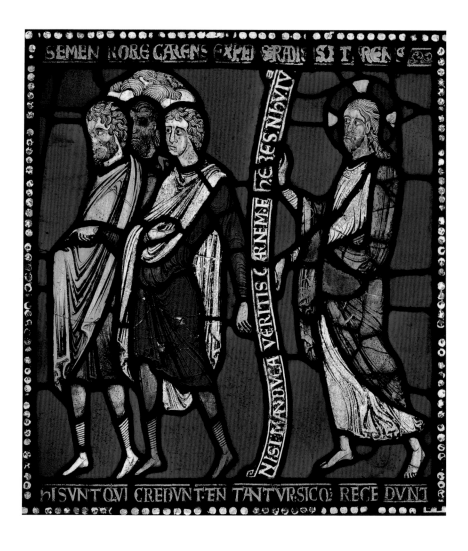

SECOND REGISTER

The Pharisees Turn away from Christ

The Sower on Stony Ground with Birds

n. XIV, 6 i and n. XV, 19 (formerly n. XI, 36, 30)

The first scene of the sower from the parable recounted by Matthew (13: 3–5) and Mark (4: 3–5) shows the seed falling by the wayside only to be eaten by birds or lie among stones. This was paralleled with the Pharisees turning away from Christ, which the inscription at top and bottom of the panel likens to the believers who, being tempted, turn away. Christ also carries a scroll which quotes the Gospel of John (6: 54): 'whoso eateth my flesh and drinketh my blood, hath

eternal life'. This refers to the theme of the entire window – comparison of the seed with the resulting bread that is the body of Christ at the Eucharist. The implication behind this comparison is that those who do not believe and do not take Communion will be judged as lacking at the Last Judgement.

The complexity of the composition of the scene of the sower is exceptional for this date. The figure of the sower is placed with one foot on the near edge of the front lead line and the other on the light green weedy ground. The rocks between his legs and behind him break up the sweeping arcs of the ploughed land. A path of stony ground rises on the right, where birds eagerly devour the

seeds that have fallen by the wayside. At the top right a tree, with a bird perched in its branches, defines the back plane of the glass. The dark blue background suggests the sky, and a white bird that overlaps the outer red ring of the frame suggests distance between it and the sower, as if it has just flown into the picture. The use of greens and purples in the sower's clothing help the figure to blend into the middle ground, suggesting space. The lead lines of the ploughed field invite us to ascend into the distance. Only the head, which was replaced by Caldwell Sr, and some small infills disturb the design of this panel.

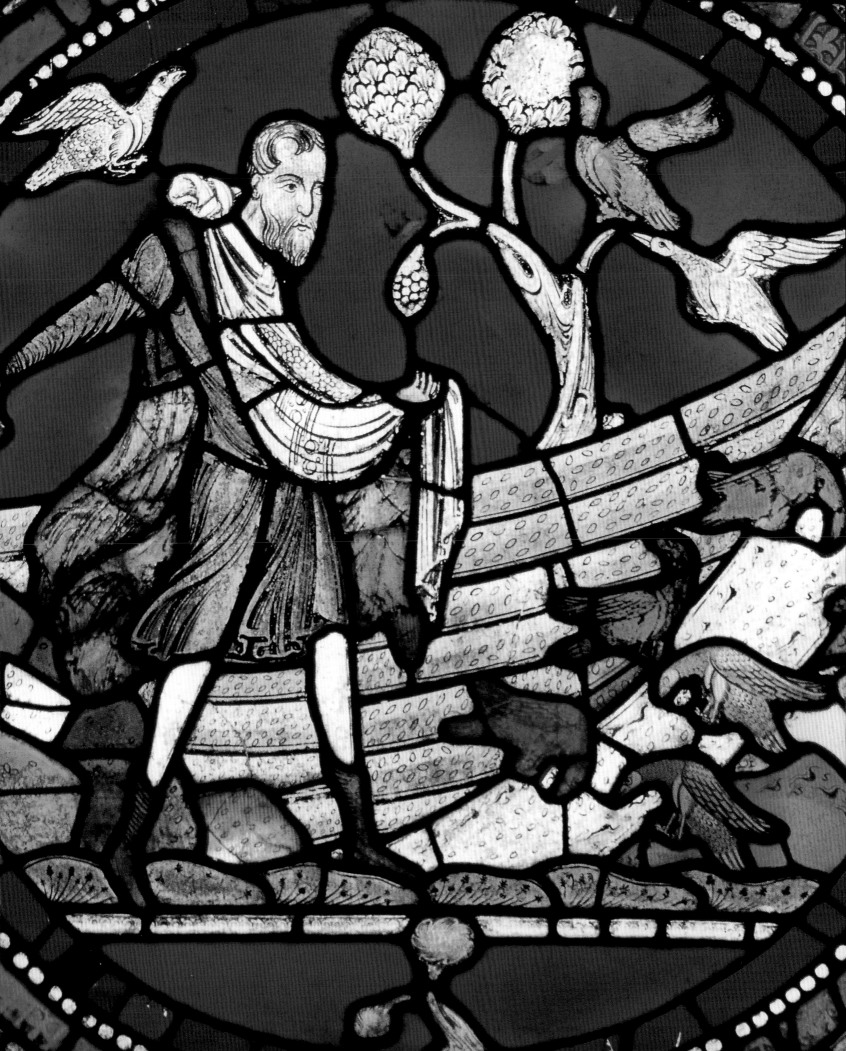

THIRD REGISTER

Daniel, Job and Noah: the Three Righteous Men

The Sower on Good Ground and Among Thorns

The Thorny Ones: the Emperors Julian and Maurice

n. XV, 9 i, 8, 7 (formerly n. XI, 24, 25, 26)

The second scene of the Sower from the parable recounted by Matthew (13: 7–8) and Mark (4: 7–8) shows the seed falling on thorny ground and on good ground. The three righteous men represent the good seed. This is made explicit in the inscription, which originally read: 'God sowed the words of the father: from these his fruit increased on the good ground threefold; his own crown was given to each'. This explains the three angels who descend from heaven to crown the three seated figures, each carrying a scroll with their name.

On the other hand, the Roman and Byzantine Emperors Julian the Apostate (361–63) and Maurice Tiberius (582–602) represent the thorny ground. Julian was renowned in the Middle Ages for having forced a revival of paganism and for having re-dedicated a shrine to Apollo on the Island of Delos. Maurice, regarded as a saint in the Eastern Orthodox Church, made an enemy of Pope Gregory the Great through his approval of the title 'ecumenical patriarch' for the Patriarch of Constantinople, John IV. By the twelfth century in the west both Maurice and Julian were regarded a 'avaricious and rapacious princes' on the basis of Gregory the Great's pairing of their names in an attack on Maurice in his letters.

The link with the central panel is provided by the inscription, which once read: 'these thorny ones are the rich and extravagant; they bear no fruit since they seek earthly things'. They are thus presented seated between a bowl full of gold coins, with officials in attendance behind them.

The panel of the sower again shows the artist attempting a precocious composition. The sower is shown in *contrapposto* (head turned back to the

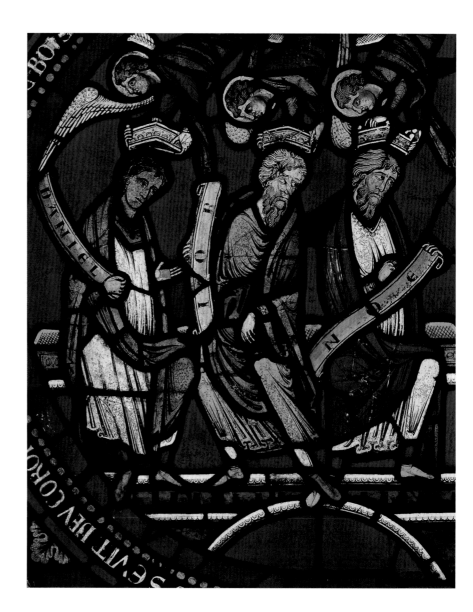

right while he walks to the left, and shoulders parallel with the picture plane). The lead lines form a sloping design that suggests recession. The brown and white seed can be seen floating down through the air and falling behind the sower, who is brought forward by the red of his tunic. Purple and light blue are chosen for the weeds so that they will sit on the ground around the sower owing to their colour, and the globular shapes of the rolling hills behind him are set against the

deep blue sky. Together with *The Sower on Stony Ground with Birds*, this panel represents one of the most accomplished explorations of landscape from the twelfth century.

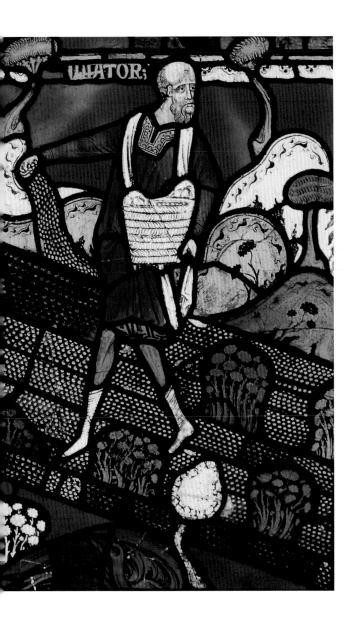

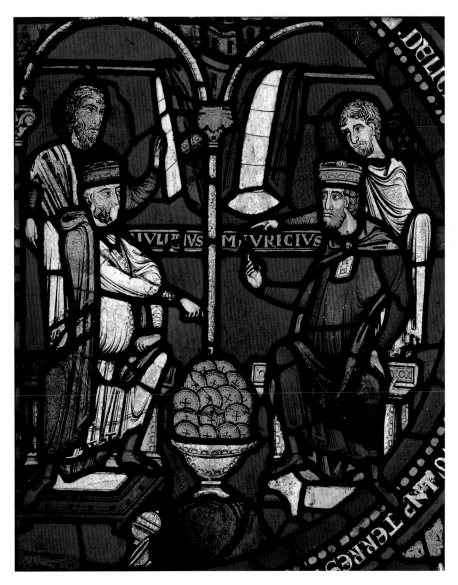

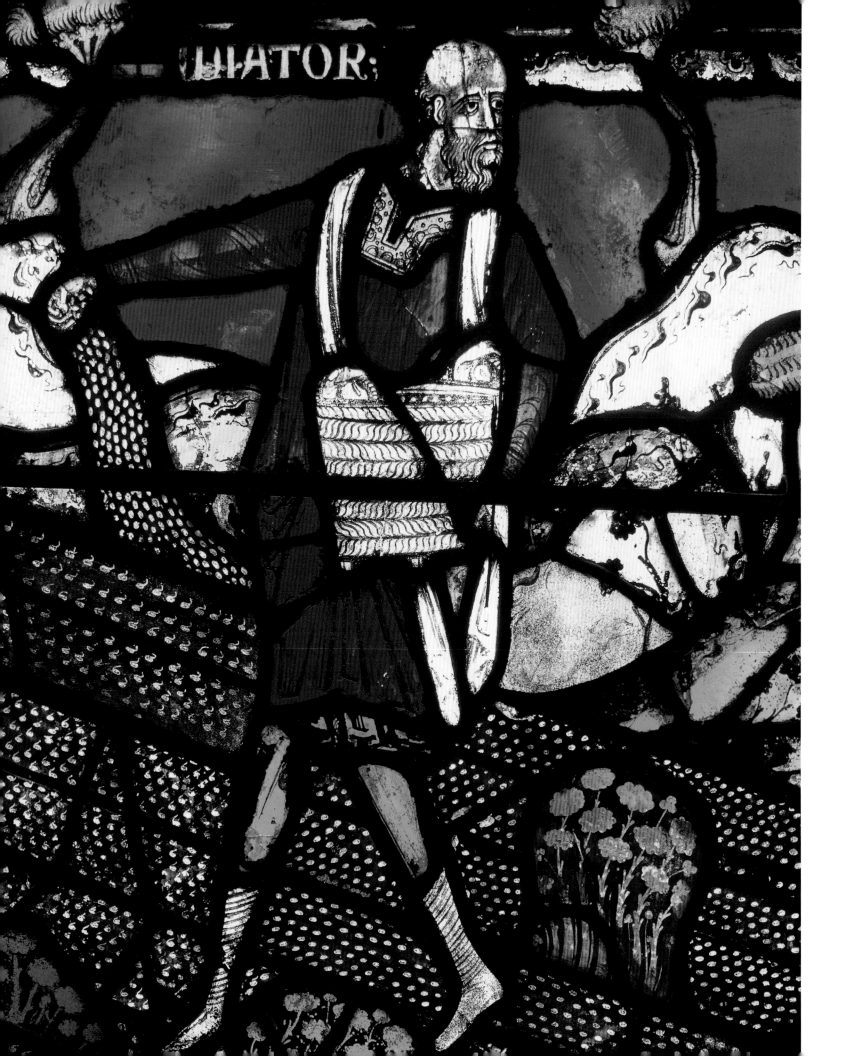

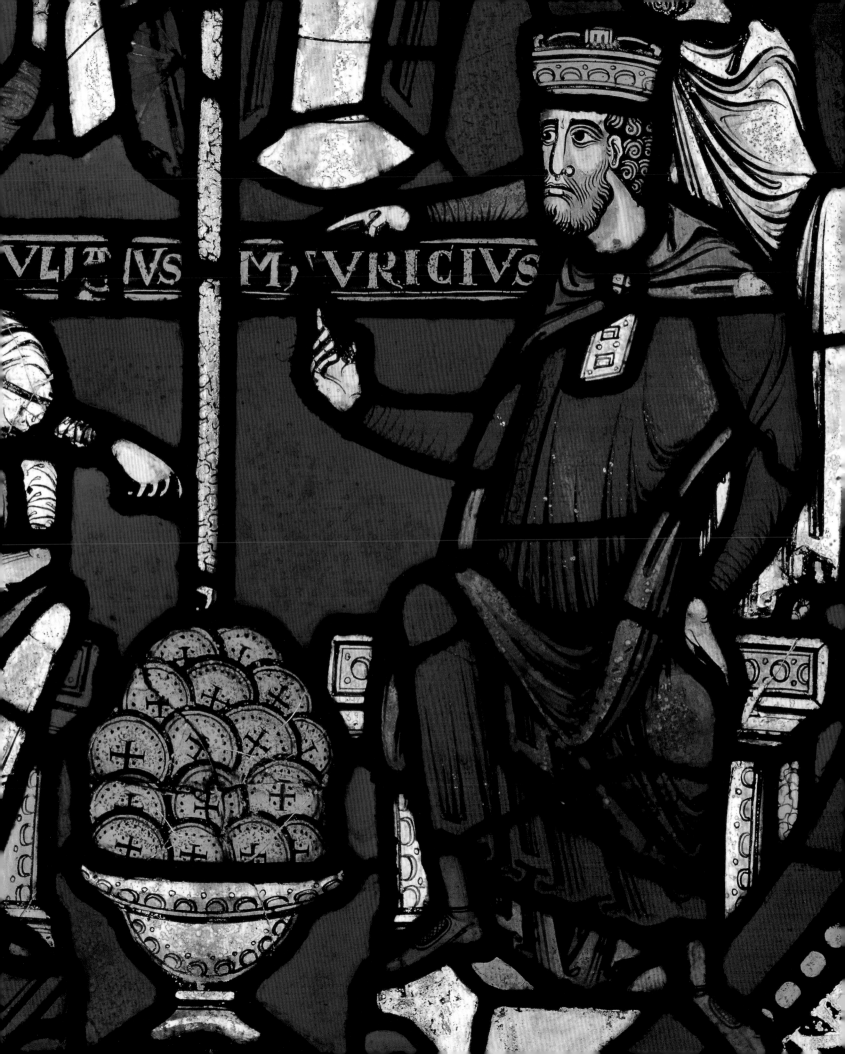

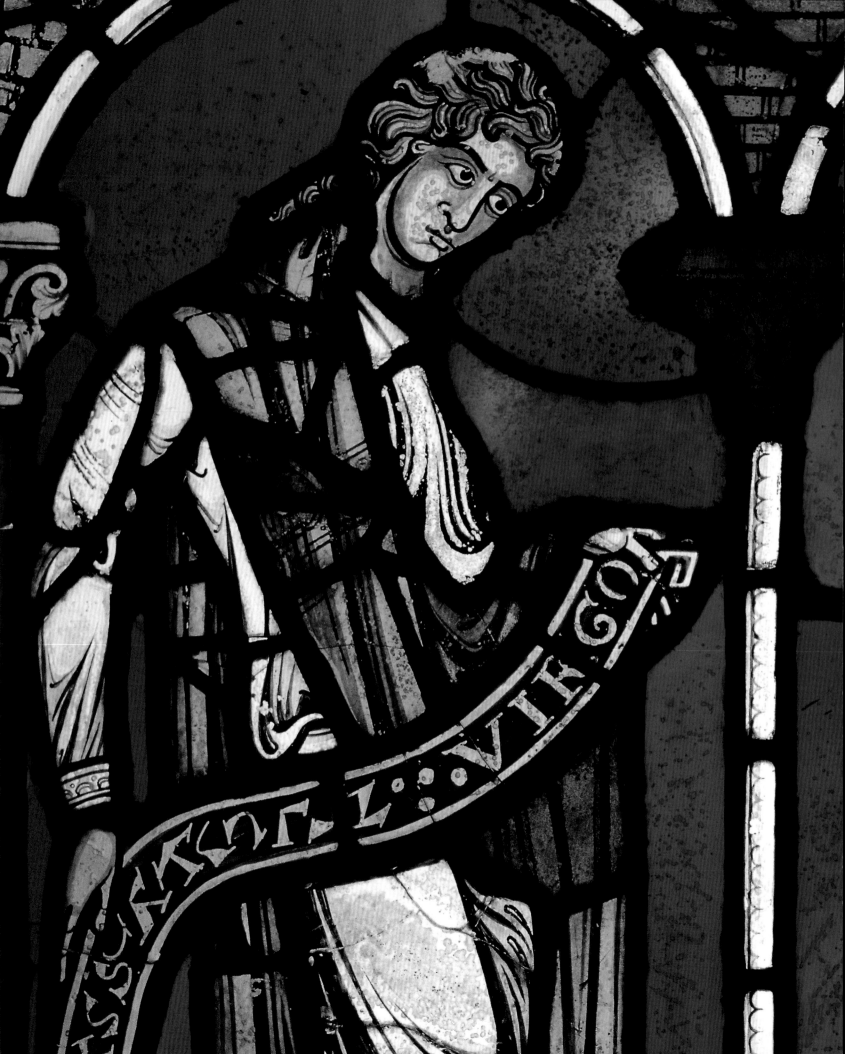

FOURTH REGISTER

The Three Virtuous States: Virginity, Abstinence and Marriage

n. XV, 14 (formerly n. XI, 20)

This panel and its pair, *Ecclesia and the Three Sons of Noah* are the comparative panels that would have been placed around the *Parable of the Leaven* or *Three measures of Meal* (Matthew 13: 33 and Luke 13: 20–21).

The virtuous states are discussed by Augustine and are commonly associated with the idea that the yeast in the leavening of the meal should be identified with virtue or faith. Each of the three measures of meal referred to in the Gospel was regarded as one of the three virtuous states: 'it is like leaven [yeast], which a woman took and hid in three measures of meal, till the whole was leavened [rose]' (Luke 13: 21). The idea is that each state is different but grows to maturity through equal virtue, so that one can remain a virgin, abstain in widowhood or marry and still be virtuous.

All three figures are represented by men: Virginity by a clean-shaved man carrying a scroll inscribed *Virgo*; Abstinence or Widowhood by a bearded man carrying a scroll inscribed *Continens;* and Marriage by a man carrying a scroll inscribed *Coniugatus.*

FOURTH REGISTER

Ecclesia and the Three Sons of Noah

n. XV, 12 (formerly n. XI, 22)

A trinitarian interpretation of the three measures of meal (see page 83) is announced by the surviving inscriptions, which can be supplemented from manuscript sources to read: 'From these three sons is one faith in the Godhead. The three measures of meal united are the three persons of the Godhead. Noah's sons ruling for me each in his own part'.

Ecclesia (the personification of church) stands on the left-hand side of the scene with Shem, Ham and Japhet, the sons of Noah, on the right. Each holds on to the disc of the world, which is schematically divided into three and inscribed MU|ND|US ('world'). The *Glossa Ordinaria*, the handbook for interpreting biblical scenes used in the twelfth century, identifies the woman in the Parable of the Leaven as Ecclesia, which explains her presence here. Shem, Ham and Japhet populated the whole world after the Flood, according to Genesis (9: 18–19). The unity of the world, which 'was of one language' before the building of the Tower of Babel, emphasises visually the unity of the trinity. The disc held by the three also recalls the communion wafer, which had already taken on a small round shape in the western church by the twelfth century.

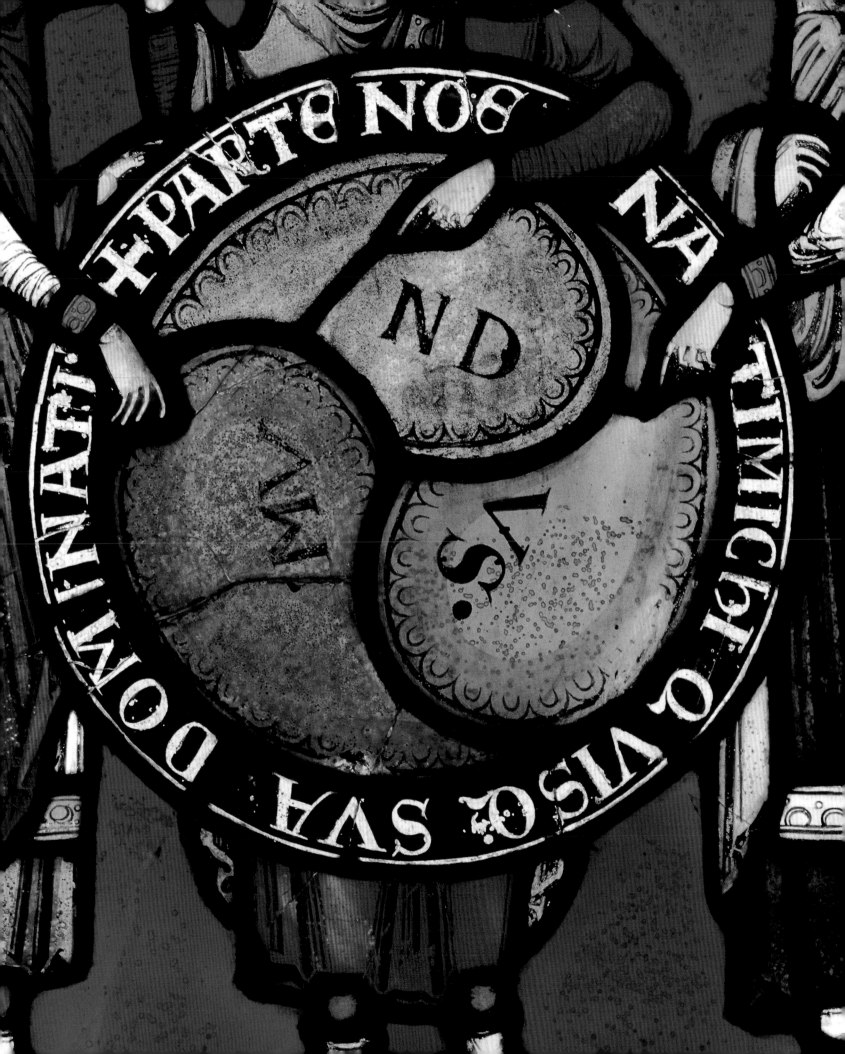

CORONA REDEMPTION WINDOW

East End, Corona I

The visual impact of the window is based on the arrangement of three quadrilobe panels, each with a central biblical scene from the New Testament (the anti-types): *Pentecost, The Resurrection* and *The Crucifixion*. These are supported by four semicircular scenes from the Old Testament (the types). These scenes are supplemented by two intermediary New Testament anti-types placed in diamonds between the three quadrilobes, which are also surrounded by another four Old Testament 'types' in smaller roundels. This scheme is familiar from the typological windows of the quire aisles (see pages 46–84), but the condensation of the scenes and the multiplication of the types suggest a more inclusive scheme. Some of the ideas behind this design may have originated among metalworkers from the Mosan region of Flanders during the twelfth century. They often used the quadrilobe design to explore typological imagery in relation to the Crucifixion.

At least three different makers have been identified in the window, but the overall scheme must have been decided by a single iconographer who probably appropriated visual ideas from other media. The most important of the artists can also be identified in the Becket Miracle Windows (see page 102) and is named after the scenes of the Plague in the House of Jordan Fitz-Eisulf (see pages 154–61). This master used some of the techniques employed by the Master of the Parable of the Sower, and may have been trained by him (see page 76).

The date of this window cannot be ascertained with any great accuracy, but the developed draperies of all three artists and the containment and miniaturisation of the scenes suggest that the window should be dated *c.*1200–07, before the exile of the archbishop and monks (1207–13).

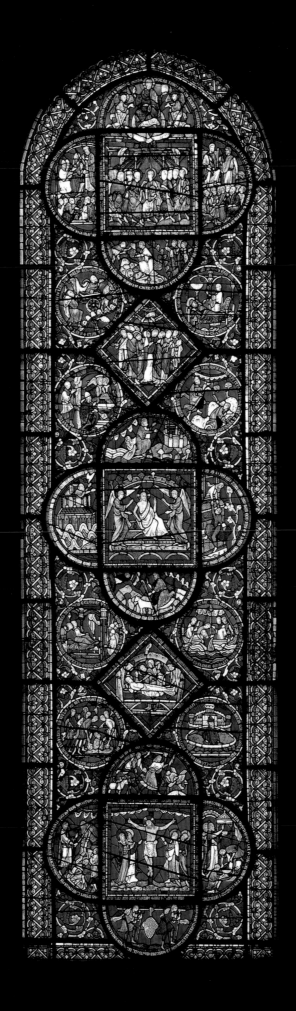

Pentecost

Moses Consecrating Aaron

Jethro Before Moses

Corona I, 47, 46 , 48

Eleven of the Apostles are seated, with John at the centre. The biblical authority for this scene rests with the text in Acts (2: 1–4):

> And when the day of Pentecost was fully come, they were all with one accord in one place. And suddenly there came a sound from heaven, as of a rushing mighty wind, and it filled all the house where they were sitting. And there appeared unto them cloven tongues like as of fire and it sat upon each of them. And they were all filled with the Holy Ghost, and began to speak with other tongues, as the Spirit gave them utterance.

Pentecost is called Whit Sunday in England, possibly because of the practice of wearing white robes for baptisms (if they were delayed because of Easter). The hymn *Veni, Sancte Spiritus*, ascribed in England to Stephen Langton, Archbishop of Canterbury, was sung at mass for Pentecost week. The festival (named after *Pentekosti*, the Greek for 'fiftieth') was a Jewish harvest festival know as the Feast of Weeks (a period of seven times seven days) which took place 50 days after the Passover feast. This was transposed into 50 days after Easter.

The Old Testament parallels for this scene were *Moses Consecrating Aaron* (where the oil for anointing is likened to the tongues of fire), on the left, *The Law Given to Moses* (regarded as a manifestation of God through fire in the same way as the tongues of fire), below, *Jethro before Moses* (Jethro's advice to Moses to delegate to advisers was seen as a parallel for the Apsotles being given their mission to evangelise after the Spirit had entered them), on the right and *Christ in Judgement*, above.

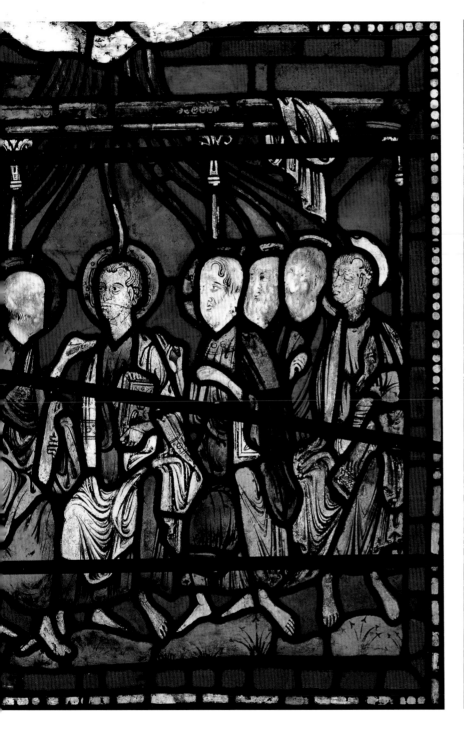
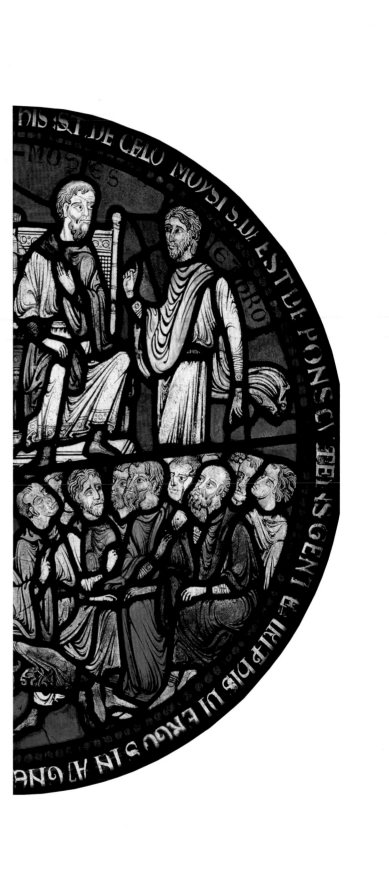

The Ascent of Elijah

Corona I, 40

This is the top right-hand roundel above the diamond-shaped central scene of the Ascension. It was regarded as the prefiguration of the Ascension because of the visual link between the ascent of Elijah and that of Christ. It was also a parallel for those who remained on earth after Christ's ascension to carry on His work – as Elisha, who was chosen by Elijah while working oxen in a field, took on his mantle (*pallium* in Latin) after he had ascended to heaven, symbolically taking on responsibility. The *pallium* became the symbol of episcopal authority in the Church, and thus a further meaning could be attached to the mission of the church after the Ascension:

> And it came to pass, as they still went on, and talked, that, behold, there appeared a chariot of fire, and parted them both asunder, and Elijah went up by a whirlwind to heaven. And Elisha saw it, and he cried, My father, my father, the chariot of Israel ... He took up also the mantle [*pallium*] of Elijah that fell from him ...
> Vulgate 4 Kings 2: 11-12

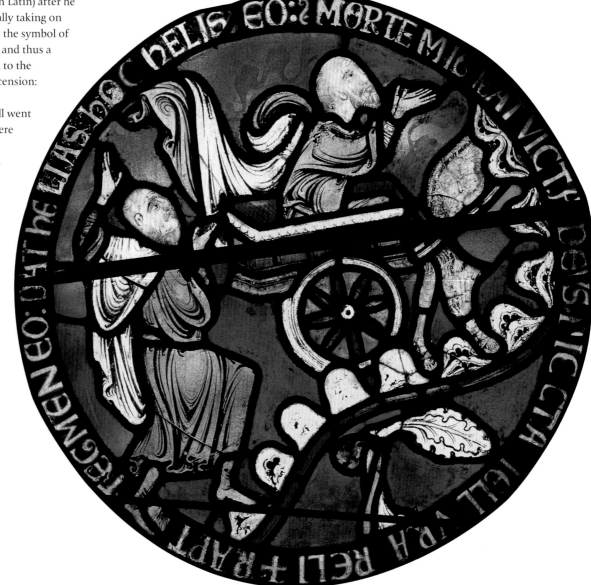

The Ascension

Corona I, 37

This representation, with only the feet and a few inches of the tunic of Christ visible, while a crowd of Apostles with the Virgin at the centre look up, grew out of an Anglo-Saxon literary tradition. It diverges from Early Christian and Byzantine representations, which show Christ as if ascending a mountain toward God's hand or enveloped in a mandorla often held by angels. The Anglo-Saxon literary conceit was that Christ needed no help to ascend. An almost identical composition can be found in the *St Albans's Psalter* (Hildesheim Cathedral MS St. Godehard 1, p.54), as well as in the prefatory miniatures of the *Eadwine Psalter*, copied at Canterbury in the twelfth century (London, Victoria and Albert Museum, 816–1894 [MS 661]). Apart from the *Ascent of Elijah*, the parallels, or types, from the Old Testament include: *The Entry of the Priests into the Holy of Holies* (vulgate 3 Kings 1: 8, 6–11), which illustrates a passage where the Ark of the Covenant is opened after blood sacrifice and 'the glory of the Lord had filled the house of the Lord', *The Ascent of Enoch* and *The Sundial of Ahaz* (see pages 92–93).

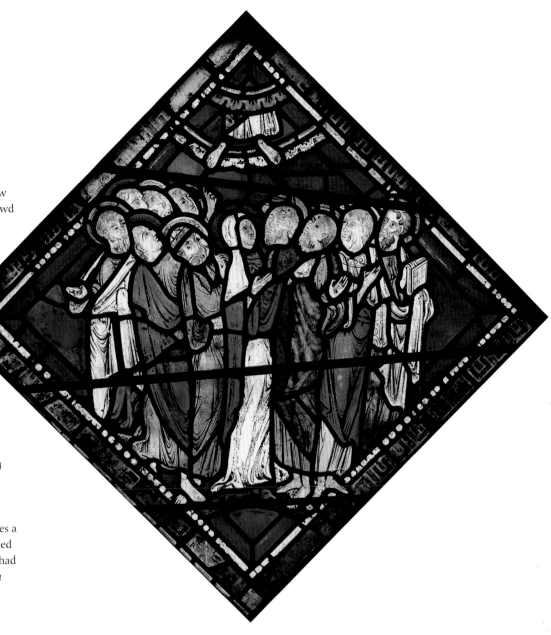

The Ascent of Enoch

Corona I, 34

This authority for this illustration is loosely based on Genesis (5: 21–24), and St Paul's letter to the Hebrews (11: 5): 'By faith Enoch was translated that he should not see death; and was not found for God had translated him …'

Tradition had it that Enoch was taken up to heaven like Elijah, and the two were often paired in eschatological interpretations of the Second Coming, where they are named as the 'Witnesses' of the Apocalypse. The composition here repeats the figure of Enoch twice in so-called 'continuous narrative' – he prays on the right and then ascends a hill on the left to be received by God's hand. The ascending figure recalls images of the Ascension itself which belong to the early Christian tradition.

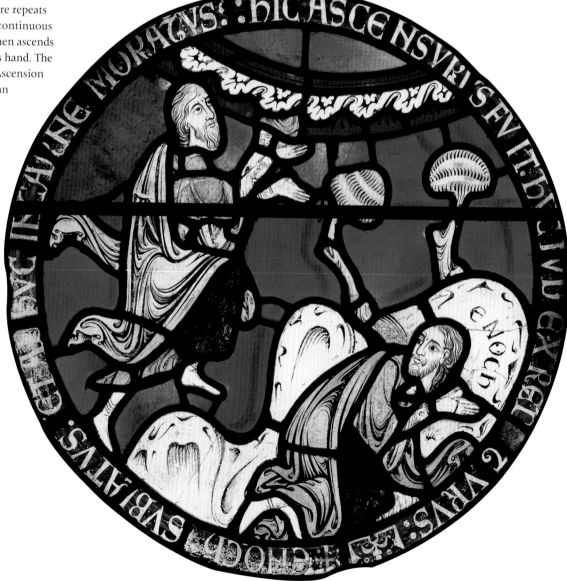

The Sundial of Ahaz

Corona I, 42

In this image King Hezekiah's life hangs in the balance. He is about to die, but God intervenes and grants him 15 more years of life. As a sign the clock goes back ten degrees. Hezakiah had already been incorporated, as son of Ahaz and a King of Judah, in the Genealogy of Christ in the clerestory windows, where he was shown seated and carrying the sundial (see page 41). Here a scene is depicted from the book of Isaiah (38: 1–8). Isaiah approaches the sickbed of Hezekiah, pointing with one hand at the king and with the other at the semicircular sundial placed on a thin shaft behind the bed. The use of the sundial as an attribute for Hezekiah appears to have been developed in England, and it is used here both as an allegory of deliverance and as a demonstration of 'ascent' and 'descent' – the clock is seen to literally 'rise' according to God's will.

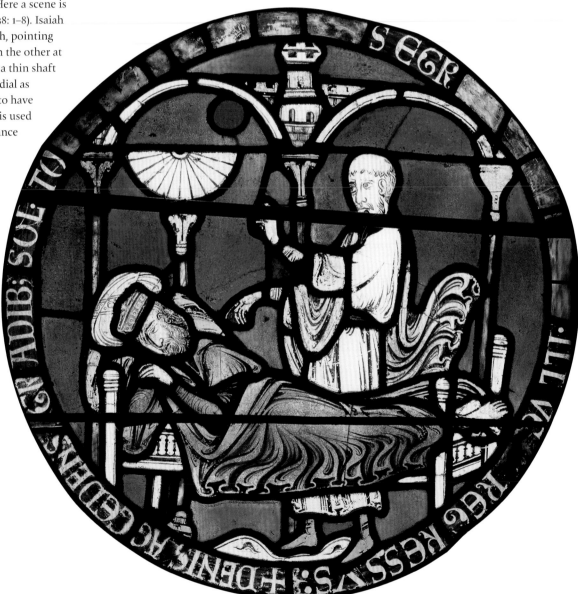

Samson Sleeping with Delilah in Gaza

Corona I, 22

This scene is a 'type' of the Entombment. It can be understood on a basic visual level: Samson sleeps, just as Christ only 'sleeps' in the tomb; the guards wait outside to capture Samson after Delilah has cut his hair (Judges 16: 19), whence he derives his strength, just as the guards wait outside Christ's tomb. The surviving inscription takes these basic visual signals further, explaining: 'For the sake of the Church the flesh of Christ was shut in the marble, just as Samson slept for the sake of his beloved'.

It is the irony of Samson's initial defeat at the hands of Delilah and his eventual victory that is explored here.

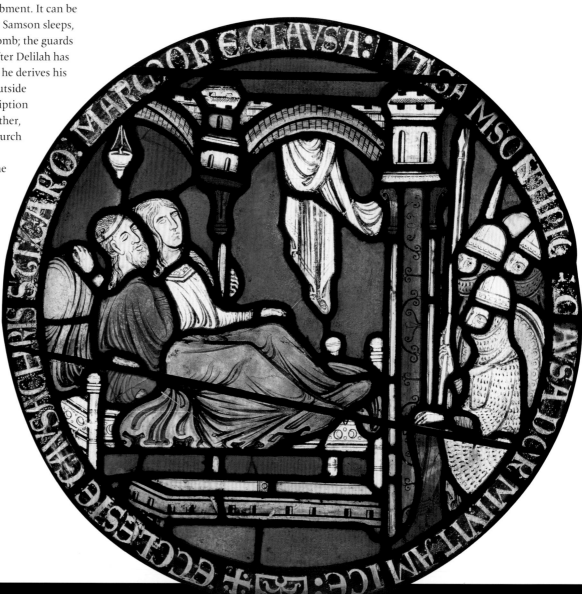

Jonah Swallowed by the Whale

Corona I, 24

This is one of the most common 'types' of the
Entombment. Jonah is called on by God to go to
preach in Nineveh but is so afraid that he instead
goes to Joppa and buys a passage by ship to
Tarshish. God's displeasure is felt in a storm that
threatens the ship. When the sailors realise it
is Jonah's fault that there is a storm, he tells
them to throw him overboard. Jonah is
duly dispatched into the deep, only to
be swallowed by a whale in whose
belly he spends three days and
nights (Matthew 12: 39). Through
prayer within the fish, Jonah is
released from his temporary
tomb and is cast up on to dry
land. This was thought to
be both a symbol of the
Resurrection and of the
redemption of those who
confessed their sins
through prayer.

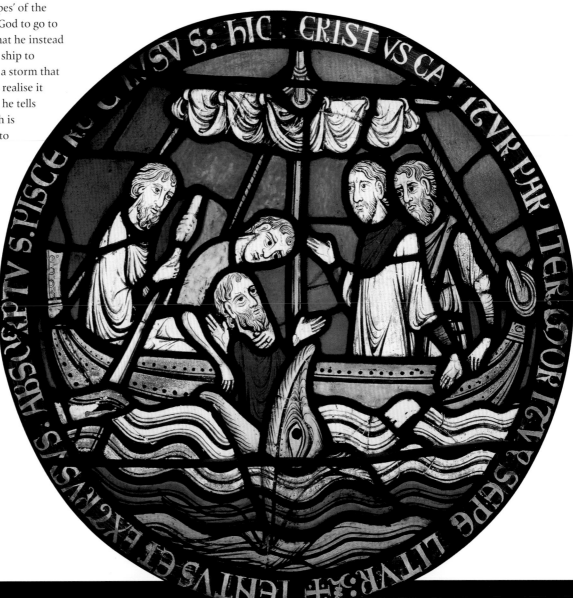

The Crucifixion

Corona I, 4

The central panel of the Crucifixion was supplied by the restorer Austin in 1853. It was placed at the bottom of the window, close to the altar beneath. It is surrounded by substantially ancient glass that uses some of the most well know 'types' of the Crucifixion. Above is the *Sacrifice of Isaac*, where Abraham is tested by God when He asks him to sacrifice his own son. Abraham is obedient to God's will, but an angel intervenes and a ram caught in a thicket replaces the boy. The parallel with Christ, the Son of God, being sacrificed in order to redeem the sins of mankind is referred to again in the crossed sticks on the altar – a rare device also seen in the mosaics of the Cappella Palatina in Sicily.

Below, the spies who were sent by Moses to explore the Promised Land return with the Grapes of the Valley of Eschol. This is seen as a *figura*, or shape of the cross itself (they form a T shape with the sticks), but the grapes are also a Eucharistic reference to the blood of Christ. The inscription, however, tells another sermonising story, not found in the Bible, which reveals a latent anti-Semitism that can be found in a number of typological windows: 'The one refuses to look back at the cluster and the other thirsts to see it; Israel knows not Christ, the gentiles adore him'.

On the right-hand side the Tau on the Lintel is depicted. This commemorates the Passover, when God instructs the Israelites: 'take the blood [of the lamb] and strike it on the two side posts and on the upper door post of the houses … for I will pass through the land of Egypt and I will smite all the first born… And the blood shall be to you for a token on the houses where ye are, and when I see the blood I shall pass over you' (Exodus 12: 1–13). There is no biblical reference to the letter T (tau) being inscribed on the lintel, but the *figura*, or shape it made, was invented by iconographers to further emphasise the typological link with the Crucifixion. (The T-shape of the *Grapes of the Valley of Eschol* was also made to fit this interpretation.) The inscription provided for this scene emphasises the purity of the lamb, and compares it with Christ who is sacrificed to take away the sins of the world.

Finally, on the left-hand side, Moses saves the Israelites from thirst, during their wanderings in the wilderness, by striking the rock with his rod to produce water (Exodus 17: 6–7). The inscription suggests that, just as the stone was wounded and produced water, so Christ was wounded in the side and produced blood and water. 'But one of the soldiers with a spear pierced his side, and forthwith came there out blood and water' (John 19: 34).

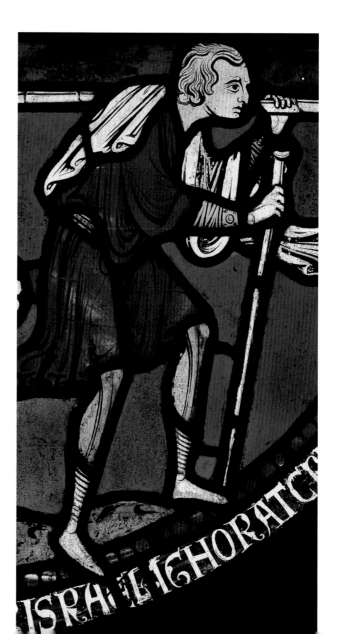

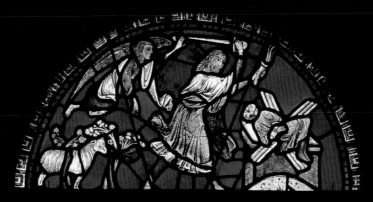

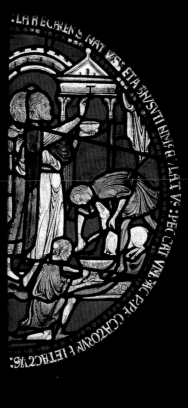
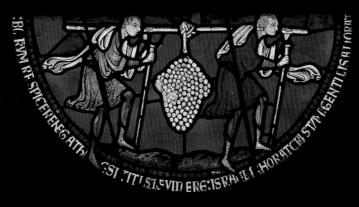

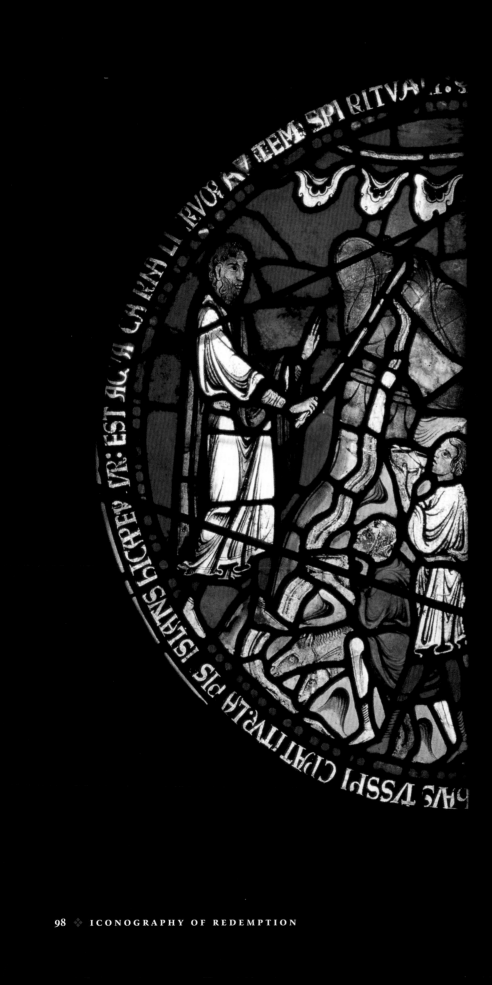

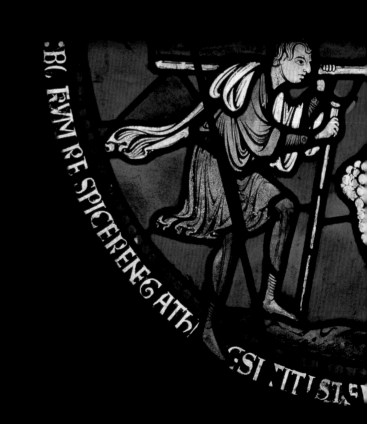

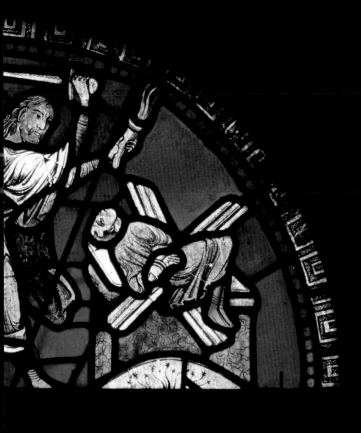

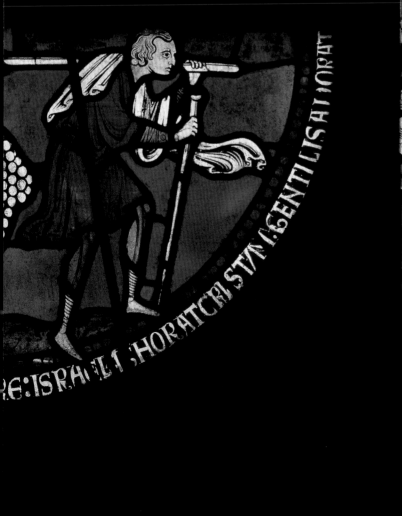

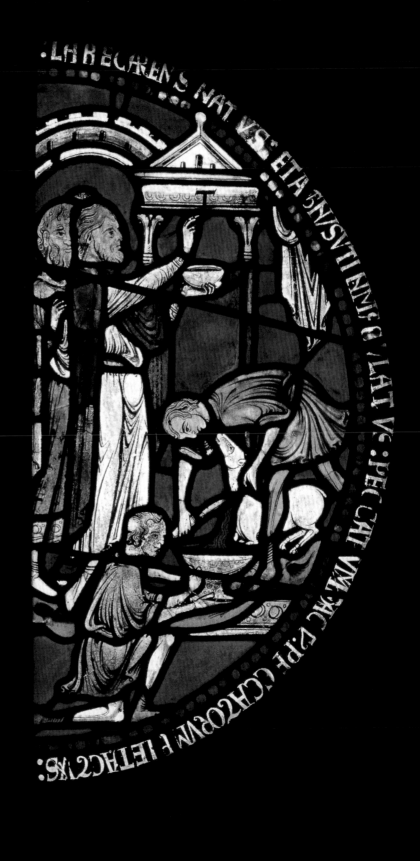

TREE OF JESSE

East End, Corona n. III

Jesse is named in the middle of St Matthew's list of the ancestors of Christ (Matthew 1: 1–17) as the father of King David. He is singled out by Isaiah in his prophecy: 'And there shall come forth a rod [*virga*] out of the root [*radice- radix*] of Jesse and a flower [*flos*] shall rise up out of this root' (Isaiah 11: 1–3).

A verbal link had been made as early as the third century by Tertullian who called Jesse the 'stem' (*radix*), the Virgin Mary the 'rod' or 'shoot' (*Virga* – a pun on *Virgo*) and Christ the 'fruit' or 'flower' (*flos*). The visualisation of this idea as a tree inhabited by the ancestors of Christ, leading to images of the Virgin and Christ, appears to have developed during the eleventh century; it was popular by the middle of the twelfth century in almost all artistic media.

The two remaining figures of the Tree of Jesse at Canterbury are the Virgin and King Josiah. The artist who designed this window has been named after it – the Jesse Master. He appears to have worked with the Master of the Parable of the Sower on the North Oculus Window (N. XVII) and on the figures of Salmon and Booz (S. XXVIII, formerly N. IX). The ornamental work in the North Occulus Window is very close to that in the Jesse Window, but the Jesse Tree seems to have been his last work. A comparison has also been made between the Christ in Majesty at the top of the Becket window at Sens Cathedral (Yonne) and the Jesse designs for Canterbury. Despite this and other resemblances to glass in France, the strongest parallels for the Jesse Master are with other glass painters at Canterbury and with the Great Seal of King Richard I of England made in 1195 and put into use by 1198. The importance of this glass lies in the delicate manipulation of folds and the miniaturisation of the figures in relation to the background, which produces a style that looks forward to the delicate Gothic patterns of the thirteenth century. It is the antecedent of the so-called 'sweet-style' used in the Psalter of Robert de Lindesey, Abbot of Peterborough 1214–22.

Below: Psalter of Robert de Lindesey, Abbot of Peterborough, (London, Society of Antiquaries MS 59, f.36). The thin limbs and delicate features found in this manuscript illumination were anticipated by the stained glass at Canterbury. The appealing nature of this style has lead to it being called the 'sweet style' in English art.

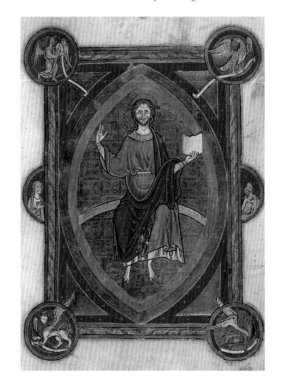

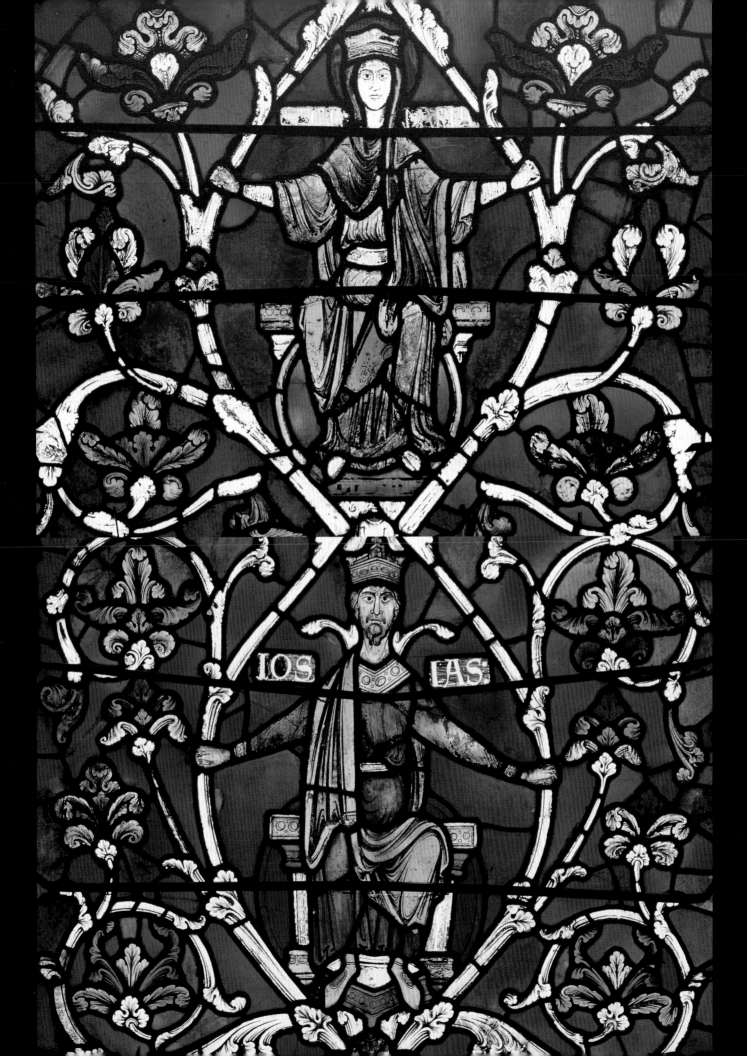

The Becket Miracles

The fire which destroyed the quire at Canterbury in 1174, in some ways, could not have occurred at a better time. It allowed first William of Sens, and then his successor William the Englishman, to re-model the interior of the Church (the lower walls and foundations were still intact). William the Englishman, following the designs of William of Sens, built the Trinity (or St Thomas') Chapel (finished *c.* 1179–84) and the Corona (1180–84).

From an early stage it was intended that the shrine of St Thomas would be displayed in the Trinity Chapel, but, owing to political events (notably the exile of the archbishop and monks from 1207 to 1213) as much as to the need for the furnishings to be completed, the relics of St Thomas were not translated into his shrine until 7 July 1220.

The placing of the shrine in the centre of the Trinity Chapel determined the iconography of the surrounding glass. The textual sources, written by Brother William of Canterbury and Prior Benedict and compiled by 1180, record events after Thomas' death in 1170 and his canonisation in 1173. Many of the miracle scenes depend on these texts, but at least 17 do not, and the inscriptions (or *tituli*) on the glass do not correspond closely to the texts. The scenes appear to be a genuinely unique visual record, which depends on the design of the armature for the number of images allocated to each miracle; for example, in n. IV (shown opposite), where the glass is paired in roundels, two scenes are used for each miracle, but in n. II scenes are grouped in threes, sixes and nines, because the armature allows for this.

Window n. IV and part of n. III are attributed to the Petronella Master, named after the scenes of the epileptic nun of Polesworth (see pages 106–07). The armatures of the windows on the south side (s. III and s. IV) follow the same design, which suggests that the same teams worked on both sides of the Trinity Chapel ambulatory. This artist uses decorative vine scrolls in the backgrounds of scenes and elongates his figures. There is a contrast between the Petronella Master's lithe figures and those associated with the so-called Fogg Medallion Master (named after a roundel of the life of St Thomas Becket, formerly in n. VI but now in the Fogg Museum, Harvard University), which are sturdier and recall the work of the Master of the Parable of the Sower. This suggests a later date for the Petronella Master's work, perhaps after the return of the monks from exile. The Petronella Master has been associated with French stained glass, such as that at St Remi in Rheims, but his work is also close to English manuscript illumination of the period *c.* 1220 and recently discovered wall paintings at Chester Castle made for Henry III after 1237. Other ambulatory windows (n. II, n. III, s. II, s. III, s. VI and s. VII) are attributed in whole or in part to the Fitz-Eisulf Master, named after the scenes of the *Plague in the House of Jordan Fitz-Eisulf* (see pages 154–61). He has been associated with stained glass at Sens and Chartres Cathedrals, but his work is best seen in the Canterbury windows. This suggests that he may have worked in France but was not necessarily trained there.

Right: n. IV (old number 4) from the the Trinity Chapel Ambulatory.

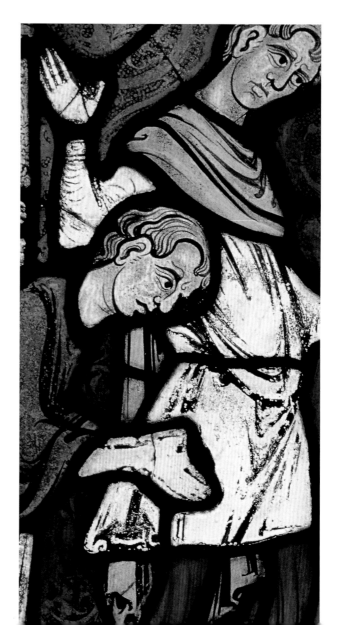

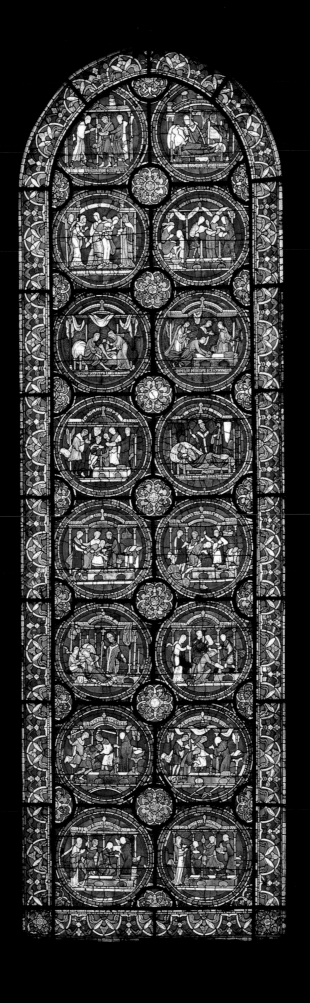

NORTH AMBULATORY WINDOWS

Trinity Chapel Ambulatory, n. IV (old number 4)

The artist of this window, although probably working after the exile of 1207–13, may be compared with that of Nahsson and Aminadab from the clerestory (see pages 36 and 38). He has been named the Petronella Master after the miracle scenes of her life in this window. He miniaturises his figures here to fit in with the new Gothic style of the thirteenth century, but retains a monumentality and clarity in his designs, which suggests that he had been trained in an earlier period and was adapting to new ideas.

Particularly interesting is his use of the tomb as a common setting for the miracle scenes. He establishes a foreground that shows the tomb with two oval insets at the side for pilgrims to crawl up to and kiss the inner stone of the tomb chest. Figures behind this are spatially removed into a middle ground by an overlapping effect that removes their feet from sight. The delicate columns of a ciborium, sometimes draped to give a further sense of three-dimensionality, disappear behind the figures to establish a background. This suggests a corridor of space in which the figures stand. These effects antedate those seen in wall paintings that were produced much later in the thirteenth century.

SOUTH AMBULATORY WINDOWS

Trinity Chapel Ambulatory, s. II and s. VII (old numbers 7 and 12)

These windows belong to the period after the monks returned from exile in 1213, although some work appears to have been done before their departure. The window shown opposite (s. II) is stylistically very close to n. II (see page 140), which was executed by the Master of Jordan Fitz-Eisulf and his associates. It has been suggested that s. VII was designed before the exile in 1207 but completed after the return in 1213. It is stylistically part of the same group as the windows associated with the Master of Jordan Fitz-Eisulf. The miracles depicted are of thanksgiving and of the protection of children. The theme of survival after accidental burial, by a collapsed house and a mound of earth (see pages 122–23) is unusual in its subject matter but conforms to the idea of St Thomas as an agent of intervention on behalf of parents whose children are in danger.

Right: s. II (old number 7) from the the Trinity Chapel Ambulatory.

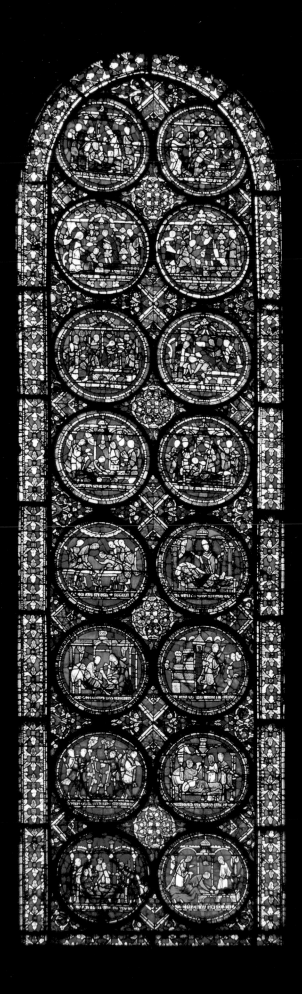

The Cure of Petronella of Polesworth

n. IV, 49, 50

Petronella, a nun of Polesworth, who appears to have suffered from epilepsy, came to the tomb of St Thomas rather than trust herself to 'hirelings and those who are not true physicians'. She is first depicted in the centre of a group of nuns in a dishevelled state and having an epileptic fit; she is helped along as she looks down at the ground.

In the second scene she is seated at the tomb, having her feet bathed in the holy water of St Thomas. The story suggests that St Thomas is the true physician, not those who try to cure her. She departs from the tomb not knowing whether she has been cured, but because of her faith she never has another fit.

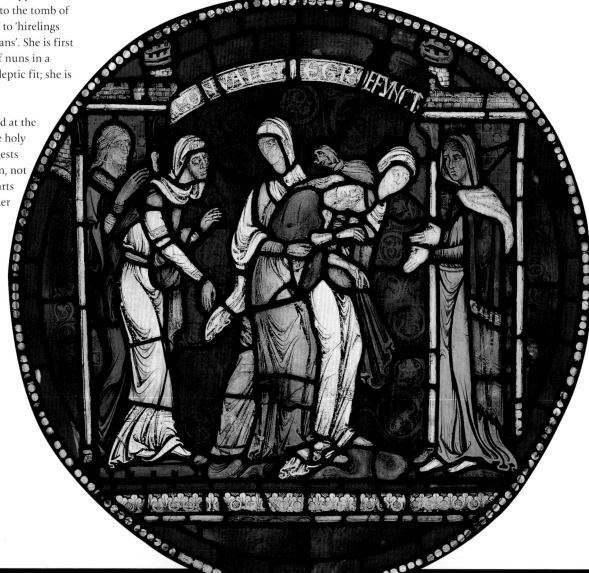

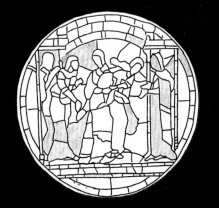

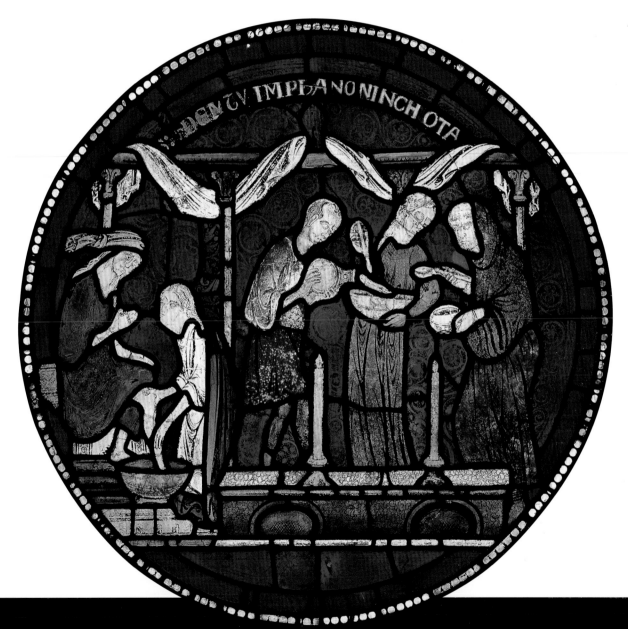

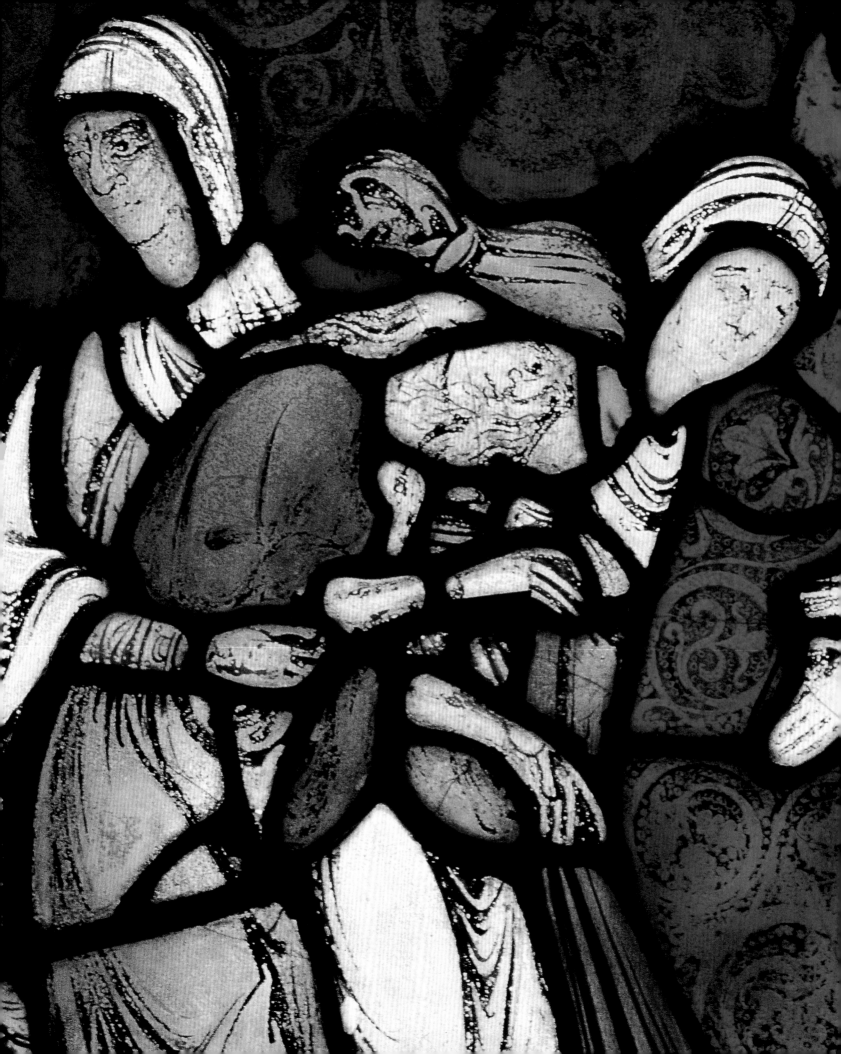

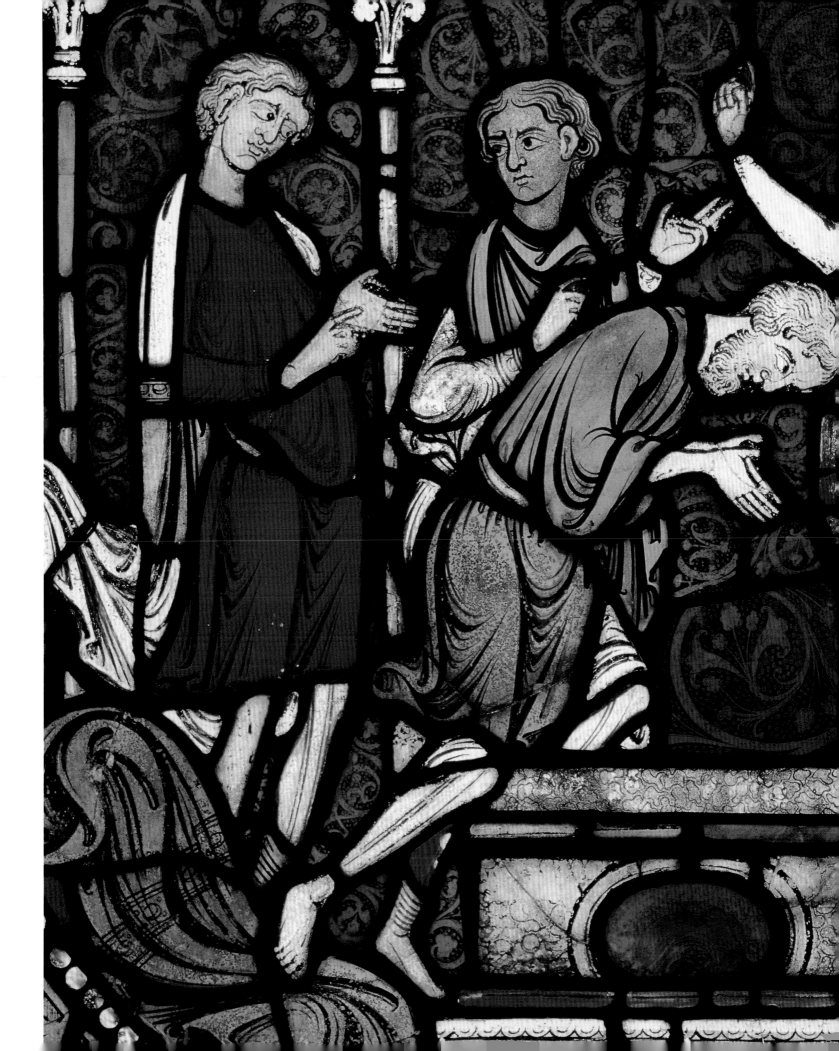

The Cure of Robert of Cricklade

n. IV, 28, 29

The two scenes take place in an almost identical setting at the tomb of St Thomas in Canterbury. Robert of Cricklade, an Austin canon and prior of St Frideswide's, Oxford, had become lame when he was in Sicily. He was on his way back to Oxford when he recovered, having already prayed at the tomb of St Thomas at Canterbury.

The second scene depicts Robert, without his crutch, returning to place it, with his cloak and boots, at the tomb as an *ex voto*, or offering – a common practice among those who had either been cured or wished to be cured. The inscription here reads: 'his stick, his garment, his boot are all witnesses to his cure'.

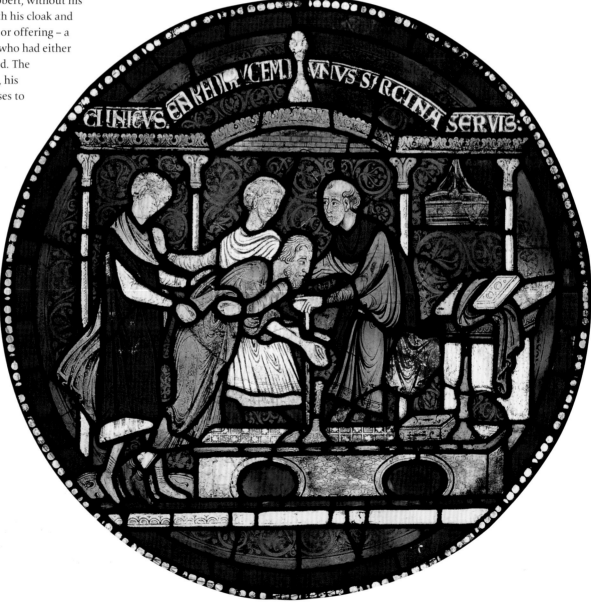

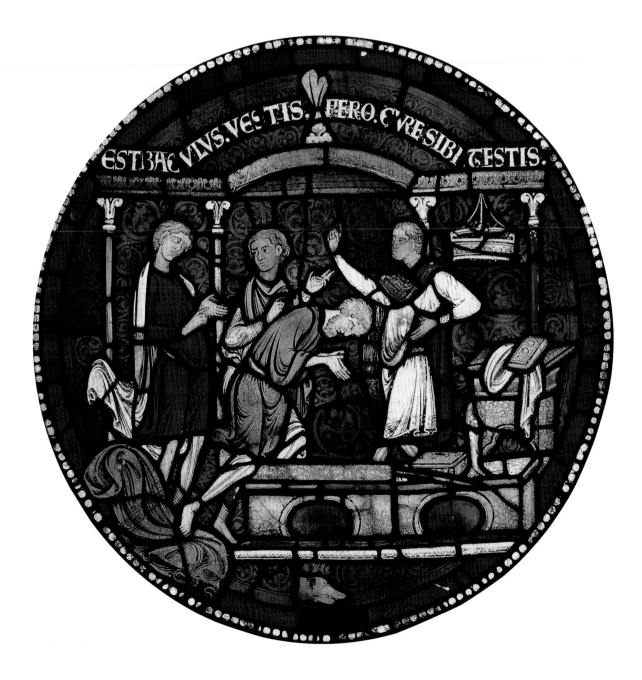

The Cure of 'Mad Henry of Fordwich'

n. IV, 14, 15

The first roundel of the next pair of scenes shows the 'mad Henry of Fordwich', who was dragged by his friends to the tomb with his hands tied behind him. He ranted and shouted all day at the tomb, but, after spending the whole night in the Cathedral, he returned home perfectly sane. The abuse of Henry by his friends, who use sticks to beat him with some gusto, is shocking. He is forced to kneel with his hands tied behind his back, as recounted in the text of this miracle.

In the second scene a dignified and elegant Henry prays at the tomb. The sticks and the rope used to bind and beat him are placed in the foreground as an *ex voto*, or offering, while a monk and one of his friends gesticulate in amazement.

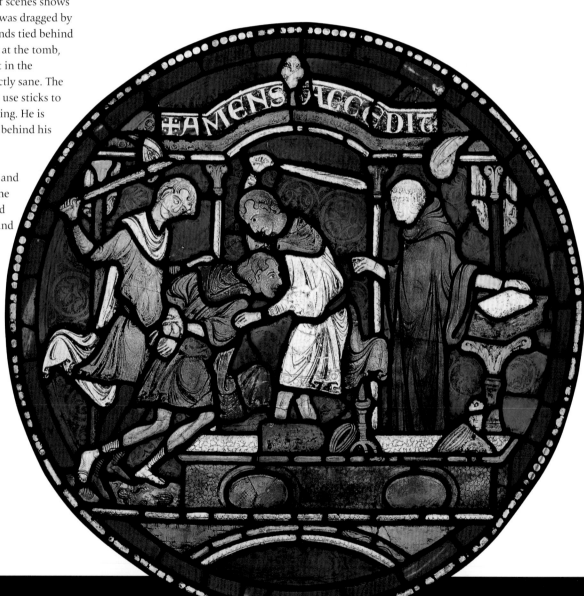

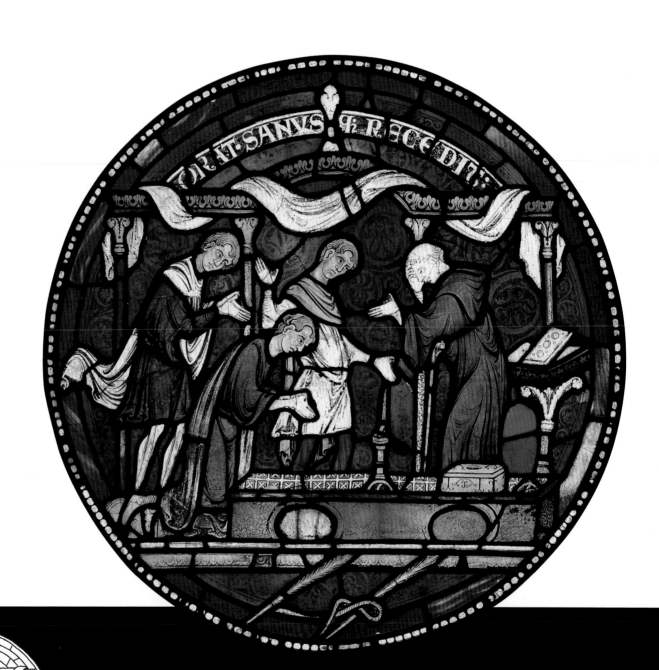

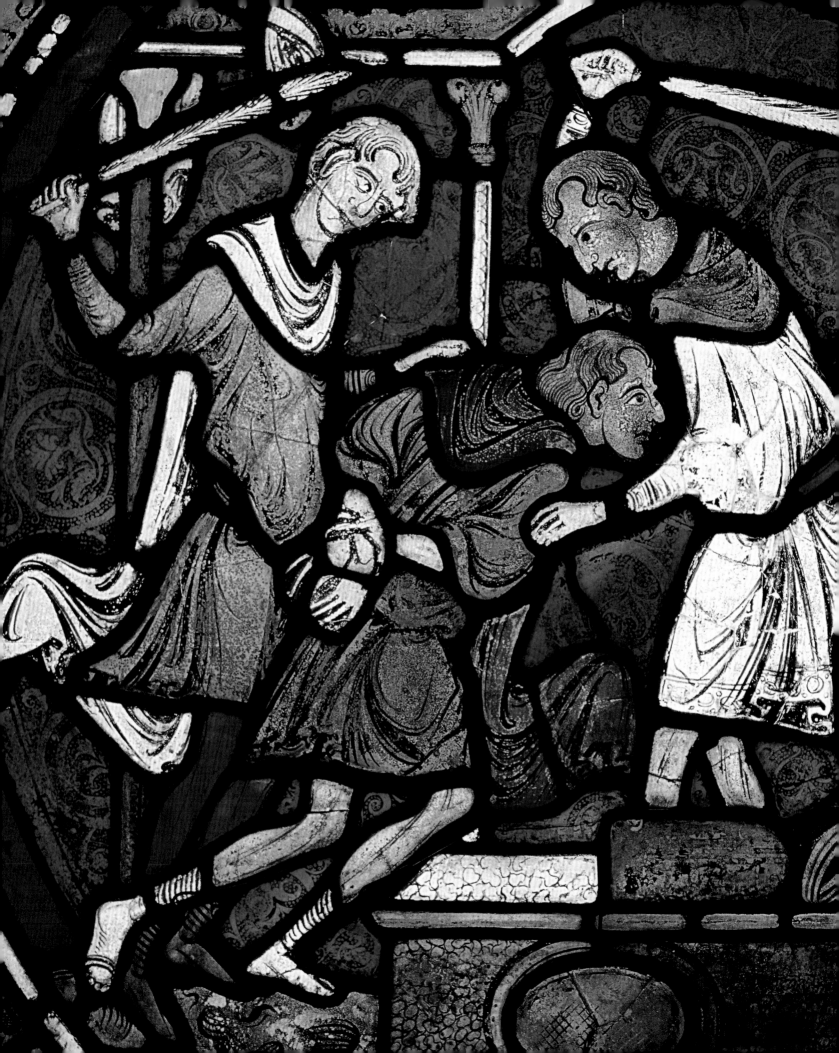

Juliana Puintel Presenting a Coil of Precious Wire at the Tomb

n. IV, 22

The second roundel of a pair of scenes recalls Juliana Puintel's offering at the tomb. After suffering stomach pains from eating fish, she was persuaded to make the pilgrimage to Canterbury by her priest. The roundel appears to show her own offering of a precious wire coil and, perhaps, her husband making another offering behind her.

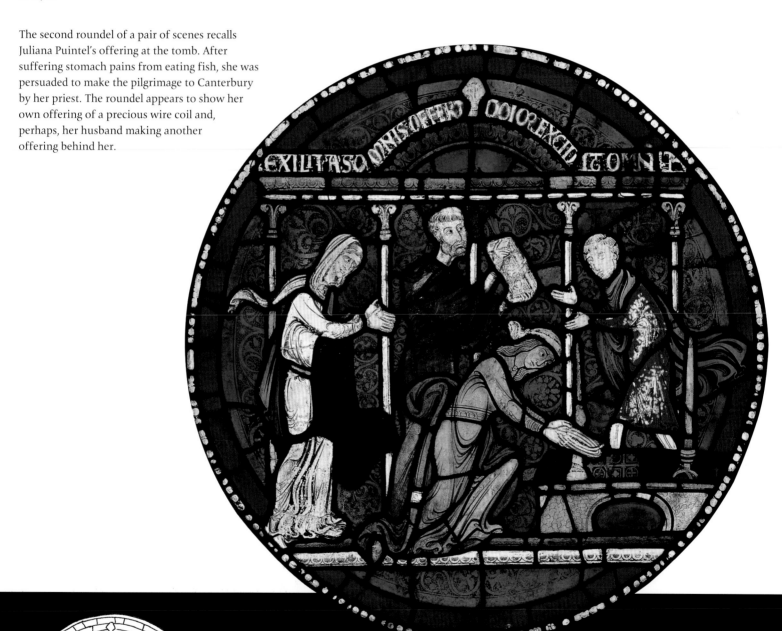

The Cure of Ethelreda by the Blood of St Thomas

n. IV, 8

If Austin's restoration of the bowl is correct, this is the first in the pair of scenes relating to Ethelreda of Canterbury, who suffered from a malarial disease known as Quartan fever because of its recurrence every fourth day. The inscriptions suggest that she had grown pale through loss of red blood cells, but, when she imbibed the blood of St Thomas mixed with water, she recovered.

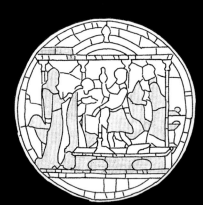

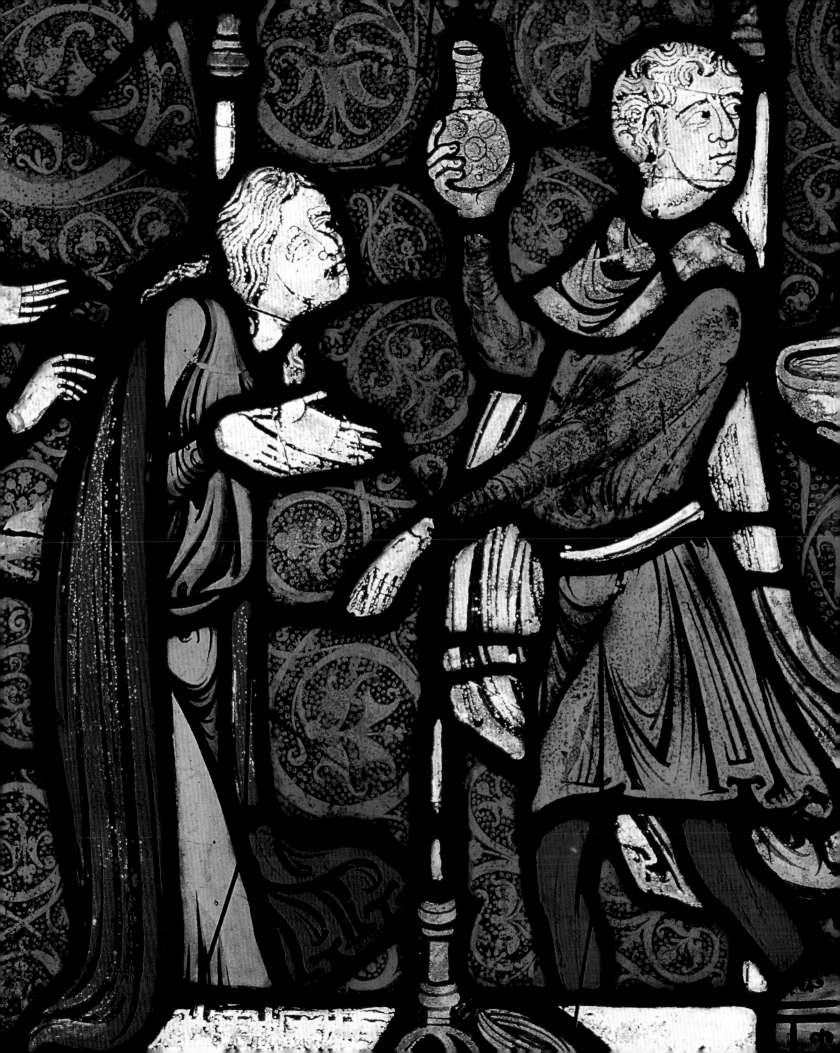

The Cure of William of Kellet

s. II, 30, 23

The carpenter William of Kellet, near Lancaster, vowed to go on a pilgrimage to Canterbury but postponed it, just like Jordan Fitz-Eisulf (see page 154). St Thomas caused William to cut his own leg so severely with an axe that he thought he was beyond hope and took to his bed entrusting himself to St Thomas. The saint then appeared to him in a dream, explaining that he had caused William's injury as punishment for his breaking his vow, but that he could also cure him.

When William's bandages were removed, a day after the apparition of St Thomas, not even a scar remained.

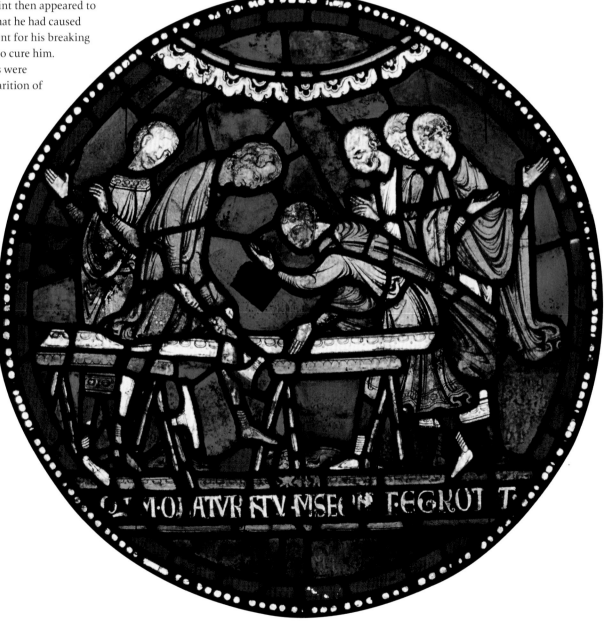

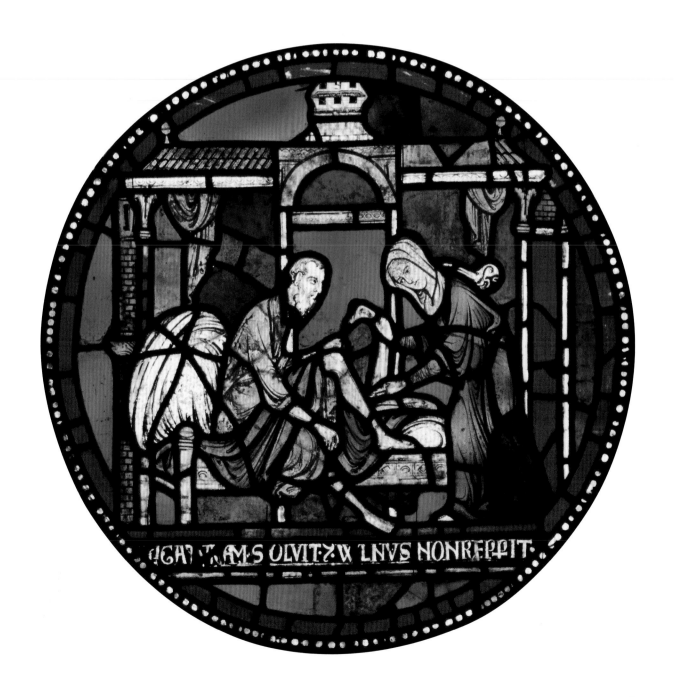

The Cure of Adam the Forester

s. II, 16

Adam came upon three poachers in a forest. One of them shot him through the throat, but he was cured after drinking the water of St Thomas, which he had acquired on pilgrimage.

The restoration history of this panel is especially interesting as it was carefully drawn in 1897, and the original appearance can be compared with the conserved glass (see pages 210–11).

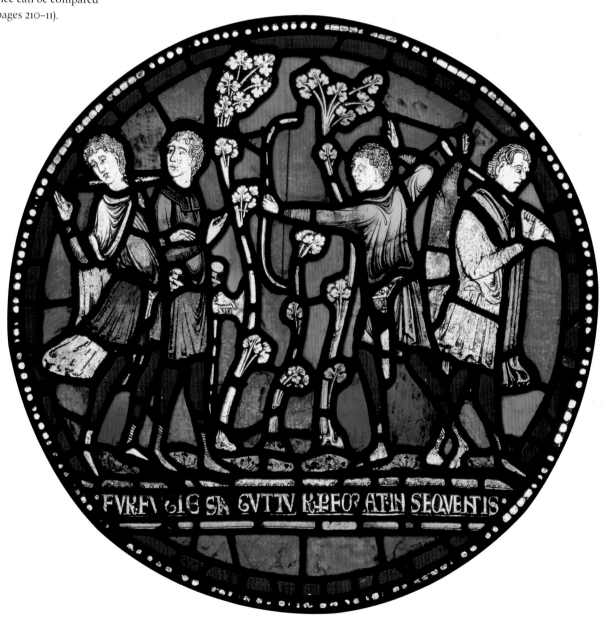

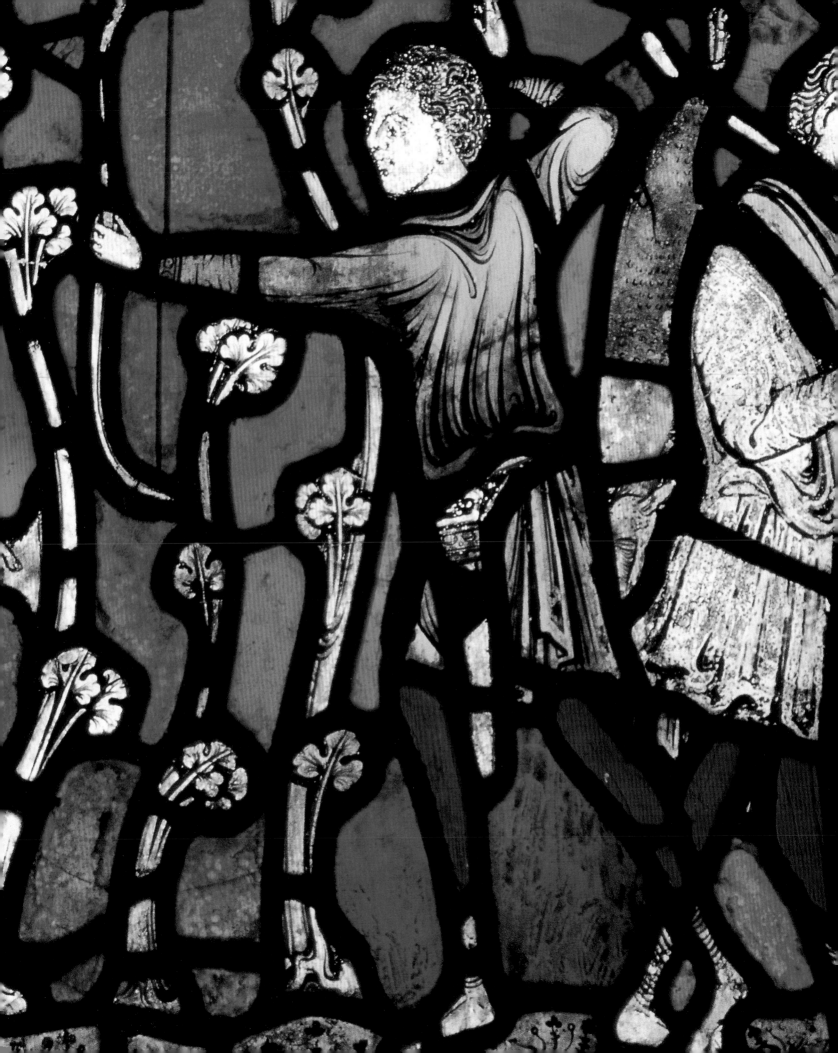

ECCE P EPENTI NA PREMIT VRPV ER II S RVINA

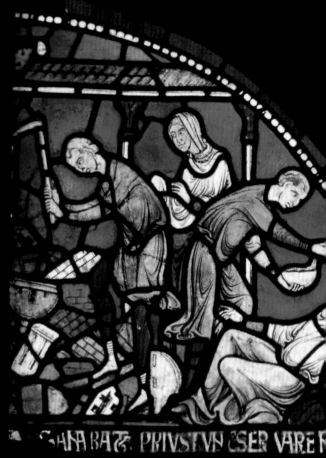

ANA BAT PRIVS EVN ESER VARE

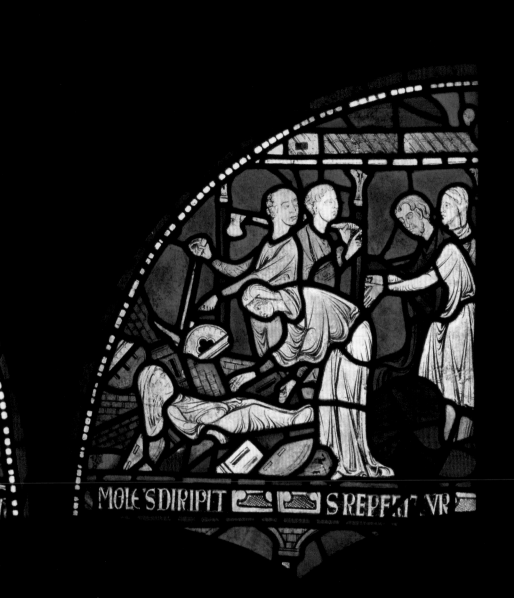

MOLE'S DIRIPIT S REPFFAT VR

The Cure of Geoffrey of Winchester

s. VII, 56, 52, 51

At 16 moths old, Geoffrey of Winchester had already been saved from a fever by the holy water of St Thomas, but disaster struck again when the house he was living in fell down as he lay in his cradle. His mother cried out: 'St Thomas, save the boy who you once gave back to me'.

In the central scene, the mother is depicted falling into a faint while men search the rubble. In the final scene, Geoffrey is found unhurt and his mother stoops over him.

Trinity Chapel Ambulatory, n. III (old number 5)

This window was most probably glazed soon after the return of the monks to Canterbury in 1213 by the same workshop that created n. IV (see page 104), supervised by the Petronella Master who created the other window. The design is made up of four large roundels, each with four smaller petals contained within it. The introduction of 'diaper' (or repeat pattern) infills in the corners outside the main roundels suggests a date later than that of n.IV. The spatial arrangements around the tomb of St Thomas are simplified to great effect; the tomb is angled to suggest depth, and objects can be placed on the same ground level as the tomb to suggest a firm middle ground.

The petal design used here was copied on two surviving pilgrim *ampullae*, or holy water containers, of St Thomas that are now in Bergen and Paris. The schematic scenes depicted on these lead containers appear to be the only recorded instance of the scenes depicted in the windows being used in another medium.

The scenes depicted here concern victims of leprosy, dropsy and the issue of blood, as well as the healing of lameness and injury. The most important scene is that of the emergence of St Thomas from a shrine (see page 126), which moves away from the low tomb depicted in the rest of the surviving glass (see page 110, for example). Whereas the low tomb indicates the site in the crypt where St Thomas was originally buried, this image of a tall shrine must indicate the site of the shrine in the centre of the Trinity Chapel. The fact that the shrine is depicted would normally suggest that the glass should post-date the translation of the relics of St Thomas in 1220. Most art historians believe that a fictive shrine is depicted, however, because it is likely that the glass would have been in place for the translation on 7 July 1220. Nevertheless, this depiction does raise problems over the exact date of the glass and how soon after the return from exile in 1213 the Trinity Chapel ambulatory was glazed.

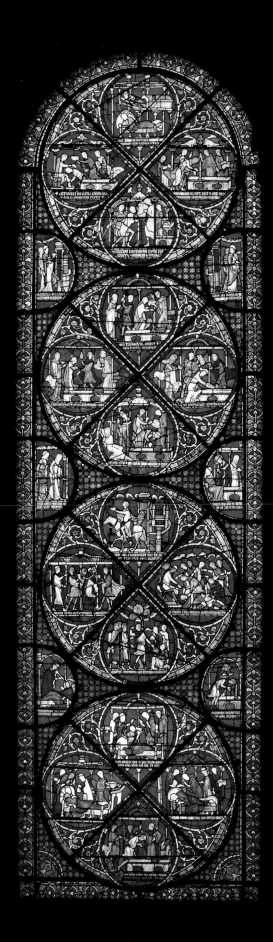

An Apparition of St Thomas from his Shrine

n. III, 45

The iconography of this scene is controversial as it depicts a house shrine that is placed high up on stilts, rather than the low tomb that is usual in the glass at Canterbury. The miracles recorded by Brother William and Prior Benedict all occurred, before the shrine was built, at the original burial place in the crypt beneath the Trinity Chapel. The shrine of St Thomas was made ready for the translation of his body on 7 July 1220.

It seems unlikely that anyone other than St Thomas is actually depicted here, although it has been suggested that this may be the apparition of another saint inspiring the unidentified man sleeping below to recognise St Thomas' sanctity. The shrine is typical of those that survive from a number of churches in the Mosan region of Flanders from the late twelfth and early thirteenth century.

The Cure of Godwin of Boxgrove

n. III, 40

This panel depicts Godwin, a servant of the monks of Boxgrove Priory, who was a leper. He came to Canterbury to find a cure at the tomb of St Thomas. He had a vision of the saint giving away his vestments, and, finding himself cured, he emulated the saint by giving his shirt as an *ex voto*, or offering, to the tomb. The interior scene depicted here is of great interest as the cross-section and tunnel effect with a gable above suggests a constricted space. This is enhanced by the fact that the recipient's head overlaps the ceiling, and the action takes place between a column on the right, which is in front of the recipient, and an interior column on the left, which is behind the shirt, suggesting the emergence of the figure from inside.

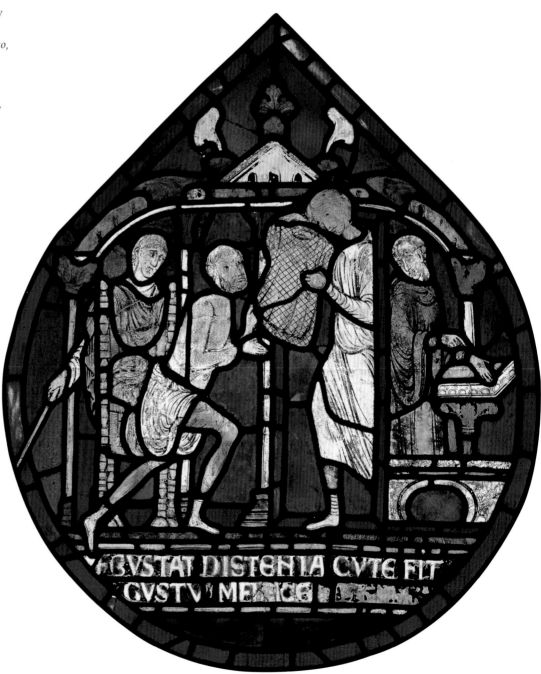

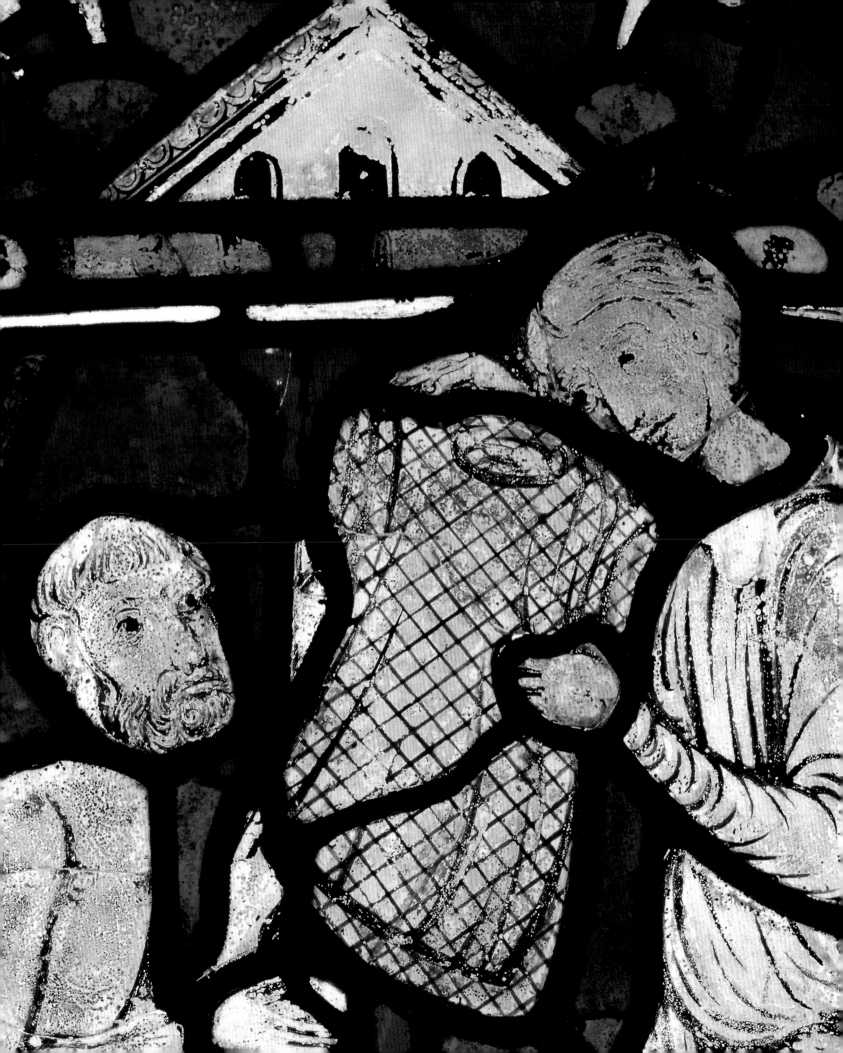

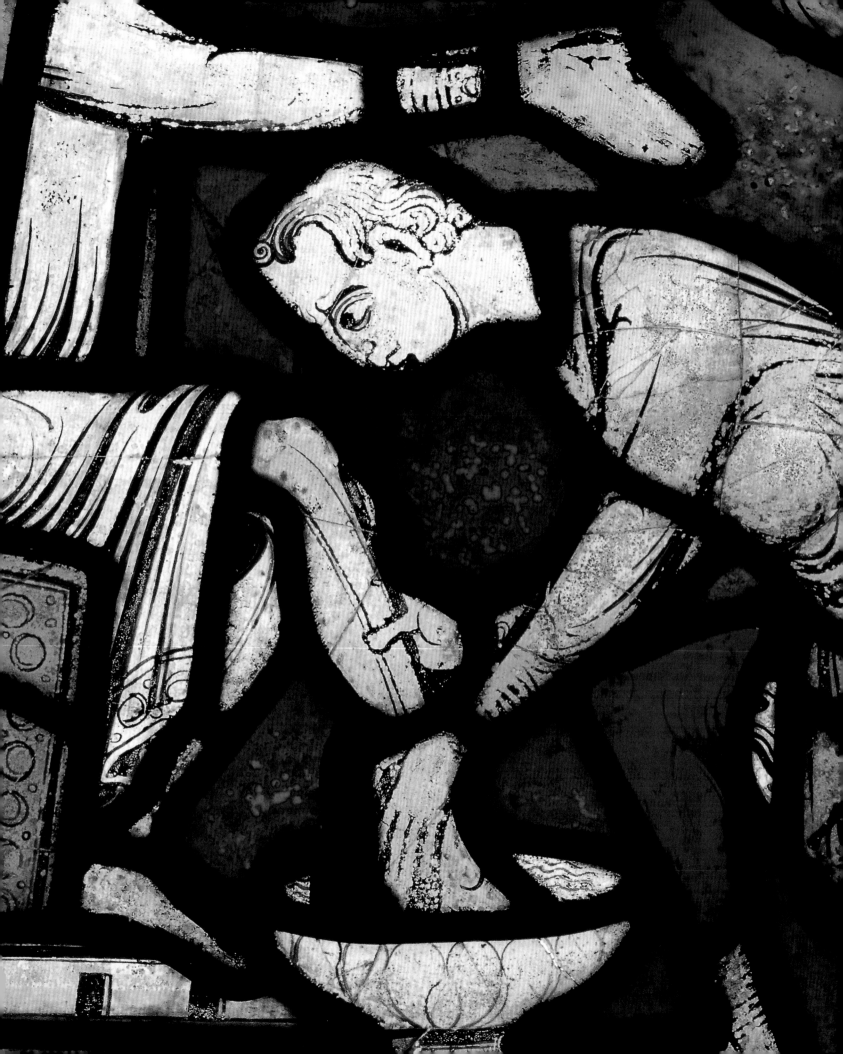

The Cure of Roger of Valognes

n. III, 42

This scene fits in with a number of possible readings. The most attractive is that of the story of Roger of Valognes, who promised to come on a pilgrimage to Canterbury but forgot to do so. He subsequently injured his left foot (shown as the right) and journeyed to Canterbury to wash in the holy water of St Thomas, whereupon he was cured.

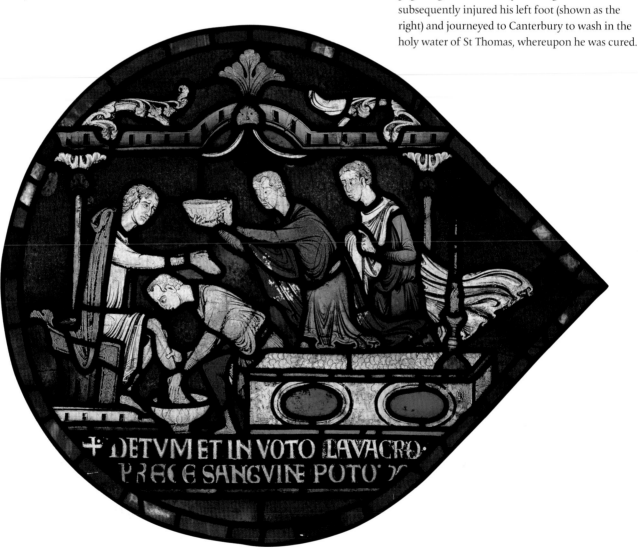

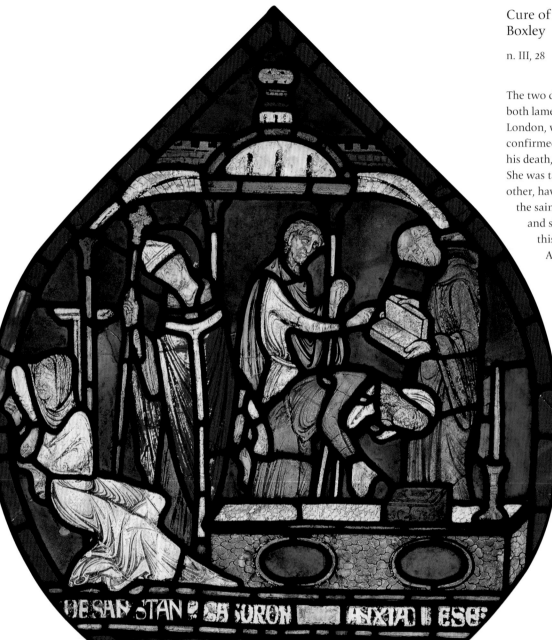

Cure of the Daughters of Godbald of Boxley

n. III, 28

The two daughters of Godbald of Boxley were both lame from birth. At Newington Cross in London, where St Thomas was reputed to have confirmed a group of children only days before his death, he cured one by a vision in a dream. She was taken to Canterbury to give thanks. The other, having been left behind, complained to the saint of the unfairness of being neglected, and she too was cured by a dream. Although this panel contains replacements by Austin Jr (see page 211), the figure of St Thomas is still intact. Both the dream and the thanks of the elder daughter appear to be shown.

Walter of Lisors

n. III, 21

This beautifully preserved panel cannot be identified with any great certainty. The inscription refers to the cure of leprosy, but the figure appears to be leaving Canterbury rather than arriving, as required by the inscription and the story. The use of the open door, through which the horse and rider emerge, is very effectively suggested. The sweep of the city wall, enclosing the buildings within, also presents a perspectival arrangement much more advanced than the schematic representations usually used at the time.

PIGNVSI A·N MO DIC·FVR

The Cure of Eilward of Westoning

n. III, 18, 19, 16

On the left Eilward, who came from Westoning in Bedfordshire, is seen after a drunken night at the tavern. He entered the house of his neighbour, Fulk, who owed him a *denarius* (silver coin) but would not give it to him. He was brought before a magistrate (on the left, wearing a cap) for abusing the man, suffered trial by water and was found guilty.

On the right Eilward is then blinded, castrated and left for dead by his accusers at the request of the Viscount of Bedford, who acted as magistrate. This is graphically shown – Eilward's prostrate body is abused in the centre of the composition.

Eilward confessed his sins after his mutilation to the Chaplain of St John in Bedford and was told to pray to St Thomas. Before long his sight was restored, and he travelled to Canterbury to give thanks to St Thomas. He was feted in Bedford and then London – in the bottom panel he is shown giving away the gifts he has received to the poor and crippled.

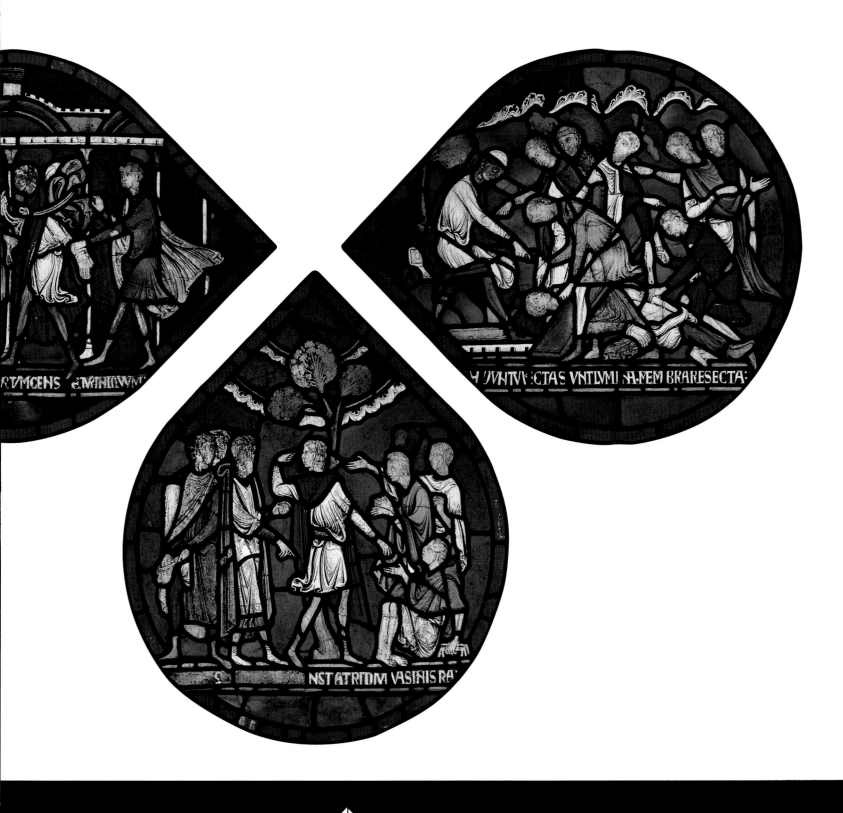

RVMGENS E MINIQVM

H·JVNTVR CTAS VNTLVMI SH·MEM BRARESECTA:

NSTATRIDM VASINIS RA

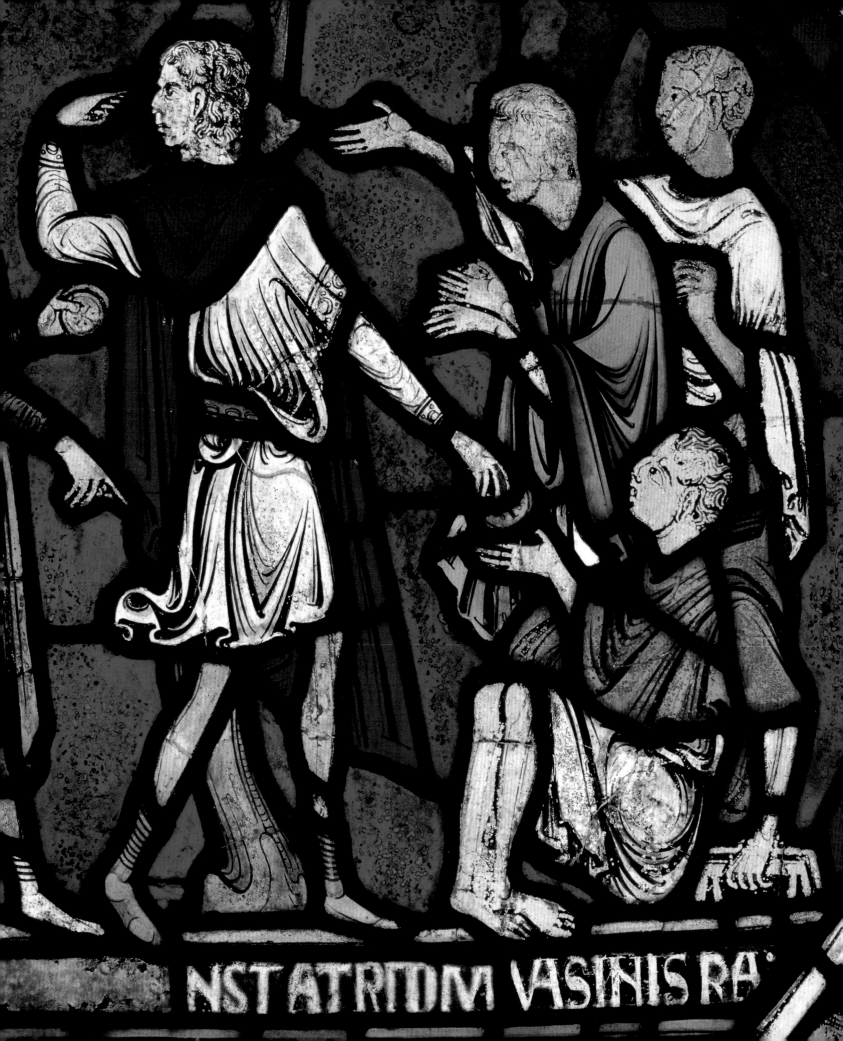

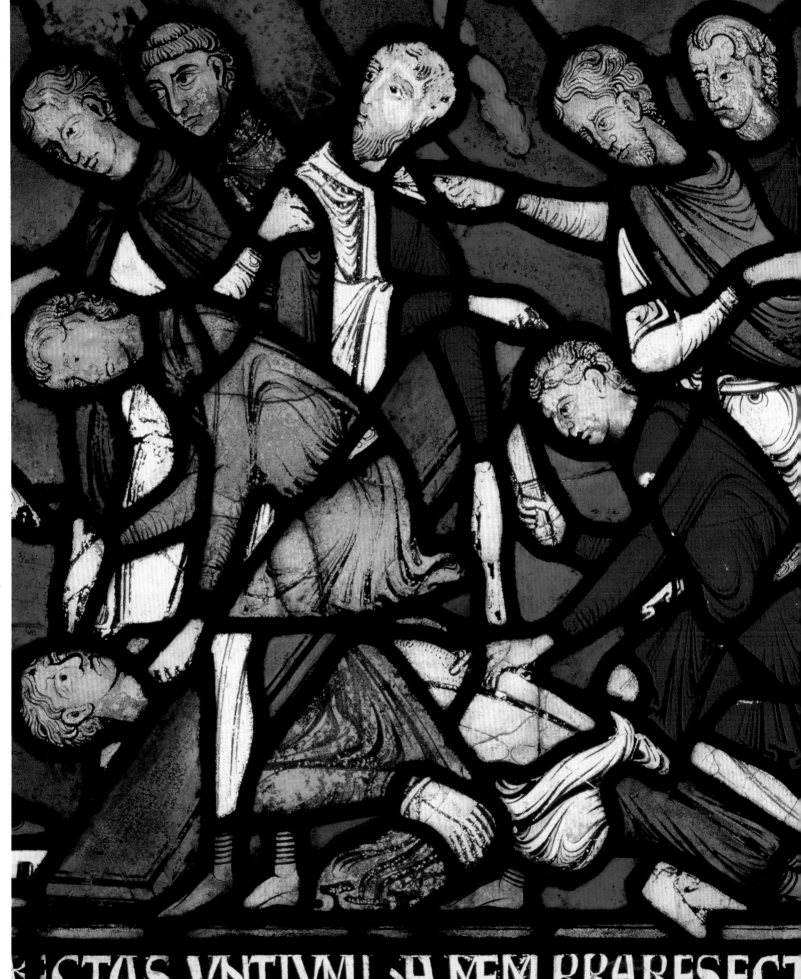

...CTAS VNTLVMI A·MEM BRARESECT...

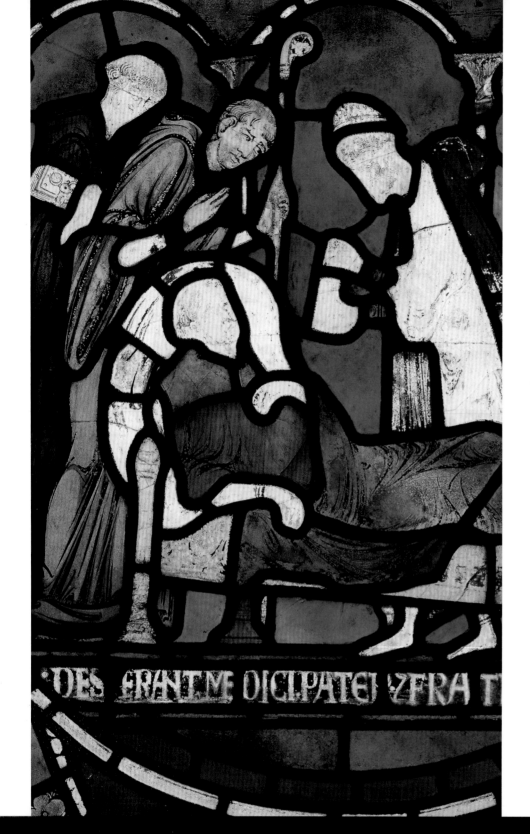

The Cure of Hugh of Jervaux

n. III, 6, 9, 7

The story of Hugh, a cellarer (the monk charged with the provisioning of a monastery), is depicted in three surviving scenes. He is seen on the left being tended by a lay physician (in the centre, wearing a cap) in the presence of the abbot on the left, but he is perceived to be dying. The ineffectiveness of surgeons and physicians is a theme in the miracles of St Thomas.

In the centre the monks are seen to take over the administration of the blood of St Thomas mixed with water. The physician (on the left) may be identified again by his cap. 'Hope remains for the hopeless in the blood of the saint' states the inscription.

The final scene, on the right, sees Hugh turning on his side in bed with a stream of blood emanating from his nose – after this nosebleed he was cured. The physician and attendant are seen uselessly observing, on the right this time.

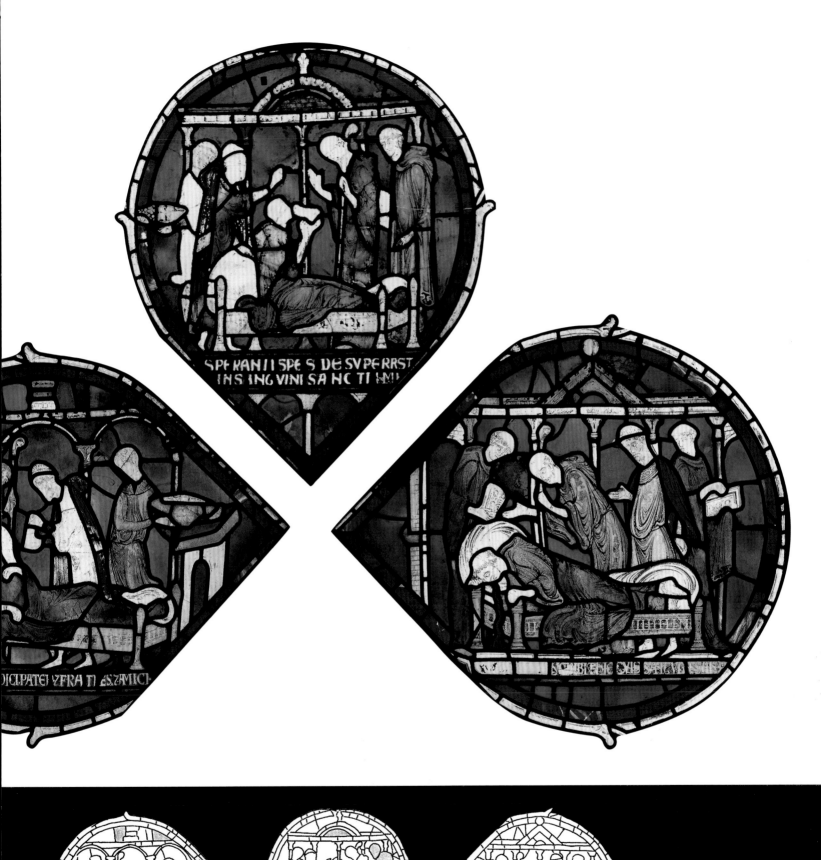

BECKET MIRACLE WINDOW 6

Trinity Chapel Ambulatory, n. II (old number 6)

This window shows a number of stylistic and compositional similarities with the stained glass at Sens Cathedral (Yonne). It is executed by the Master of Jordan Fitz-Eisulf, named after the scenes depicting Jordan's cure by St Thomas contained in this window. He also worked on the Corona Redemption Window (see page 86), and appears to have been trained by the Master of the Parable of the Sower (see page 76). It is probable that this window was executed after the exile of 1207–13. It shows that ideas derived from French glass had arrived at Canterbury through the cross-fertilisation that occurred during this period of time.

It has been suggested that a single atelier, responsible for this glass, travelled from Sens Cathedral to Canterbury Cathedral and then went on to Chartres Cathedral, executing glass in all three sites. Certainly the detail of the ornament used and the colour tones favour this assertion. Comparison between the superimposed petal design in Window 6 and the St Eustace Window at Sens reveals a common design, which cannot be found in other windows of the period. At Sens the full width of the Romanesque window is occupied by a geometric design formed essentially of two large cubes, but at Canterbury the design is lengthened and attenuated to fit an essentially Gothic lancet window. This suggests that the impetus for the overall design of these almost unique windows may have come from Sens to Canterbury.

Window 6 depicts miraculous cures of blindness, leprosy, drowning, madness and plague. One such tale, *Plague in the House of Jordan Fitz-Eisulf*, is allocated nine scenes, the largest of any surviving miracle sequence at Canterbury. The complexity of the leading allows for this multiplication of scenes – four central squares are set on top of circles that are themselves broken by four petals. The artist has made full use of this innovative design, but such is the complexity of the format that it was not used by other artists – other than in its source, the St Eustace Window at Sens Cathedral.

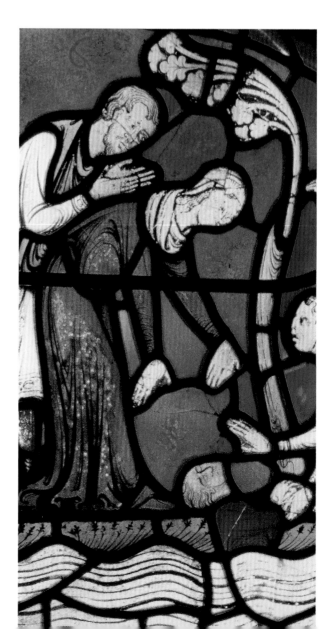

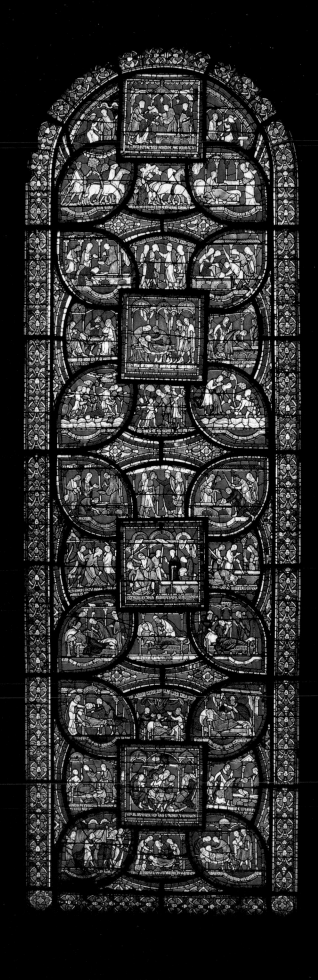

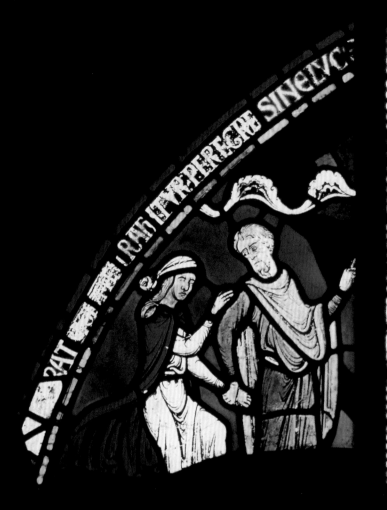

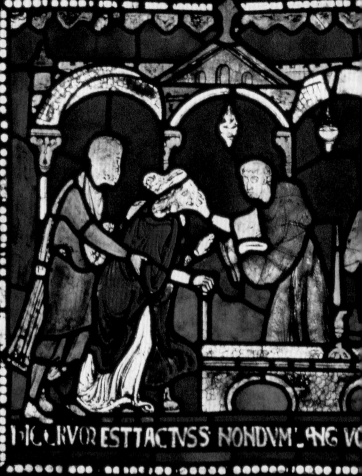

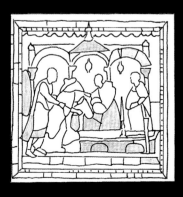

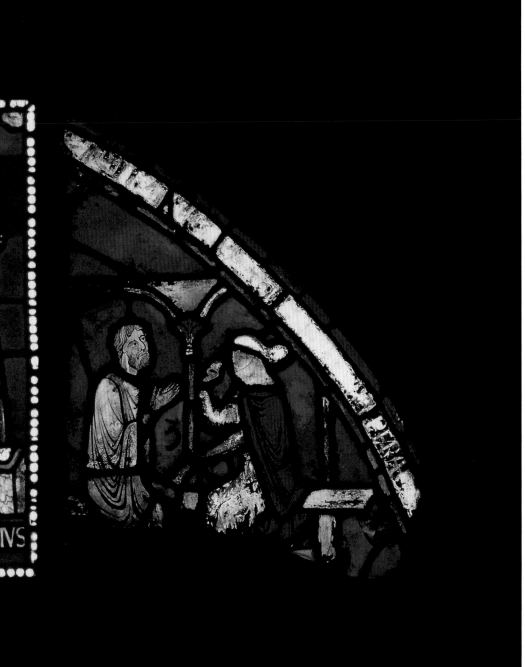

The Cure of Juliana of Rochester

n.II, 69, 70, 71

On the left the blind girl, Juliana of Rochester, is shown with her 'eyes sealed' and being led by her father.

In the centre she is supported by her father as she approaches the tomb of the saint, and a monk applies the blood of St Thomas to her eyes. No cure occurs on the spot; she must wait until she returns home before her continued faith is rewarded.

The final scene shows daughter and father seated on a long bench, giving thanks for the restoration of Juliana's sight.

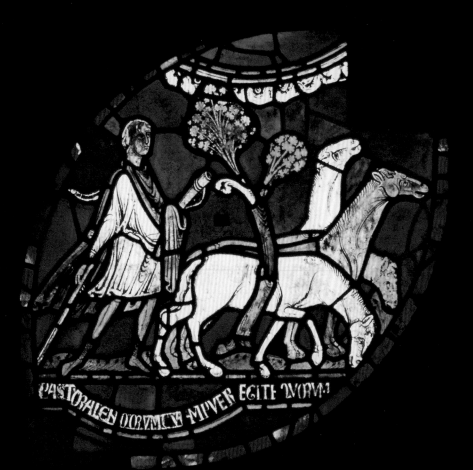

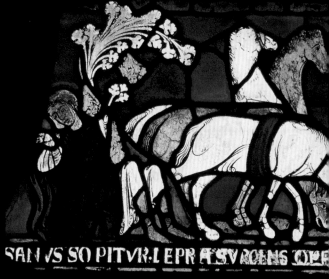

PASTORALEN OORVMICV MPVER EGITE 2VORM

SAN VS SO PITVR·L·EPR ÆSVRGENS COPE

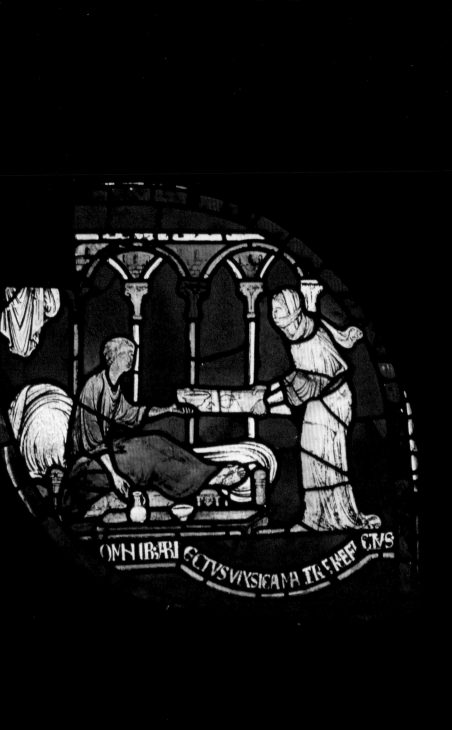

The Cure of Richard of Sunieve

n. II

Richard of Sunieve's story is narrated in six
scenes. He was the son of a poor woman and had
the job of groom and herdsman to a knight of
Edgeworth. He often slept outdoors, and, one day,
awoke to find his face swollen and spotted. He
suffered for eight years from leprosy, until he was
forced to leave the knight's employment and his
own village. His mother followed him, but she
could not touch him for fear of infection. After
deciding to go on pilgrimage to Canterbury, he
improved daily. On arrival he prayed at the tomb,
and a great swelling disappeared from his face; he
was so astonished that he thought it had fallen
from his face and searched for it. On tasting the
water of St Thomas he fell into an ecstasy and was
cured. The knight came to fetch him and also do
pilgrimage to St Thomas, in whom he did not
believe before the cure.

Panels 65, 66, 67

Richard is seen tending the horses of the knight
and then sleeping outdoors with them. (Sleeping
rough is often given as a cause of disease in texts
of the miracles.) He is then shown being fed at the
end of a long board or tray by his mother, who
fears to touch him (right). The artist has taken
particular pleasure in depicting the horses in these
scenes. He has set them behind trees and
overlapping each other to create a corridor of
space and a sense of landscape.

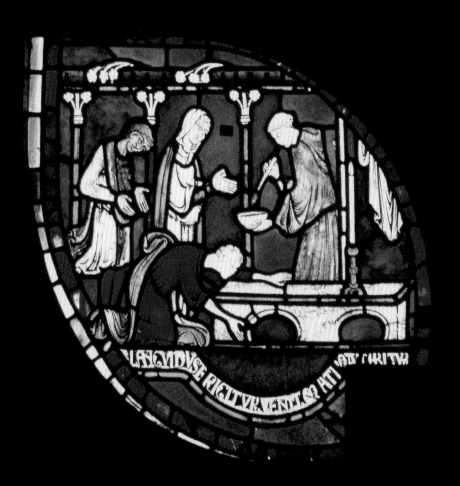

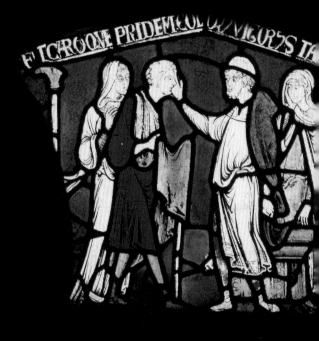

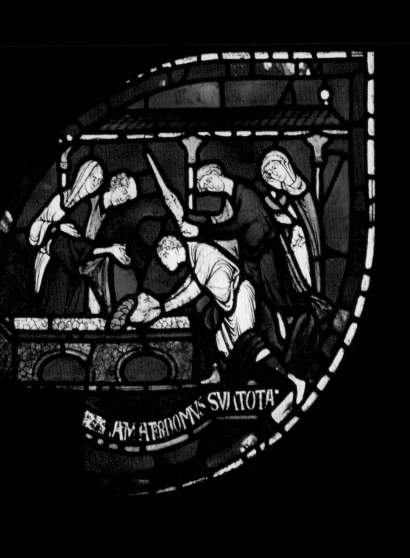

The Cure of Richard of Sunieve (cont.)

Panels 57, 58, 59

Richard is seen (left) stooping at the tomb, perhaps looking for the lump that has disappeared from his face, while a monk prepares the 'water of St Thomas', a mixture of the saint's blood and water, which Richard drinks before he is fully cured. Richard demonstrates his cure (centre), probably to his master and mistress, who are seen on the right-hand side of the scene. Finally his mother and the knight and his wife appear to be giving thanks at the tomb (right).

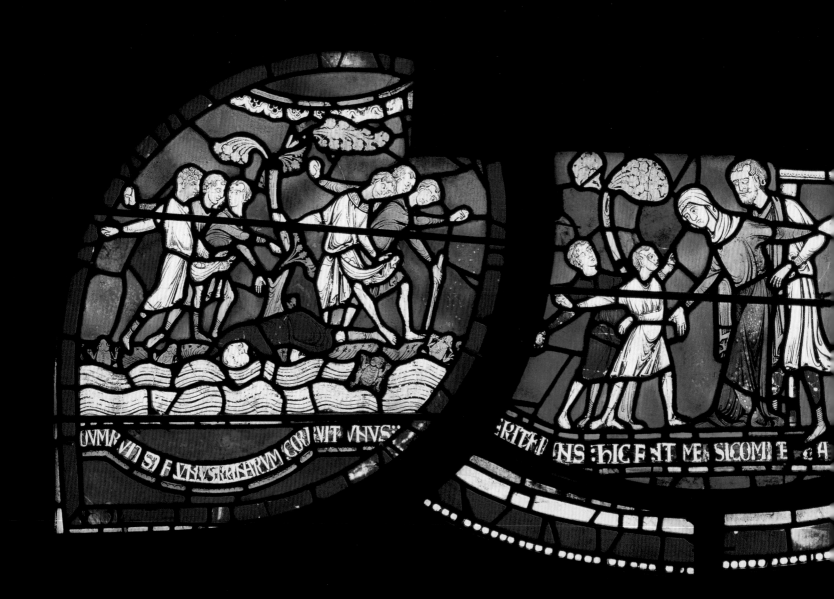

OVMARVII SI VNVSRGISHRVM CORVIT VNVS CRITFI NS HIC FNT ME SICOMI E CA

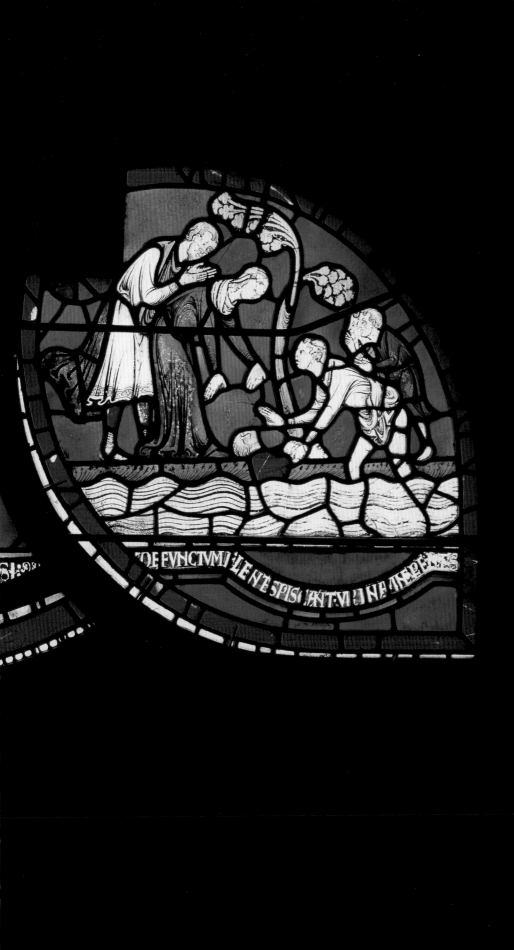

Philip Scot and the Frogs / Bobby of Rochester

n. II, 47, 48, 49

The three scenes here are all that remain of two separate stories, both involving water and a boy. The first comes from Philip Scot's story, while the second and third concern Rodbertulus (Bobby) of Rochester.

Philip, the eight-year-old son of Hugh Scot of Warwickshire, went stoning frogs with friends at a deep pool in an ironstone quarry, fell into the pool and drowned. In the first scene the boys can be seen stoning frogs as they emerge from the water 'as boys will'. The second and third scenes may have borrowed the figures of the two parents, who are first seen being told of the accident by two of the boys, from the other story – that of Rodbertulus (Bobby) of Rochester, who drowned in the River Medway 'at about three o'clock and was not dragged out until after vespers'. The final scene shows Bobby's lifeless body being pulled from the water as the distraught parents look on.

The cure of Rodbertulus would have taken approximately three more scenes. He could have been depicted hung up by his feet (to let the water out), rolled in a tub (to make him vomit) and measured by his mother with a thread, the length of which she promised she would buy in silver and present to St Thomas' tomb should her son revive. At the moment of this promise the boy vomited the water up and was cured.

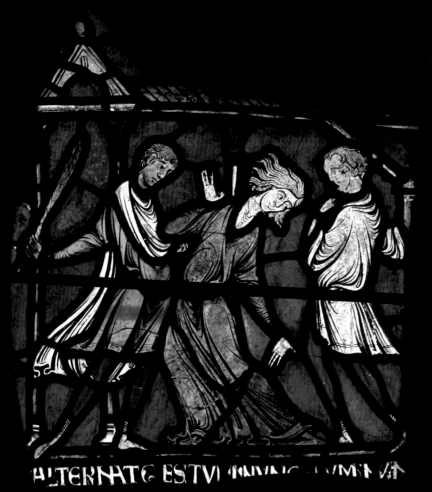

ALTERNATG ESTVI INVNG CVM IVI

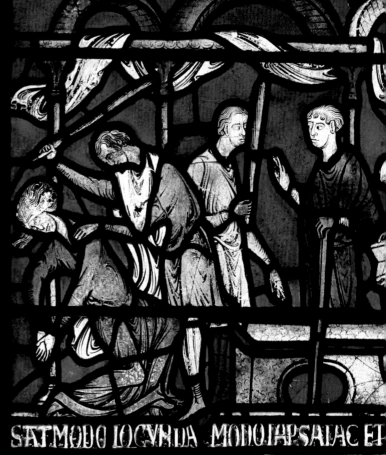

SATMODO LOCVNDA MODOTHPSAIAC ET

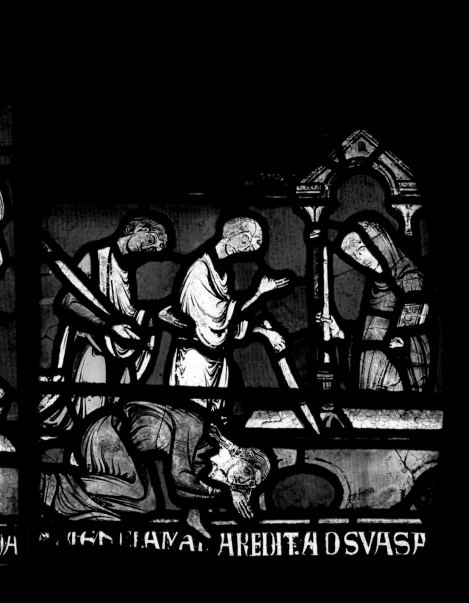

Mary of Rouen

n. II, 33, 34, 35

Mary of Rouen suffered from a nervous affliction for over a year. Up to ten times a day, she would rapidly switch from despair to hilarity. At first she would cry, then she would laugh, until finally she would clap her hands and fall into a trance or stupor. She is shown in her demented state, her posture tilted and bent, her hands flung up and down, her hair wild, and two men beating her with sticks. In the next scene, she is seen clapping her hands and falling into a stupor, her eyes already closed. Mary initially recovered at home in Rouen after vowing a pilgrimage, but the affliction returned, more violent than before, when she failed to fulfil her vow. She then went to Canterbury to visit Becket's tomb, as is pictured in the glass. In the final panel, Mary is shown recovered. Her eyes are wide open as she stoops in a deep bow at the tomb. The men who had been beating her give thanks while a monk looks on. When Mary returned home, she was cured.

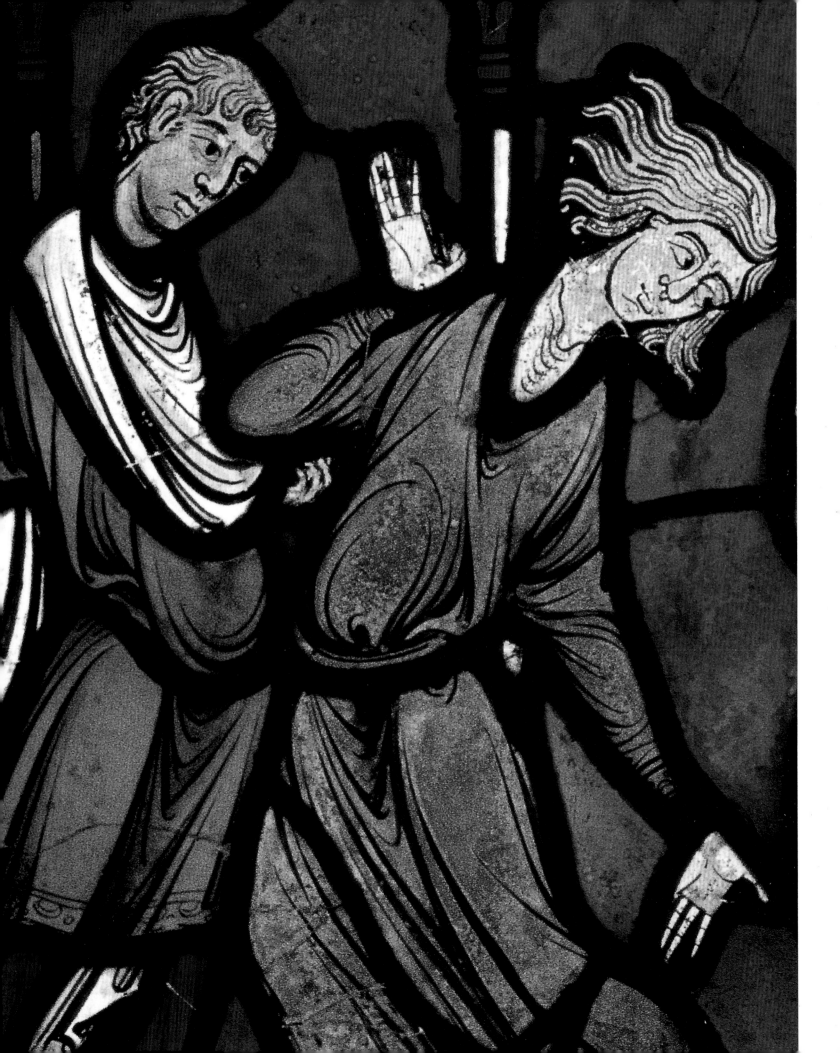

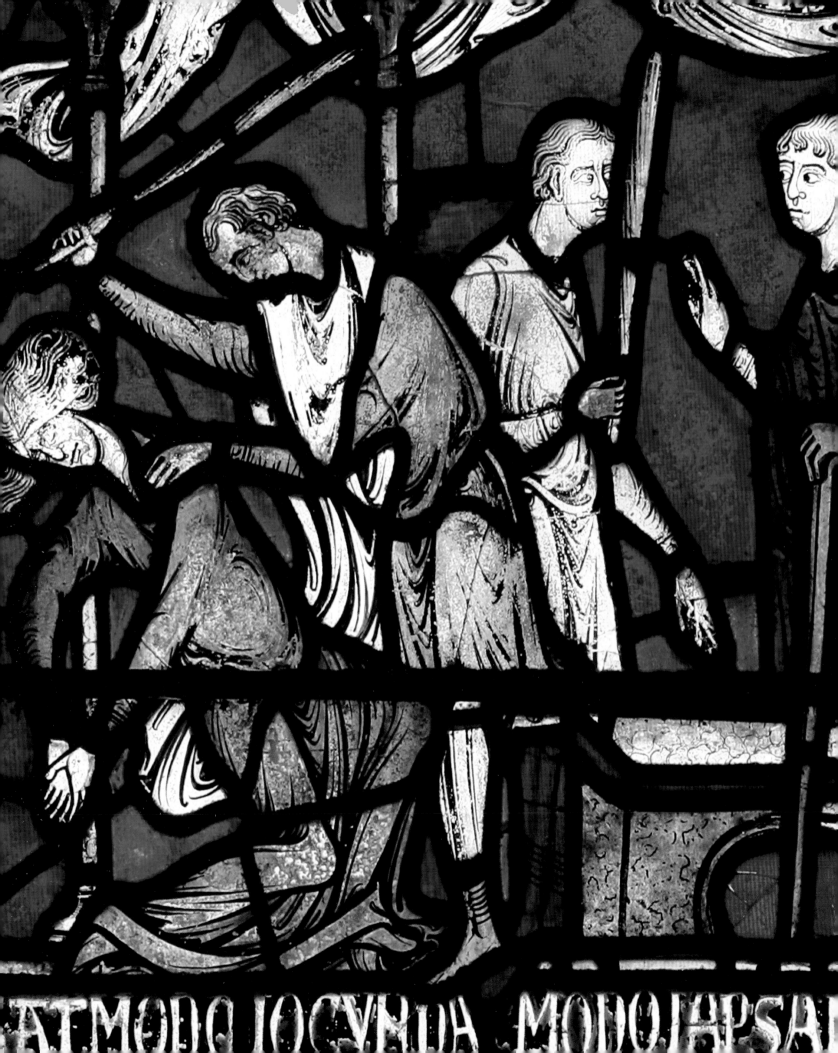

ATMODO IOCVNDA MODO IPSA

The Plague in the House of Jordan Fitz-Eisulf

n. II

Jordan, the son of Eisulf, was a knight of 'great name' according to the record of the miracles by Benedict of Peterborough. Plague struck his house. The first to die was Brito, nurse to his ten-year-old son William. Three days later the boy was also taken ill, and he died on the seventh day of his illness. A priest came, and a vigil was held overnight at William's bedside. That day some 20 pilgrims who had been to the tomb of St Thomas were received into the house and given hospitality because of Jordan's belief in the saint.

They brought with them the 'Water of St Thomas', which Jordan asked to be poured into his dead son's mouth 'in case the Martyr may give me back my son'. The priest poured the water in but thought Jordan had gone mad for requesting this, especially as nothing happened. Still Jordan refused to let his son be buried, even though it was two days now since he had died. Insisting that St Thomas would intervene, Jordan forced his son's clenched teeth apart with a knife and poured more water in. This time the boy's cheek grew rosy. Jordan sat him up, so that the water might pass down his throat. The boy eventually opened one eye and said: 'Why lament father? Why weep Lady? Be not sad. See, Thomas the Martyr has given me back to you'. His father then promised to take him to see the martyr's grave at Lent, giving him two pieces of silver and keeping two for himself and his wife as offerings. The appointed time passed, however, and they did not go.

St Thomas then appeared to a leper, called Gimpe, who lived three miles from Jordan's house, instructing him to go to warn Jordan that, unless he fulfilled his vow, he would experience as much sorrow as he had felt joy at his son's revival –

through the loss of another son. The leper resisted, complaining that he was blind and infirm, but St Thomas appeared to him a second time, saying he should tell the priest to inform Jordan. The priest dismissed the leper's vision as a dream and refused to go to Jordan. The saint appeared to the leper a third time, finally telling him to send his daughter to fetch Jordan and his wife, so the leper could tell them all that had happened to him. This took place, but the knight's Lord, the Earl of Warrenne, arrived, preventing the pilgrimage to Canterbury.

Because Jordan failed to keep his vow another of his sons was smitten with the plague, and the parents themselves then fell ill. About 20 people in Jordan's house became unwell. Jordan insisted that he and his wife go to Canterbury: 'living or dead, we will both go to the Martyr'. They were sustained by the water of St Thomas on the way, and, after they saw the pinnacle of the Cathedral, Jordan's wife walked barefoot for the last three miles of their journey to the tomb.

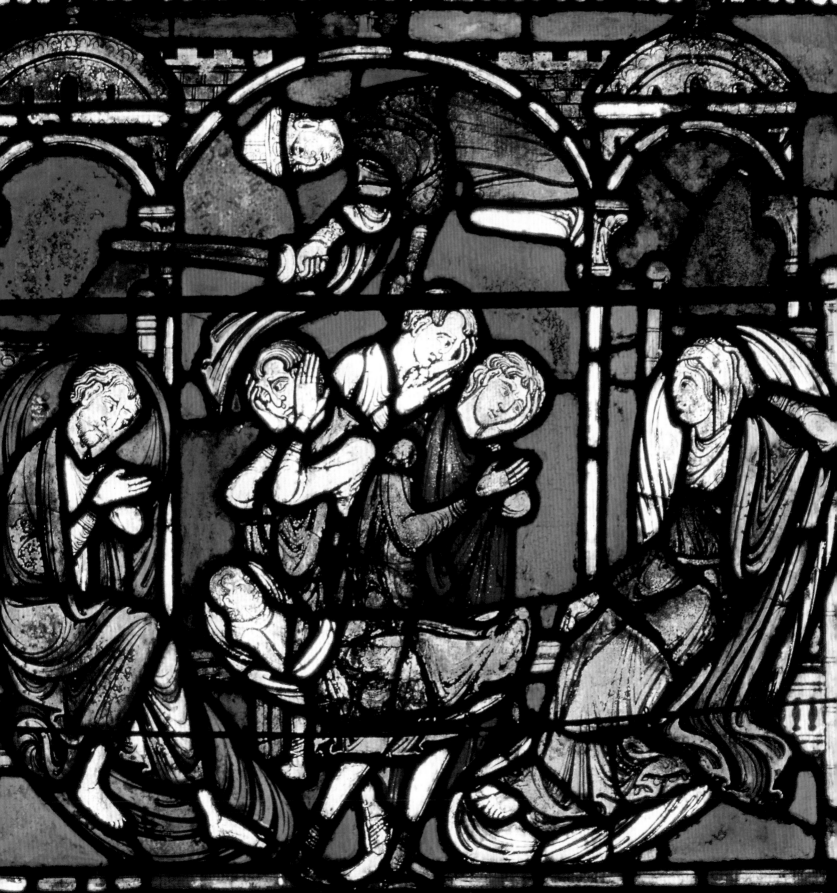

DIC TEMO LES. DOM V. E. A. MORCU A PROLES.

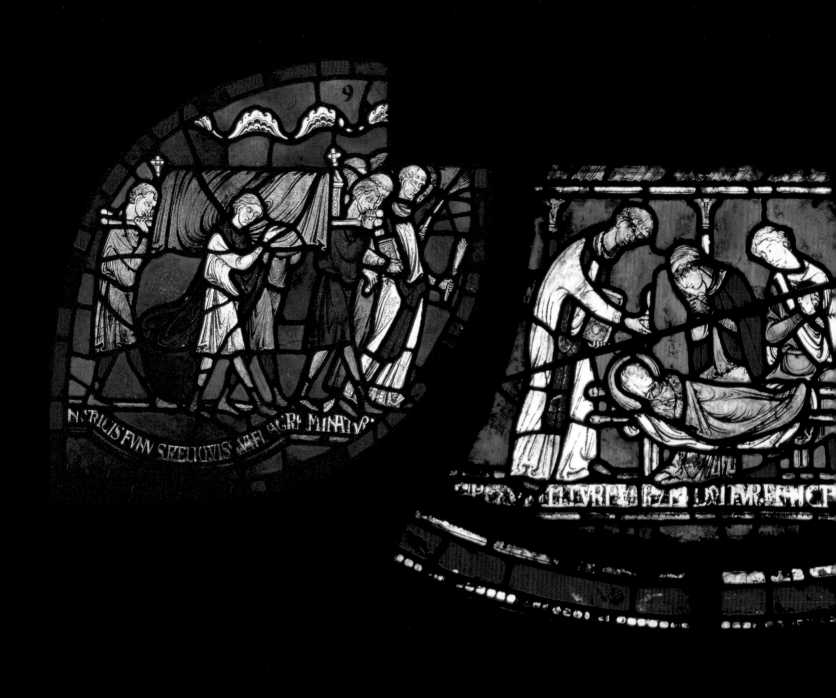

NUTRICIS FVNN SPELIONIS ...FLAGRI MINATVR·

...PEN... ELLVTFIT...EN UICI EM...NET...

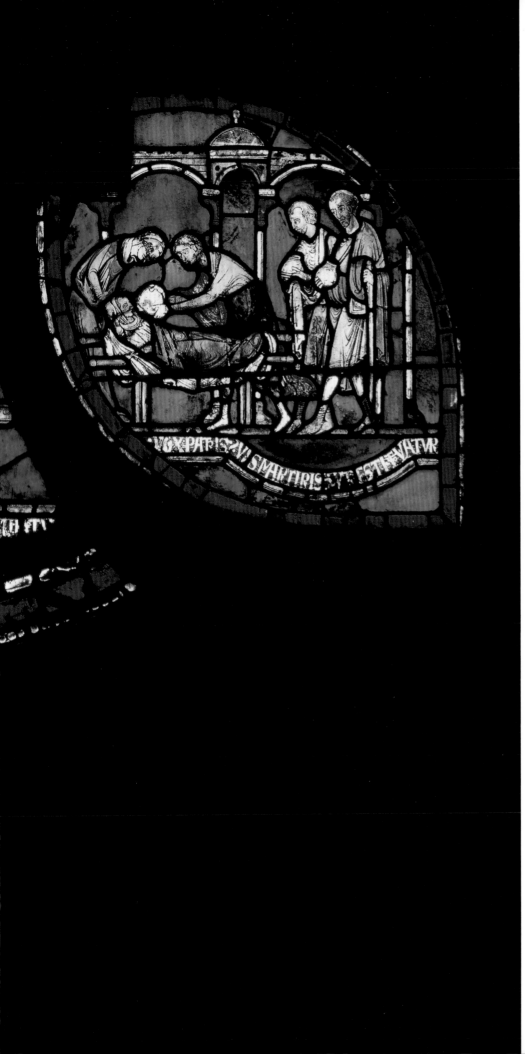

The Plague in the House of Jordan Fitz-Eisulf (cont.)

Panels 9, 10, 11

The first scene is that of the funeral of the nurse, Brito, whose coffin is being carried by pallbearers lead by a priest with an *asperge* (holy water sprinkler).

The second scene depicts the death of Jordan Fitz-Eisulf's son, William. The dead child is in the centre on a green bier, and a priest in surplice and stole with book and a candle gives the last rites, while the distraught mother and father grieve, seated on a bench.

The administration of the water of St Thomas to the dead child is depicted in the third scene – his head is lifted so that the water can trickle down his throat.

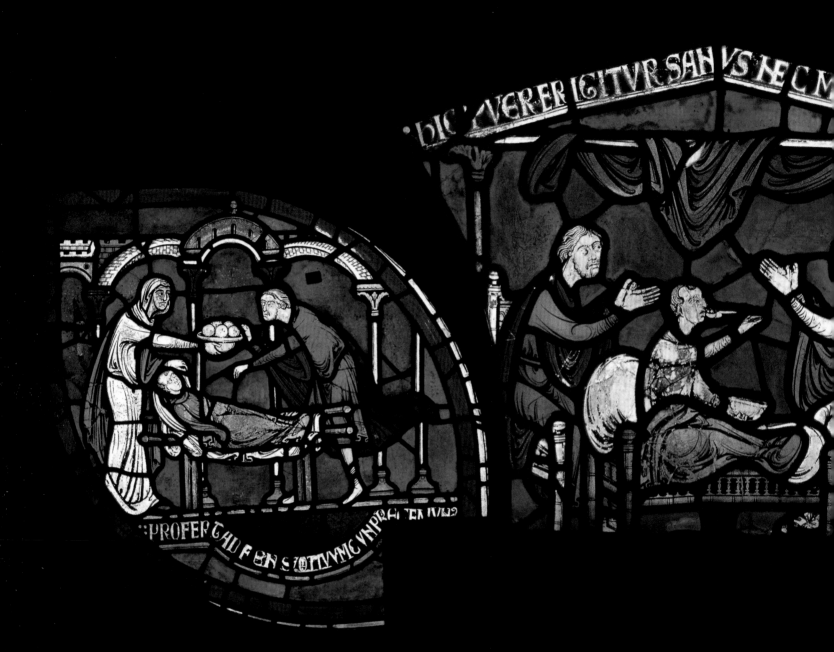

HIC ... VERERIGITUR SANVS HE CM

...PROFER

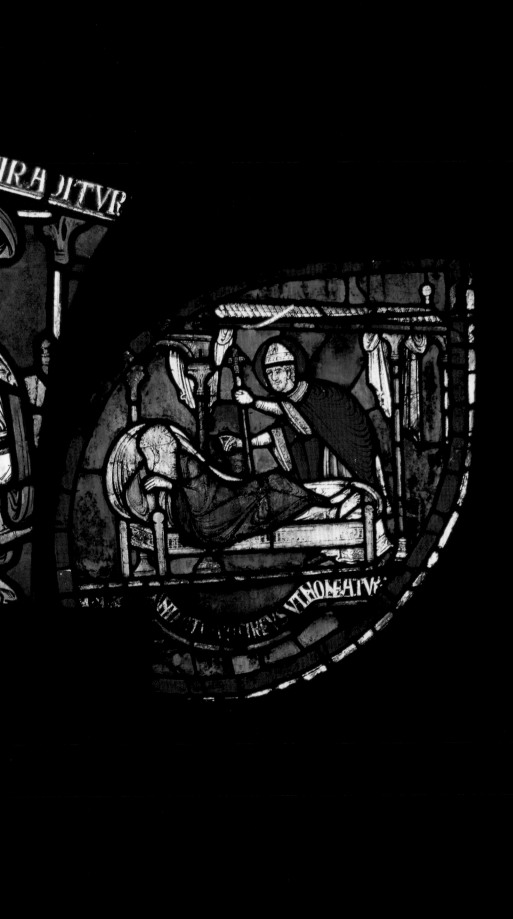

The Plague in the House of Jordan Fitz-Eisulf (cont.)

Panels 19, 20, 21

Jordan and his wife hold a bowl containing silver coins, which Jordan places in his son's hands to offer at the tomb of St Thomas. The child is opening his eyes as they make the vow to go to Canterbury.

The boy, now almost fully recovered is seen seated in bed and eating from a bowl, while his mother and father sit at his head and feet.

The apparition of St Thomas to Leper Gimpe while he sleeps in bed is depicted in the final scene of this group.

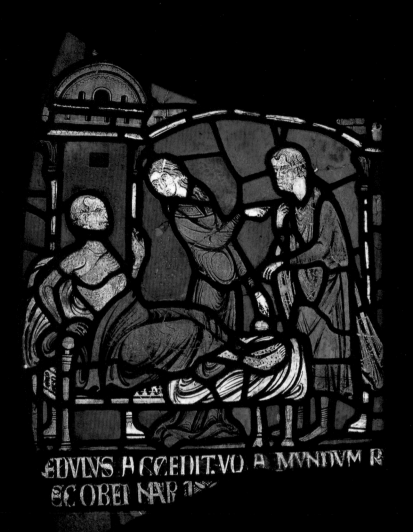

EDVLVS ACCEDIT. VO A MVNDVM R
EC OBEI NAR T

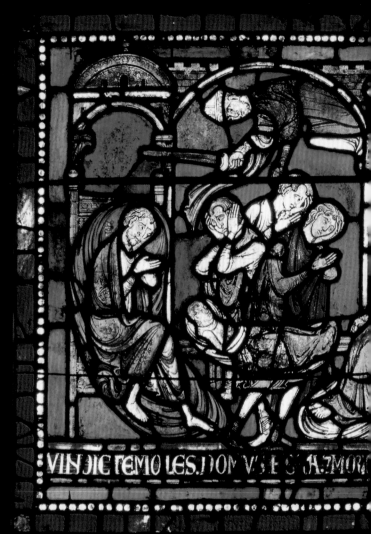

VIN DIC TEMO LES DOM VS E C A 7 MOR

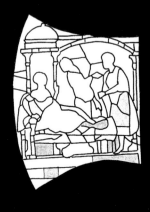

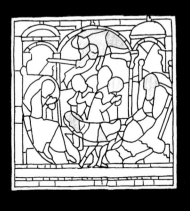

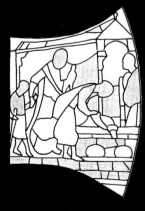

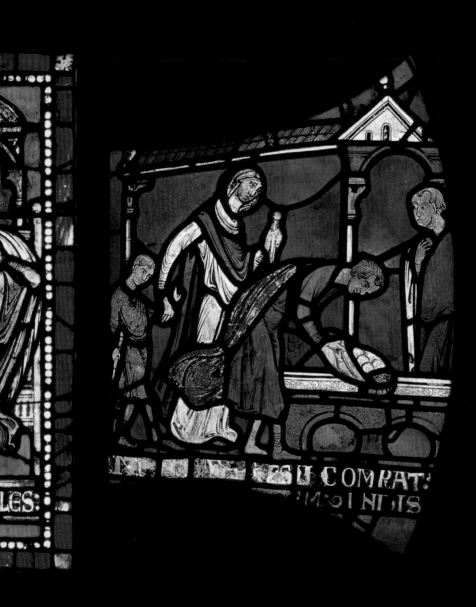

The Plague in the House of Jordan Fitz-Eisulf (cont.)

Panels 14, 15, 16

Jordan and his wife go to see Leper Gimpe, who is seen lying in bed on the left as they approach from the right. The gesture of turning away shown in the *contrapposto* of the body of Jordan's wife, as she points at her husband and away from Gimpe, suggests that she and Jordan will not heed the leper's warning.

St Thomas is seen in the centre, swooping from above as a sword-bearing avenger come to wreak havoc because the vow that Jordan made to go on pilgrimage to Canterbury has not been kept. His favourite son now lies dead in the centre, between the grieving father on the left and the mother on the right, while three members of the household gesticulate in horror.

Jordan, his wife and their revived son are finally seen giving the money that they had pledged to St Thomas' tomb.

Saints, Prophets and Kings

The glass from the West Window (see page 165) consists of 21 windows, or 'lights', and a further 44 small tracery lights. Thirteen of these lights are occupied with glass removed in the eighteenth century from the quire clerestory (see page 32). The display of the kings of England, which was originally planned for the lower lights, now survives in eight giant figures, seven of which are displayed immediately below the upper tracery with one placed in the centre of the second tier of lights. This display is particularly noteworthy, as it can be associated with the reign of King Richard II – the figures represent the most important survivals of monumental painting from his reign; the only other painting of this quality to have survived is the *Wilton Diptych*, made for Richard's personal use between 1396 and 1399 at the same time as the glass (see page 23). The representation of kings close to the main western doorway is found in the portals of French cathedrals, and it survives as a scheme in England in the magnificent sculptural displays on the west fronts at Wells and Exeter. The upper lights in the tracery display 28 figures of prophets and apostles by the same workshop, although some of them may have been moved from other parts of the Cathedral or the same window to their current positions.

The Royal Window (see page 177) has the same overall design as the West Window, with seven divisions in three registers and small tracery lights. At the very top the prophets are displayed, followed by Apostles and saints of the Church. The latter include Saints Dunstan, Thomas, Augustine, Anselm and Alphege (all of Canterbury) and others who were noted for having relics held at Canterbury. What survives from the destruction at the hands of the church commissioners in 1642 is now a gallery of donor figures depicting Edward IV, Elizabeth Woodville his wife, and their sons and daughters.

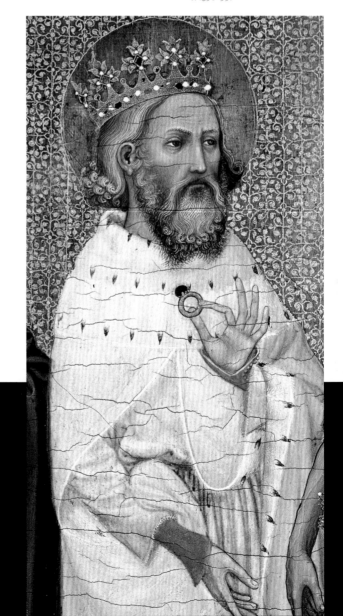

Right: King Canute from the West Window, *c.* 1396–99
Below: St Edward the Confessor from the *Wilton Diptych*, *c.* 1396–99.

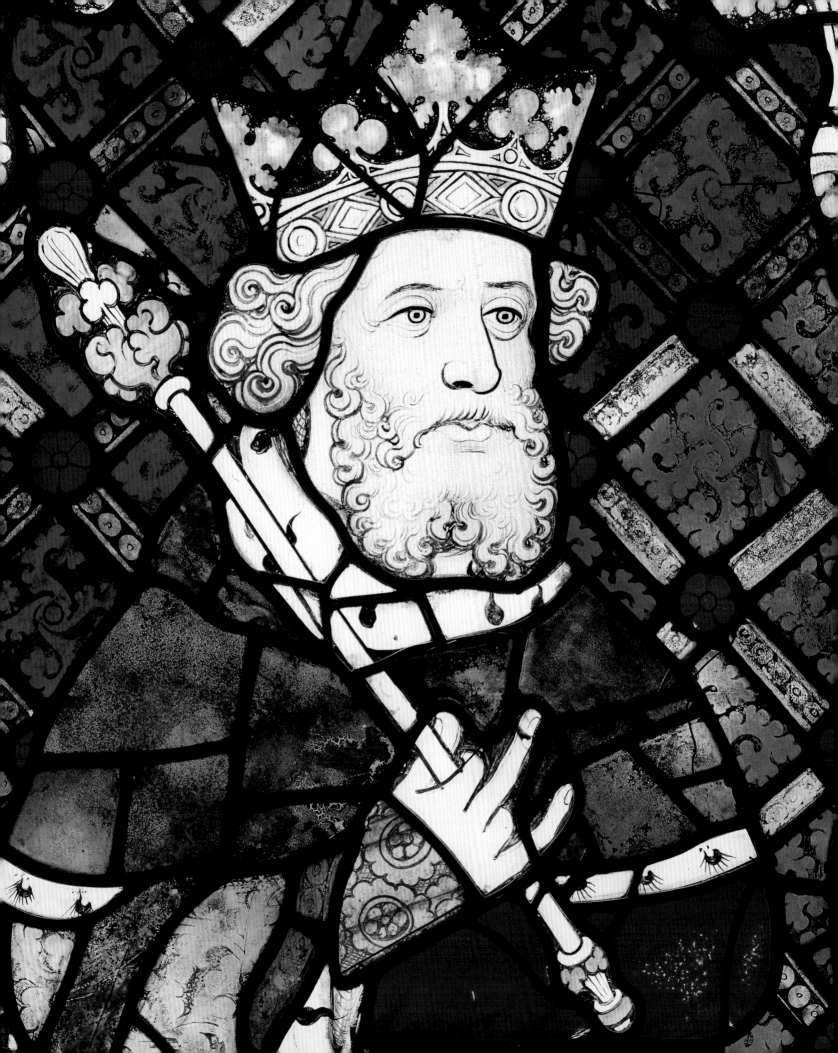

WEST WINDOW

West End, W

Represented at the very top centre of the window are the personal arms of Richard II (who reigned from 1377 until 1399), which are made up of the arms of Edward the Confessor on one side and those of France and England in quarters on the other. On the left of the window are the arms of his young wife, Queen Isabelle of France, whom he married by proxy when she was six years old in 1396. On the right are the arms of his first wife, Anne of Bohemia. This suggests that the window was planned after 1396 and before 1399, when he was deposed.

The window is also associated with Prior Chillenden (1391–1411). William Somner, writing his *Antiquities of Canterbury* in 1640, said that Chillenden's name was recorded at the foot of the window. This may mean that the lower parts of the window had to be finished by him because of the King's untimely removal in 1399.

The style of the figures may be compared with the *Wilton Diptych* (see pages 23 and 162, itself probably made for Richard after 1396, as well as the more massive *Westminster Portrait* (London, Westminster Abbey), perhaps created for the royal stall in the Abbey. This certainly suggests that Richard himself may have commissioned the West Window, perhaps because of his links to Canterbury through his father, the Black Prince. He may also have had a desire to use court artists to promote his divine rights as king in major public spaces, such as the sculptural series of kings in Westminster Hall (commissioned in 1385). He had appointed Richard Savage as King's Glazier in 1393, and it is possible that Savage could have helped in the design of these windows.

The drawing in the windows, particularly the heads, also bears comparison with the work of England's most famous glass painter from this period, Master Thomas of Oxford. His work at New College, Oxford, and Winchester College Chapel shows the same colour ranges and softness of modelling associated with the English response to the courtly sophistication of *avant garde* art in Europe *c.*1395–1420. However, these similarities may only be due to the closeness in the date of the glass. Better comparisons have been made between the glass in the clerestory of York Minster, which is associated with the glazier John Burgh, who worked at York *c.*1375–1419 but was also commissioned to produce heraldic glass for Richard II's Westminster Hall in 1399.

 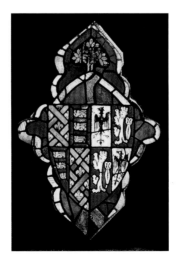

Below, left to right: the arms of Isabelle of France (1396–1409), Richard II (1377–99) and Anne of Bohemia (1382–94) (W. B 18; W. D 20; W. F 18).

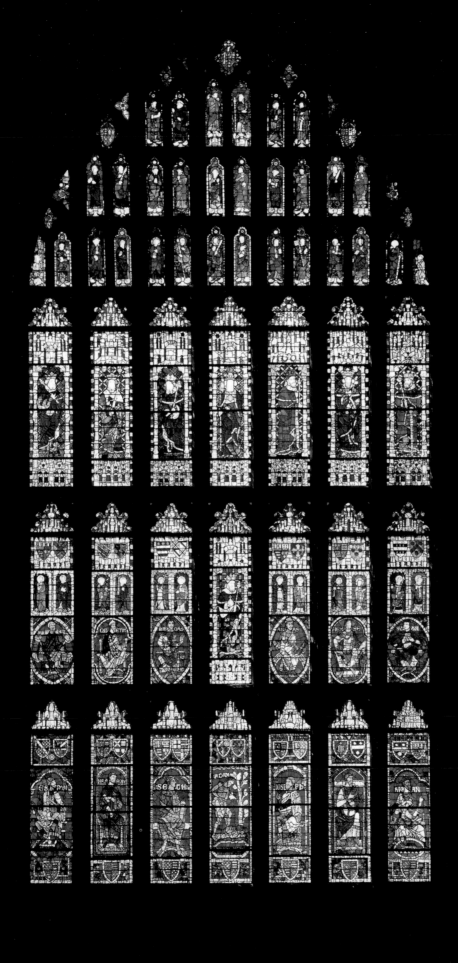

King Canute

W., a 9–13

Recorded by William Gostling in 1777 as bearing the label 'Can', this dignified figure carrying a sceptre must be identified with King Canute (994–1035). He became head of the unified kingdom of Denmark, Norway and England between 1016 and 1018, at the age of 25. He is known today for the legend that he tried to demonstrate the worthlessness of the power of earthly kings by placing his throne on the seashore and commanding the tide to retreat.

This figure may be compared directly with that of Edward the Confessor in *The Wilton Diptych* (see page 162). Attention to detail in the beards of both kings, and the long sleeves that cover the palms of their hands are particularly close.

An English King

W., b 9–13

This figure was recorded by Gostling in 1777 as bearing the inscription 'Ed' (for Edward) and carrying a book. This figure appears always to have held a sword, however, and none of the other surviving figures holds a book, so it must remain unidentified. The face is almost identical in its features to that of King Canute, but it is depicted frontally rather than in three-quarter view.

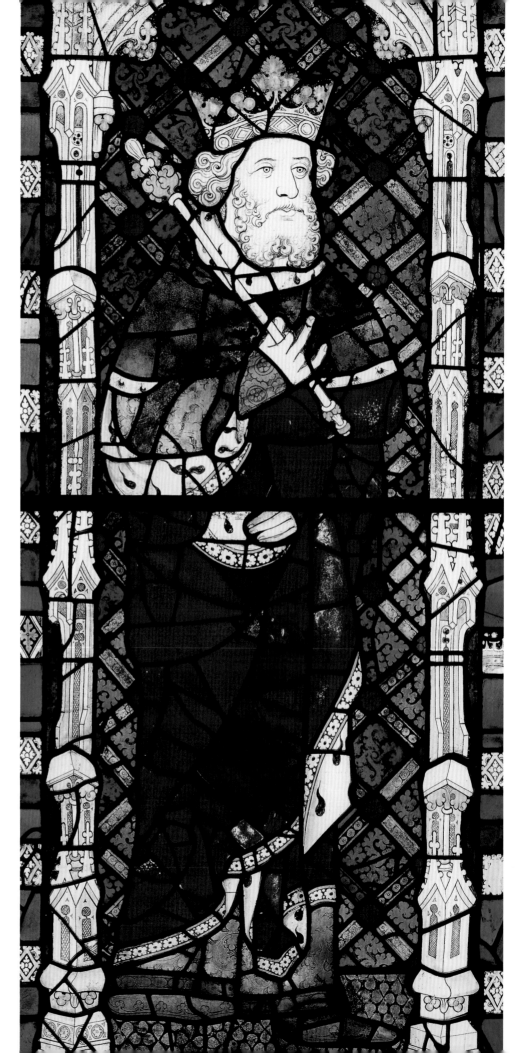

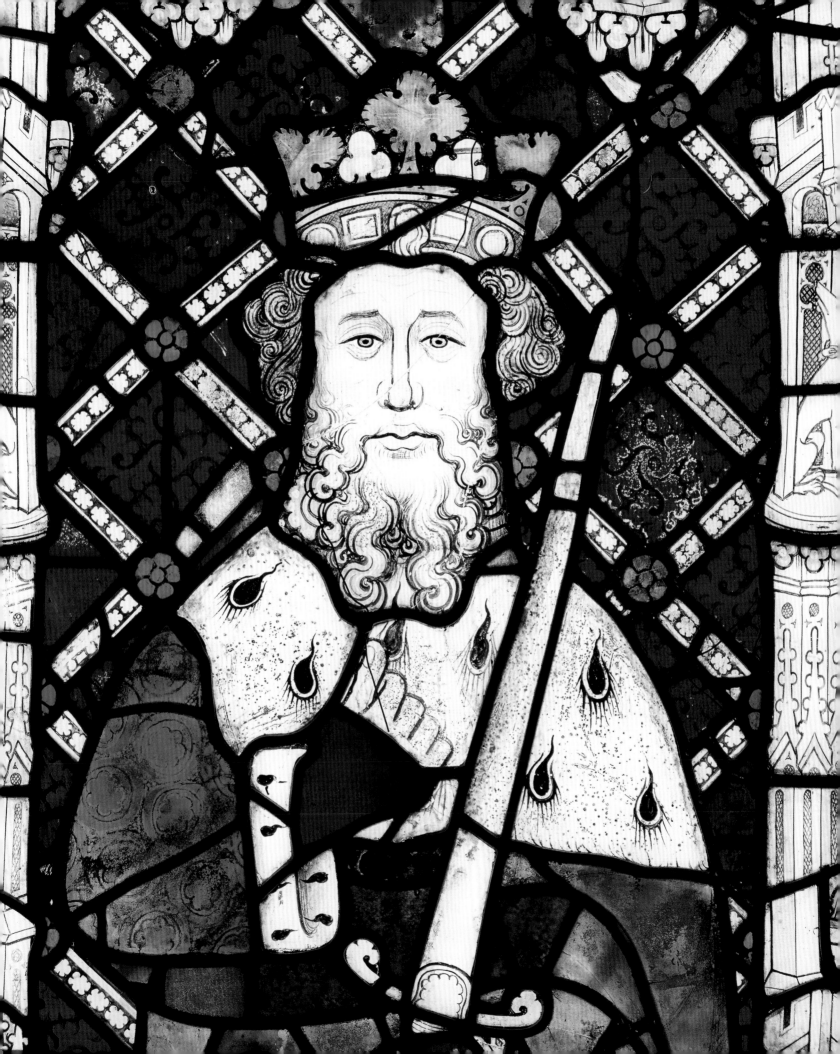

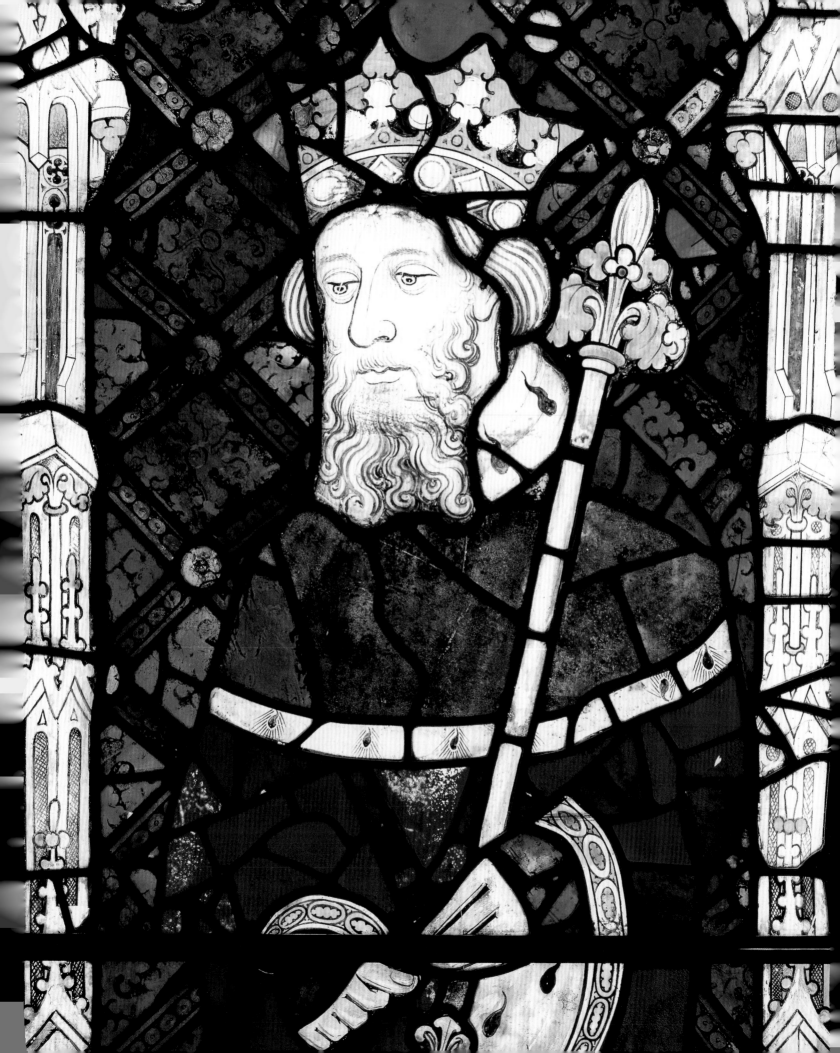

An English King

W., c 9–13

Gostling supposed this figure to be that of King Harold, but no evidence has survived to support this. The three-quarter view of the head, contemplative eyes and rounded nose are reminiscent of the work of Thomas Glazier of Oxford for Winchester College Chapel, *c.* 1393, but the hair and beard may also be compared with manuscripts produced in London *c.* 1390–1400.

An English King

W., g 9–13

Crowned and holding a sceptre, with his right hand resting on top of a sword hilt, so that it stands like a stick, this figure also remains unidentified.

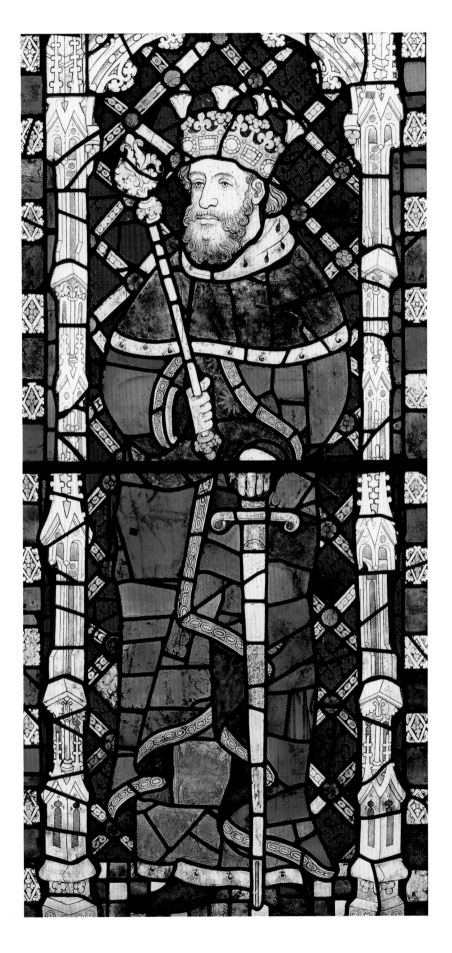

An English King

W., d 9–13

Gostling recorded the inscription '… Conquester Rex' for William the Conqueror, but he described the King as 'holding his sceptre in his right hand, and resting it transversely on his left shoulder'. As he is not depicted in this way, the figure shown here may have been transposed with that in w. f. 9–13, which has a replacement head by Caldwell.

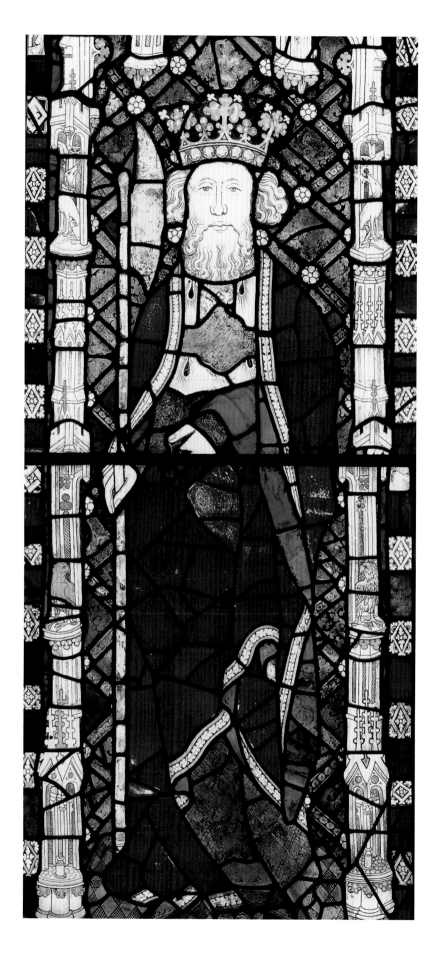

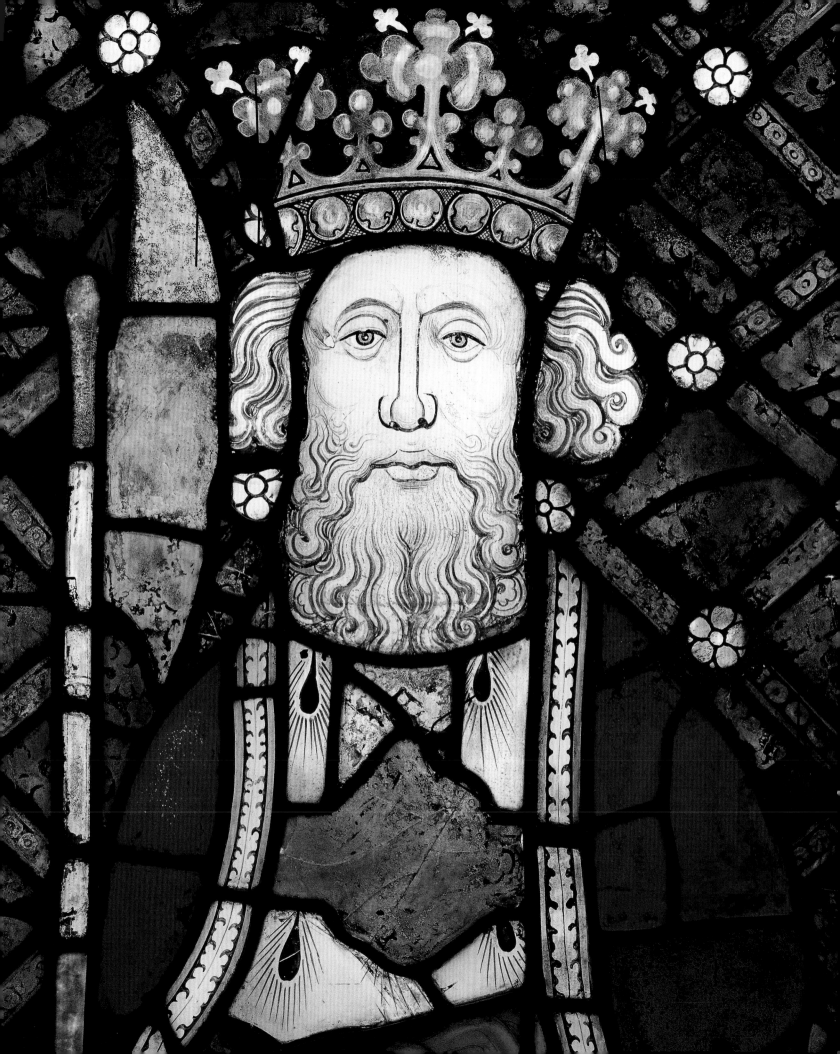

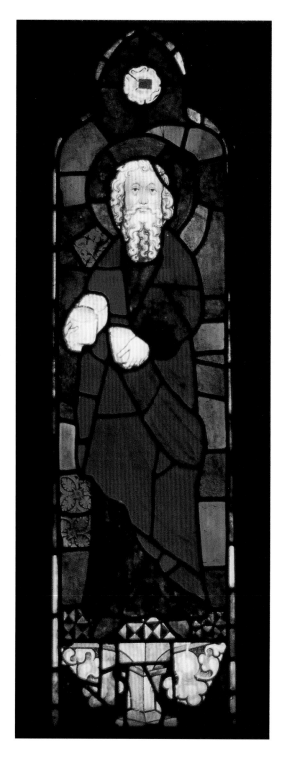

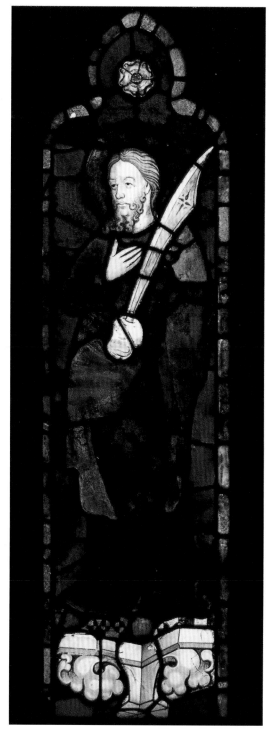

St Philip

W., B 16

He holds two loaves, symbolic of the question asked of him by Christ at the Feeding of the Five Thousand: 'Whence shall we buy bread that these may eat?' The irony of this statement was lost on the Apostle, who answered in all seriousness 'two hundred pennyworth is not sufficient' (John 6: 5).

St Simon

W., B 17

Here he holds a scimitar symbolic of one of the legends of his martydom, in which he is cut in half, but St Simon is more usually shown with a book or a saw.

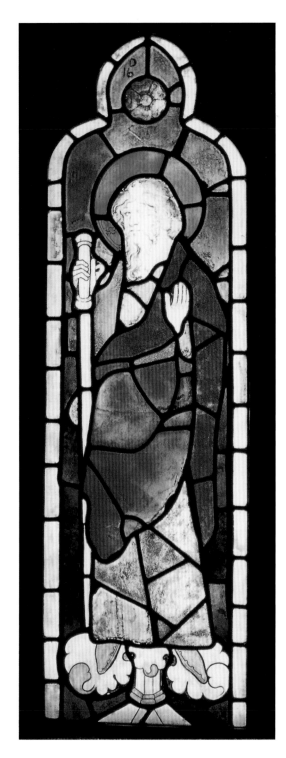

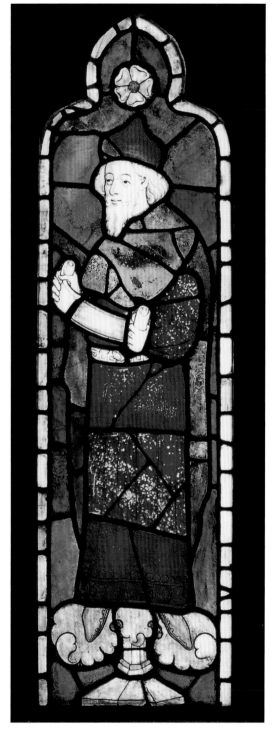

St James Major

W., D 16

Wearing a scallop shell on a band in his hair and carrying a staff, both of which are symbolic of the pilgrimage made to his shrine at Compostella in Spain.

Unidentified Prophet

W., E 16

Wearing a pointed cap.

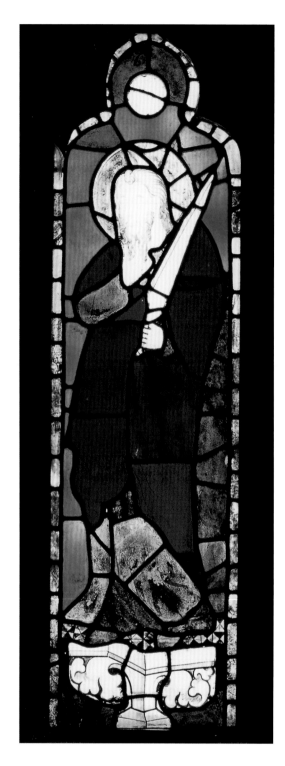

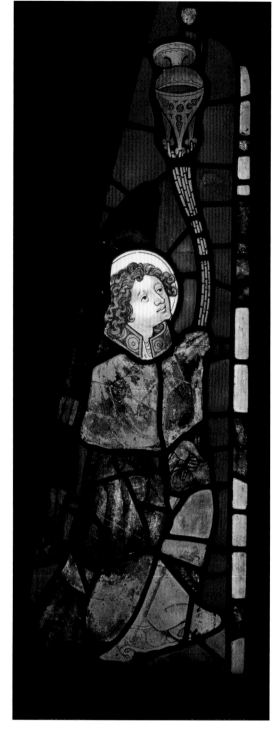

St Paul

W., F 16

Holding the sword with which he was beheaded.

Censing Angel

W., A 14

Swinging a censer up over its head.

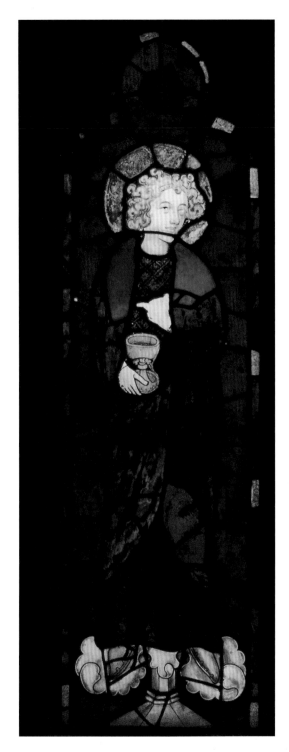

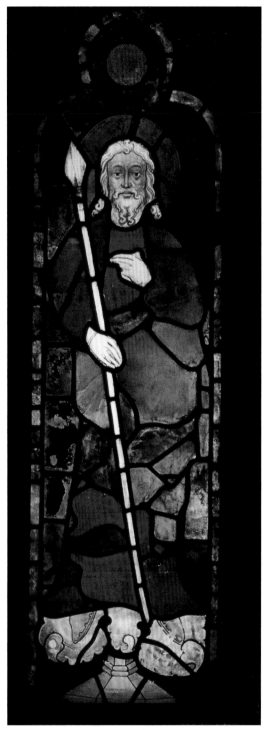

St John the Evangelist

W., C 14

He holds a chalice symbolic of the poisoned cup of snake venom he was tested with by the High Priest at Ephasus – John blessed it and it had no effect.

St Matthias

W., C 15

The 'twelfth Apostle', chosen by lot to replace Judas, he holds the spear (in place of the more correct halberd) with which he was martyred outside Jerusalem.

Northwest Transept, N. XXVIII

The window is associated with the patronage of Edward IV, as it depicts him and his family across the central register. He was a regular visitor to Canterbury between 1461 and 1471, but the window may date from slightly later than this, possibly just before his death in 1483. It may even have been completed after 1486 under the patronage of Archbishop Bourchier, whose armorials appear with those of Edward IV at the top of the window, as a posthumous tribute made after the end of the Wars of the Roses.

The main part of the window was deliberately broken and destroyed in December 1642 and is known only from a description by Richard Culmer, one of the commissioners charged with 'purifying' the Cathedral. From him we know that there was a large God the Father and a Christ, as well as a large crucifix and a picture of the Holy Ghost in the form of a dove, the 12 Apostles and seven large pictures of the Virgin 'as of Angells [sic] lifting her into heaven, and the sun, moon and stars under her feet, and every picture had an inscription under it beginning *Gaude Maria …'.* These panels probably depicted a series of the Seven Joys of the Virgin. A similar arrangement survives in the stained glass (*c.* 1509) at Great Malvern Priory. The most important piece of glass in this window was that of St Thomas Becket himself. Described as 'most rarely pictured in that window, in full proportion … But as that window was the superstitious glory of that Cathedrall [sic]; as it was wholy [sic] superstitious, so now it is more defaced than any …' The kneeling donor-portraits of Edward IV and his family were probably originally placed in the lowest register (not shown), but have subsequently been moved one row higher owing to the loss of the rest of the glass.

The window was made at the height of the Wars of the Roses. Edward IV came to the throne in 1471 after the Battle of Towton (1461), but had to flee to Holland in 1470 after the Lancastrian victory at the Battle of Edgecote Moor (1469). He soon returned to gain control following victory at the Battle of Tewkesbury (1471), after which he captured Henry VI and sent him to the Tower of London, where he died in the same year. After Edward IV's death in 1483, the unpopularity of his marriage to Elizabeth Woodville in 1464, which had produced ten children, came to a head. Her marriage was declared annulled by act of parliament, because Edward had previously agreed to marry Eleanor Talbot. All Elizabeth's children were declared illegitimate and Edward's brother Richard, Duke of York, eventually took power, after which Elizabeth's two young sons Edward and Richard died in the Tower of London. Elizabeth's daughter, Elizabeth of York, married Henry VII in 1486, after he had defeated Richard III at the Battle of Bosworth in 1485. The marriage ensured the end to the struggle between the Red Rose of Lancaster and the White Rose of York.

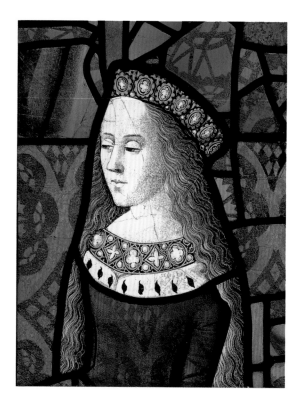

Left: stained-glass panel showing Princess Cecily (1469–1507), the third daughter of King Edward IV, probably removed from Canterbury (N. XXVIII, g 7–8) in the eighteenth century (Glasgow Museums: The Burrell Collection, no.45.75).

Richard Duke of York (1473–83?)

N. XXVIII, a 7, 8

The figure of the prince kneels inside a 'royal box' with a 'tester', or canopy, at a prayer desk, on which is placed an open book. He is crowned and robed in purple with an ermine collar. His badge of a gold falcon with a fetterlock is repeated on the left. The window was recorded in watercolours by Jacob Schnebbelie for the Society of Antiquaries of London in 1774. The head and inscriptions are replacements, but the fine stippling and stickwork (scratching out of lines in the paint) are still visible – both fit in with the new Flemish style used in this window.

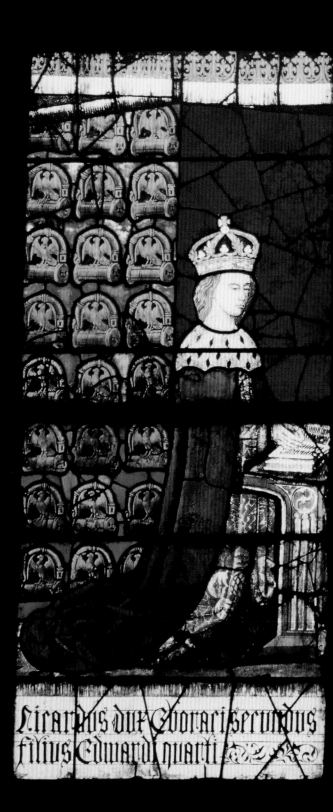

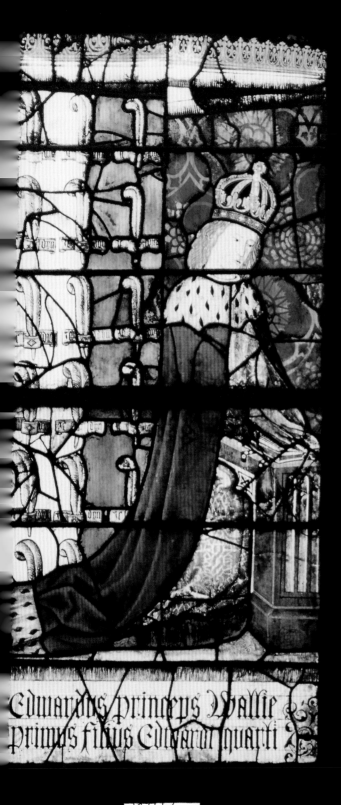

Edwardus princeps Wallie
primus filius Edwardi quarti

Edward Prince of Wales (1470–83?)

N. XXVIII, b 7, 8

Edward is shown to be slightly larger than his brother and was, indeed, three years older. He is also shown at a prayer desk in the same way as his brother, but with his own badge of the Prince of Wales' ostrich feather and motto *ich dien*.

King Edward IV (1442–83)

N. XXVIII, c 7, 8

Edward is shown larger than his son, the Prince of
Wales, but in the same position – in prayer and
holding a sceptre. The desk itself is decorated with
a carved representation of St George and the
Dragon. Behind him, his badge of the White Rose
of York *en soleil* (surrounded by the sun). His face
is better preserved than the others. A piece of glass
was inserted across the centre of his face by an
eighteenth-century restorer. This is a piece of
inspired early conservation. Later restorers would
almost certainly have created an enirely new head.

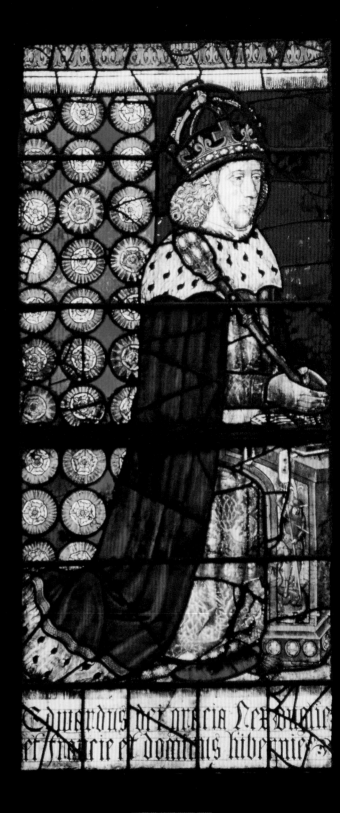

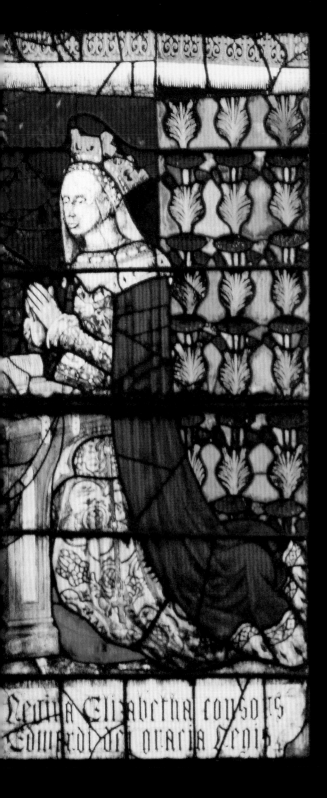

Queen Elizabeth Woodville (d. 1492)

N. XXVIII, e 7, 8

The Queen faces her husband and is also kneeling at a prayer desk. Her hand and the best part of her face and crown are well preserved. Her badge is of an unidentified red flower on a green stem.

Anne (1475–1511), Catherine (1479–1527) and Bridget (1480–1517?)

N. XXVIII, f 7, 8

These are the younger daughters of Elizabeth Woodville, and originally they would almost certainly have been placed in the last light, now occupied by Elizabeth of York and Cecily. The three were recorded in their current position by Jacob Schnebbelie when he drew them, so they must have been moved prior to 1774. The three heads represent sensitive eighteenth-century replacements for originals that must have been too damaged to save. The inscriptions describe the figures now displayed in the next light (Elizabeth and Cecily).

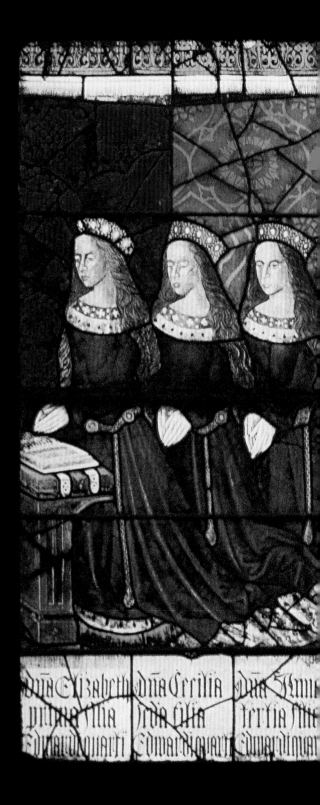

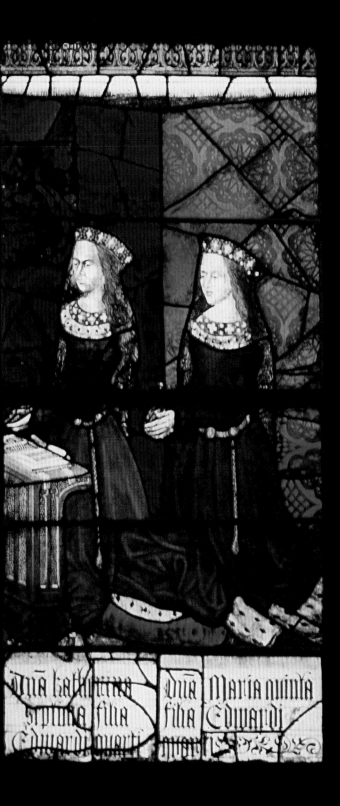

Elizabeth of York (1466–1503) and Cecily (1467–1509)

N. XXVIII, g 7, 8

The head of Princess Cecily had been removed by the time Schnebbelie drew the figures in 1774 and has found its way into the Burrell Collection in Glasgow (see page 176). It is a particularly fine example of the stippling technique. The pair would have originally been placed in the previous light, as they are the older of the sisters. The supposition that the head of princess Cecily should be identified as Mary, who died in 1482, has been rejected, as Schnebbelie recorded Cecily's name, and the discovery of a fragment of the original inscription has proved he was accurate. The eighteenth-century inscription currently visible in the glass erroneously names the second figure as Mary.

The saints who occupy the tracery have been moved around the Cathedral from time to time, but most of them did originally belong to this window. In contrast to those in the tracery of the West Window, they all have canopies and bear inscriptions identifying them, as well as attributes in some cases.

The middle range of the tracery lights displays the 12 Apostles in the approximate order of the Litany of the Saints. These are surmounted by prophets in the upper register and canonised ecclesiastics in the lower register. The Canterbury archbishops Becket, Dunstan, Augustine, Anselm, Alphege are included together with other saints whose relics were held at Canterbury such as Wilfrid of Ripon, Audoen of Rouen and Blaise. Saints Martin and Gregory the Great had chapels dedicated to them at Canterbury. Other saints form part of the Sarum Litany used throughout England by this time, such as St Jerome and St Nicholas. Many of the figures use the same template, which produces an effect of symmetry and repetition (for example, Dunstan is shown in the same pose as Wilfrid and Martin; Augustine of Hippo is shown in the same pose as Augustine of Canterbury and St Thomas Becket). Stylistically these saints fit in with the trends seen in later fifteenth-century English painting and glass, with a suggestion of involvement by, or imitation of, Flemish craftsmen.

St Dennis and St Wilfrid of Ripon

N. XXVIII, A 16, 17

St Dennis is shown holding his own head with which he is meant to have walked to his own sepulchre after being executed. St Wilfrid of Ripon, Bishop of York, is shown in his vestments carrying a crosier and book.

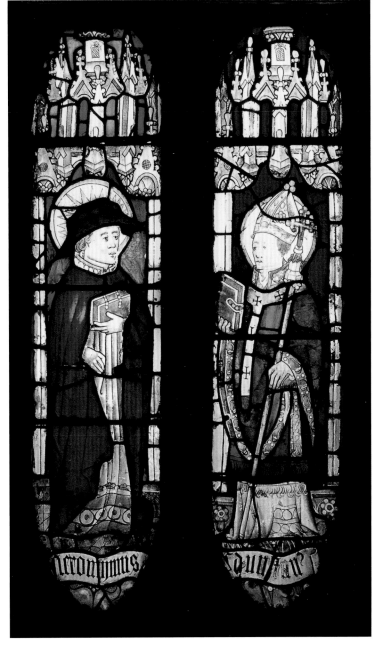

St Augustine of Hippo and St Martin of Tours

N. XXVIII, B 16, 17

St Augustine is shown as a bishop wearing a pallium over his vestment. St Martin is shown in almost the same pose as St Wilfrid before him.

St Jerome and St Dunstan

N. XXVIII, C 16, 17

St Jerome is shown in his cardinal's hat and robe. St Dunstan is shown as a bishop in the same pose as Wilfrid and Martin and is, no doubt, from the same template.

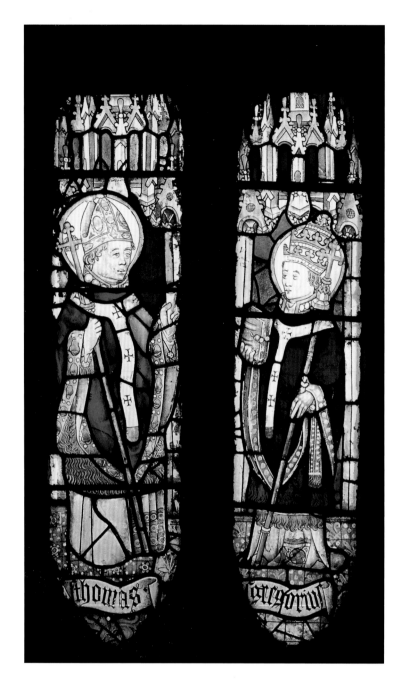

St Thomas and St Gregory

N. XXVIII, D 16, 17

St Thomas is shown as a bishop and is made from
the same template as St Augustine. St Gregory wears
the pope's triple crown but is drawn from the same
template as Wilfrid, Martin and Dunstan.

St Augustine of Canterbury and St Anselm

N. XXVIII, E 16, 17

St Augustine of Canterbury is shown with his left
hand in benediction to distinguish him from St
Augustine of Hippo (B16), but the two figures are
drawn from the same template. St Anselm is drawn
from the template for Wilfrid, Martin and Dunstan.

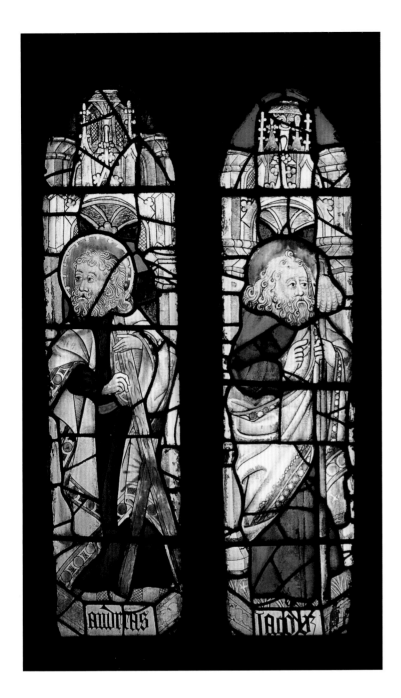

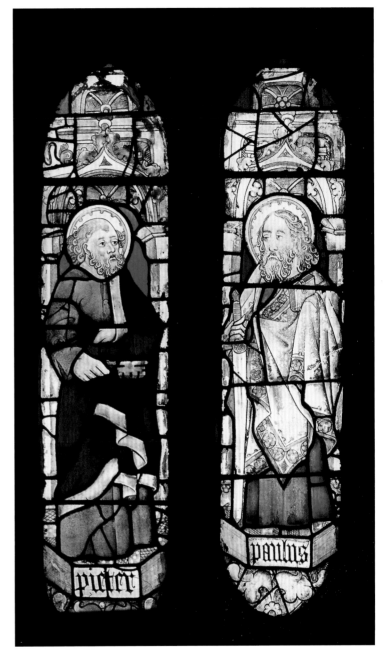

St Andrew and St James Major

N. XXVIII, C 19, 20

The apostle St Andrew carries his saltire cross.
St James holds his staff with scallop shell in his
left hand.

St Peter and St Paul

N. XXVIII, D 19, 20

St Peter holds his key. The spelling of his inscription
('Pieter' rather than 'Peter') has led to conjecture that the
glass makers of this window may have been Flemings.
St Paul is shown with his sword and holding a book.

 # Modern Stained Glass

George Austin was the first person to make a substantial contribution to the re-glazing of the Cathedral, between 1861 and 1862, when he faithfully copied the ancestors of Christ from the geneaology series in the quire clerestory, which were removed to the Southwest Transept Window and West Window in the 1790s. Sadly many of these were destroyed by enemy action in the Second World War, but they have been replaced with new copies made by Samuel Caldwell in the 1950s.

The chapterhouse windows of the history of the Cathedral and its archbishops were created c. 1895–96 by Hemmings and Company, who also provided Corona s. II and the window in the thirteenth-century style in the north transept of Salisbury Cathedral at about the same time.

Glass by Christopher Whall (1849–1924), an important representative of the Arts and Crafts movement, was installed in St Andrew's Chapel in 1900 but destroyed by enemy action in 1942. His work in the West Window of the southwest transept of 1902 has, however, survived. It shows his sensitive understanding of the technique of stained glass and the clear sense of design married with craftsmanship characteristic of the training encouraged in art schools in the late nineteenth century and carried on into the early twentieth century by his students and collaborators. Very much in the spirit of this glass is the window of St Gregory the Great by Christopher Webb, in the east walk of the cloister, of c. 1934.

From the period after the Second World War, the stately modern 'Royal Window', commemorating Queen Elizabeth II's coronation, represents a final flowering of the tradition of stained glass that had grown up through the refurbishment of parish churches throughout England in the nineteenth century. It is executed by Sir J. Ninian Comper, who also inspired work in the cloister. Work by Hugh Easton, which is also part of this tradition of glazing, can be found in the tracery lights of the west walk of the cloister. A dramatic move away from this type of 'historicist' window is seen in the work of Ervin Bossanyi in the southeast transept (1956–60), and in that of Harry Stammers of York in St Anselm's Chapel (1959).

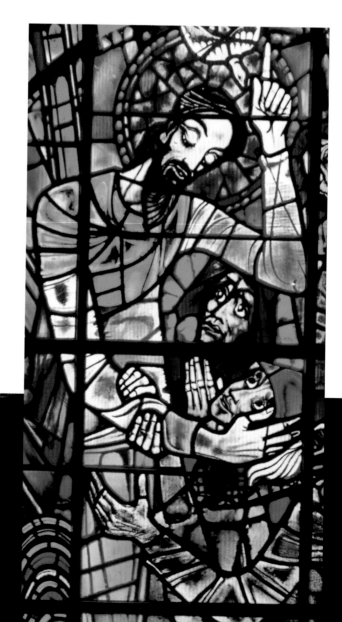

CHAPTERHOUSE EAST WINDOW

Chapterhouse I

The top row depicts Queen Bertha, St Augustine and King Ethelbert on the left. These three are accredited with the re-foundation of the Cathedral at Canterbury in 597. The story of Queen Bertha, already a Christian, who helped convert her husband Ethelbert, as recorded by Bede in his *Ecclesiastical History of England*, became part of the Victorian mythology surrounding the foundation of Canterbury and its continued primacy over all England. They are followed by the archbishops of Canterbury, Theodore (602–90), who came from Tarsus in southern Turkey, St Alphege (d. 1012), St. Anselm of Aosta (d. 1109) and Lanfranc of Pavia (d. 1089). The middle row is taken up with St Thomas of Canterbury, King Henry III or II, and the archbishops of Canterbury Stephen Langton (d. 1228) and St. Edmund Rich (d. 1240), followed by King Edward I (d. 1307), Edward the Black Prince (d. 1376) and Archbishop Simon of Sudbury (d. 1381). In the third row Henry IV (d. 1413), Henry VIII (d. 1547) and the historical archbishops Thomas Cranmer (d. 1556), William Laud (d. 1645) and John Tillotson (d. 1694) are followed by the archbishop who died in the year of the installation of the glass, Edward Benson (d. 1896), and Queen Victoria (d. 1901).

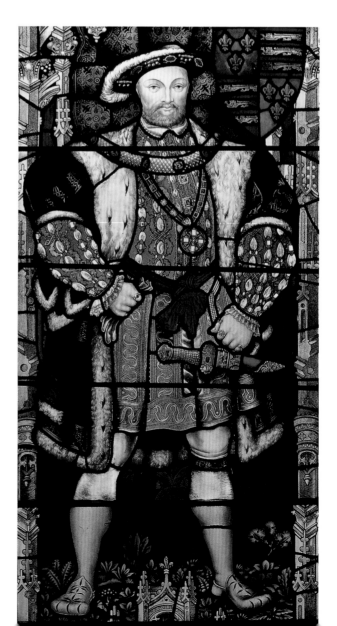

CHAPTERHOUSE WEST WINDOW

Chapterhouse w

This window depicts narrative scenes from the history of Canterbury linked to the characters chosen for the East Window. The top rows show: the meeting of Queen Bertha and St Augustine; St Augustine preaching; the Baptism of King Ethelbert in St Martin's Church, Canterbury; St Theodore of Tarsus planning the re-organisation of the Church in England; the murder of St Alphege by the Danes; Lanfranc planning the new Norman Cathedral and monastery; and St Anslem reluctantly accepting his nomination as archbishop from the sick King William II lying in bed.

The second row of scenes shows: the murder of Archbishop Thomas Becket; the penance of King Henry II; and the translation of the bones of the saint to his shrine in 1220. Representing the thirteenth century, the next scenes in this row show: St Edmund Rich advising Henry III against taxing the church; and the marriage of Edward I to his second queen, Margaret of France, which took place in the Martyrdom Transept in 1299. The last two scenes, the entry of the Black Prince with the captive King John le Bon of France after the Battle of Poitiers in 1357, and the death of Archbishop Simon of Sudbury at the hands of rioters during the Peasants' Revolt in 1381, represent the fourteenth century.

In the bottom row the funeral of Henry IV in the Trinity Chapel at Canterbury in 1413 is shown, followed by Henry VIII's visit to Canterbury in 1520 with the Emperor Charles V and Cardinal Wolsey. Two of the great Protestant archbishops of Canterbury who died for their convictions are shown next. Archbishop Thomas Cranmer, who compiled the *Book of Common Prayer*, is shown being made to listen to a sermon from the Provost of Eton before being burnt at the stake outside the University Church in Oxford in 1556. Archbishop William Laud is seen before being beheaded on Tower Hill in London in 1645. The relationship between Church and state is further explored in the scene of Archbishop John Tillotson preaching to King William III and Queen Mary *c.*1690. Archbishop Benson is shown presiding over the third Lambeth Conference in 1888 when the

'Lambeth Quadrilateral', which stated that faith rested on the sacraments, the Bible, the great Catholic Creeds, and the Episcopate, was agreed upon. Finally the coronation of Queen Victoria, which took place on 28 June 1838, is represented, with Archbishop William Howley giving communion.

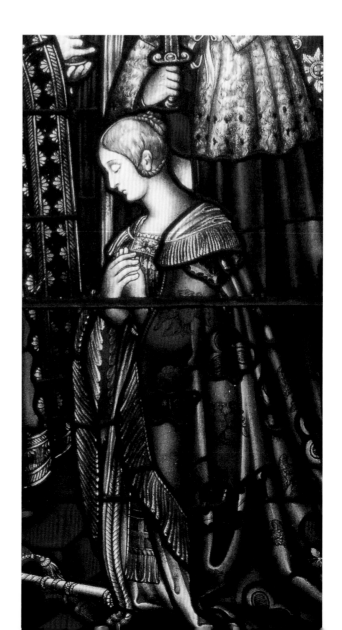

The Murder of St Thomas Becket

The Penance of Henry II

The Translation of the Relics of St
Thomas Becket

Chapterhouse w, a 3–4, b 3–4, c 3–4

These three scenes epitomise the style of the
chapterhouse windows. They reconstruct the past
in as complete a way as possible, offering the
viewer a version of the past that is both realistic
and mythologised. The layered space, with self-
conscious references to the Cathedral itself in
architectural detailing, creates a fantasy world
similar to that of French *bande dessinée* (art
cartoons). The choice of scenes also reveals much
about the ideological climate of the time. The
central image of the King brought to his knees (a
visual parallel with St Thomas on the left) is
framed by the carrying of the relics of St Thomas
by representatives of Church and state. This
indicates how the king could be humbled when he
acted without the joint consent of the peers of the
realm and the sanction of the Church.

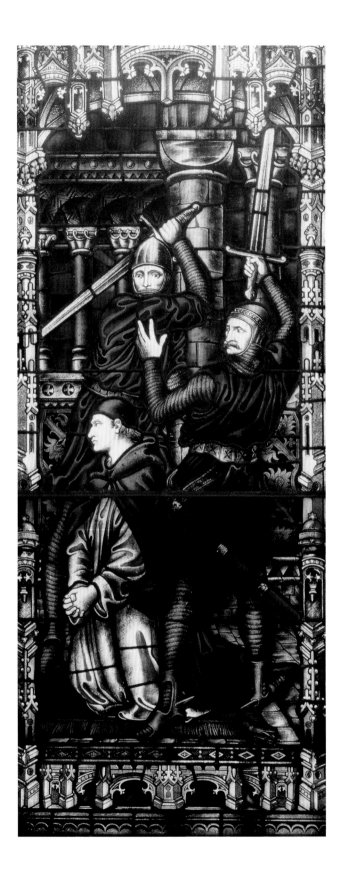

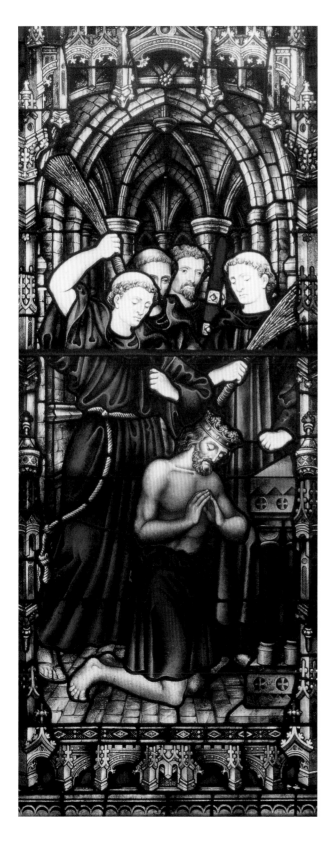

CHRISTOPHER WHALL WINDOW

Southwest Transept, s. XVII

Designed by Christopher Whall, this window was installed in 1902. The top register depicts *The Resurrection*, flanked by Uriel and St Michael. *The Agony in the Garden*, flanked by Saints John the Baptist and John the Evangelist, is shown in the middle, and *The Nativity* is shown below, flanked by Saints Bartholomew and James Major. Whall appropriated the Pre-Raphaelite sensibility for drawing, and he developed a deeply committed feeling for the methods and materials of stained glass. His training in the ethics of the Arts and Crafts movement imbued his work with seriousness and dignity, distinguishing it from that of other contemporary artists working in glass. In common with John Ruskin and William Morris, Whall believed that knowledge of the craft, in all its difficulties and labours, was at least as important as design. His philosophy, almost the antithesis of artistic practice in the twenty-first century, was to master every stage of the process, almost becoming one with the product.

The luminescence he achieves can, paradoxically, also be related to his use of Edward Prior's modern invention of slab glass (thickly moulded in a rectangular box and of an uneven texture). Although it was an entirely new invention, this material was given the name 'Early English' to emphasise its link with the ideal of reviving ancient practices. It allowed Whall to create an ethereal world of jewel-like intense colours contrasted against brilliant clear glass. The living arbour that frames the scenes owes much to its ancestor in Burne-Jones' *The Briar Rose* series (1870–90) – Whall's St Michael is reminiscent of the Prince who enters the briar wood. Whall's vision is more passionate, however, than the models on which he based his drawing style and compositions.

Below: Sir Edward Burne-Jones, *The Briar Rose, I: The Prince Enters the Briar Wood,* 1870–90, oil on canvas.

Pages 198–99: The window is shown without the mullions that divide the scenes when the glass is seen *in situ*, revealing the integrity of the design for the first time since it was installed.

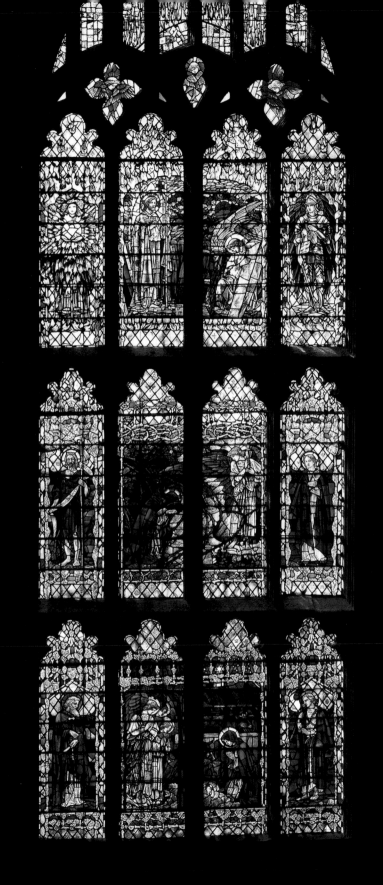

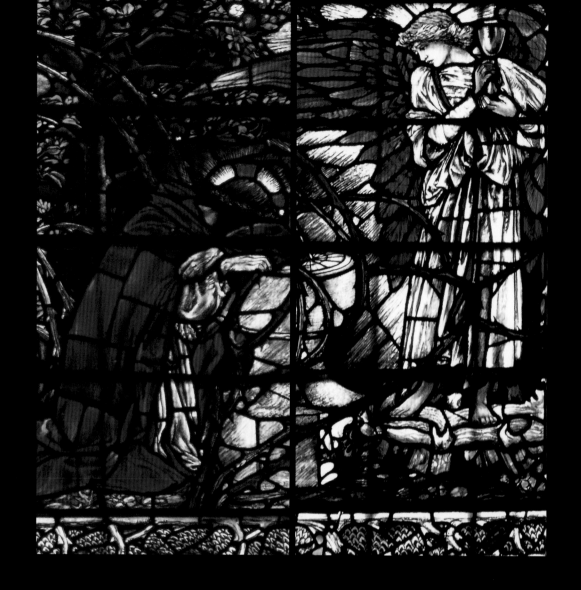

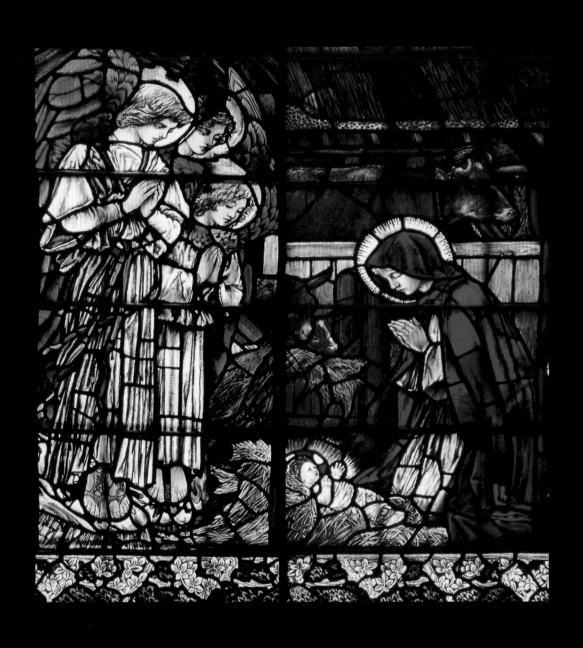

FREEMASONS OF KENT WINDOW

Northwest Transept, n. XVII

Designed by Sir J. Ninian Comper and given by
the Freemasons of Kent in 1954, this window
commemorates George VI, who acceded to the
throne in 1937, and the coronation of H.R.H.
Queen Elizabeth II in 1953. Elizabeth had been
proclaimed queen immediately after her father's
death on 6 February 1952, but she remained in
mourning for nearly 18 months before she was
crowned on 2 June 1953.

The lower register depicts King George VI and
Queen Elizabeth, the Queen Mother, in robes of
state, flanked by their daughters (Elizabeth and
Margaret) as children, also robed and wearing
coronets – their monograms ('E' and 'M') are
embroidered on cloths of honour behind them.
Elizabeth is again depicted in the upper register,
in robes of state as Queen, with her husband
H.R.H Prince Philip, as Duke of Edinburgh, Earl of
Merioneth and Baron Greenwich. Their first two
children (Charles and Anne) are placed in the same
light as their parents. The family is flanked to their
left by the Lords Spiritual, led by Archbishop
Fisher, who presided over the coronation of
Elizabeth II, and followed by the Archbishop of
York (Cyril Forster), the Bishop of Winchester
(Alwyn Williams Garbett) and the Bishop of
London (J. W. C. Wand). The right-hand flank of
the Lords Temporal includes the Lord Chancellor
(Lord Simonds), the Lord High Constable (Field
Marshal the Viscount Alanbrooke), the Earl
Marshal (the Duke of Norfolk) and the Lord Great
Chamberlain (the Marquis of Cholmondeley).

The tracery retains nineteenth-century glass
by Ward and Hughes depicting *The Annunciation*
and fifteenth-century armorials of the Salt
Fishmongers' Company of the City of London.
John Barnewell, who supplied the Cathedral with
fish from 1473 until 1479, when he died, may well
have paid for the original glazing of the window.

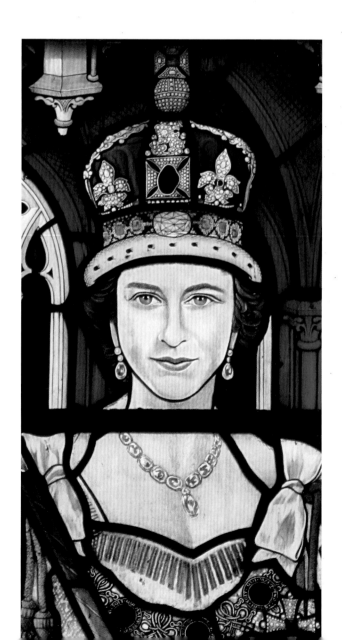

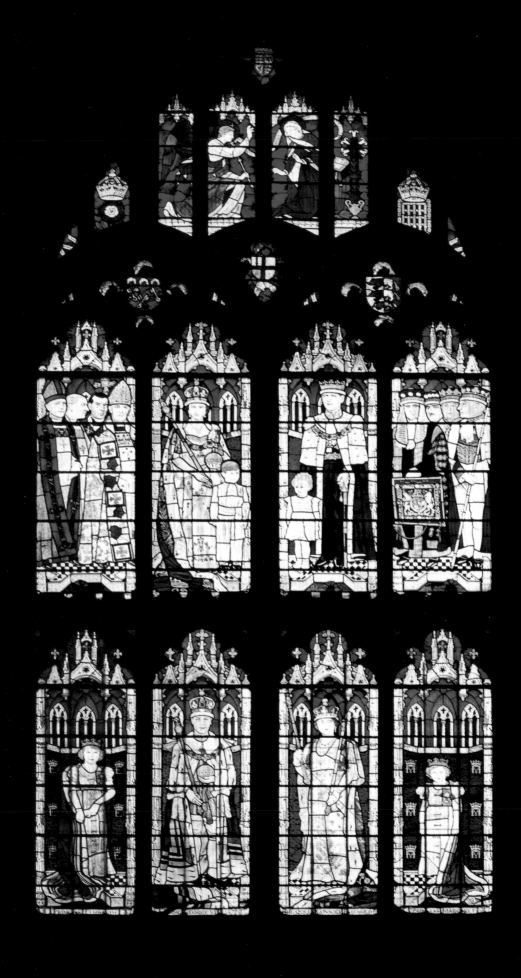

ST ANSELM'S WINDOW

St Anselm's Chapel III

The other windows of St Anselm's Chapel (originally dedicated to Saints Peter and Paul) were re-glazed by the prolific nineteenth-century firm of Clayton and Bell and largely destroyed by enemy action in 1942. This window was inserted into surviving fourteenth-century stonework in 1959 by the famous York glazier Harry J. Stammers. The original glass of the window (now lost) was created just before 1336 – we have surviving documents that attest to its glazing in that year. It consists of five lights surmounted by a central rose and two trefoils in the tracery.

A large figure of St Anselm is depicted in the centre of Stammers' window. On the left are King William II (Rufus) and Archbishop Lanfranc. The monk-physician Baldwin and King Henry I are on the right. All surmount small scenes from their lives in the lower panes. In the centre St Anselm's *Cur Deus Homo* ('Why God Became Man'), the book he started in England after succeeding Lanfranc and finished in exile in Capra in Italy, is shown. Both Baldwin and Eadmer, who wrote the *Vita Anselmi*, looked after the secular side of Anselm's duties. Indeed, Anselm is reported to have had little interest in such things: '… when secular matters press upon me in a troublesome way, my mind is struck with a horror of them, just as an infant is alarmed when it is faced with a terrifying apparition. And I do not take pleasure in dealing with these matters any more than a child takes pleasure in his mother's breasts, when, at its weaning, a bitter substance is smeared on them.' Compelled by these needs, he placed the entire management of his household under the care of the monk Baldwin (*Vita Anselmi* 13).

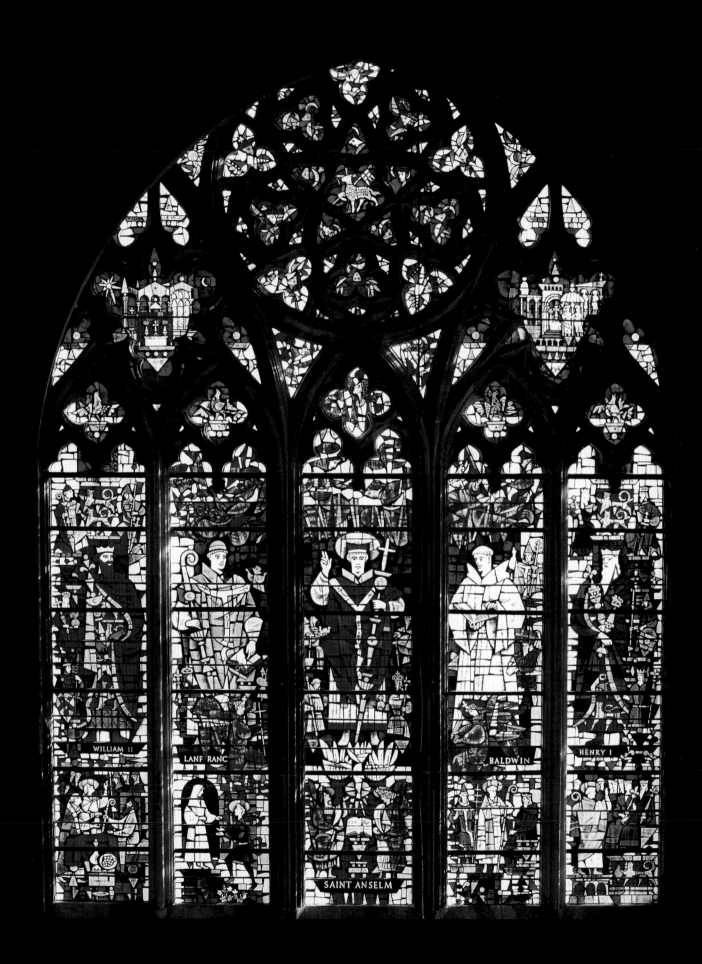

THE ERVIN BOSSANYI WINDOWS

Southeast Transept, s. XI, s. XII and s. XIII

Salvation

Peace

Christ Walking on the Waves (Faith)

St Christopher (Action)

This was originally the site of the Ninth and Tenth Typological Windows of the 1180s. The windows were re-glazed by the firm of Clayton and Bell before 1897, but this glass was destroyed by enemy action in 1942. The Hungarian-born artist Ervin Bossanyi was asked to replace them between 1956 and 1960.

Bossanyi was interned in France during the First World War and worked in Hamburg, Germany, until 1934, when he was forced to flee to the United Kingdom. Examples of his work prior to his arrival are held in the Ely Glass Museum. His first major work in England was the rose window above the Ark, executed in 1937 in memory of Emma, Lady Rothschild, at the New West End Synagogue. The Tate Gallery commissioned a controversial window, which was completed in 1942 and installed in 1948, inspired by the glass of Chartres Cathedral. Bossanyi also designed glass for Washington National Cathedral, USA, Michaelhouse School in South Africa, Christ Church, Port Sunlight Village and the Goldsmiths' Library of the University of London.

Peace (shown on page 206) was installed in 1956. It depicts Christ in Glory, but in the guise of God the Father welcoming the children of all nations to his bosom. The window shows Bossanyi's willingness to emphasise the emotional power of colour.

In *Salvation* (shown opposite), completed in 1958, he makes a joyful but emotional statement about moving on and leaving behind the evil of the Second World War, which had destroyed the windows he was replacing at the Cathedral. A man is guided upward by an Angel to the bosom of a universal family who await him above. A padlock with its keyhole in the shape of a Nazi swastika lies below.

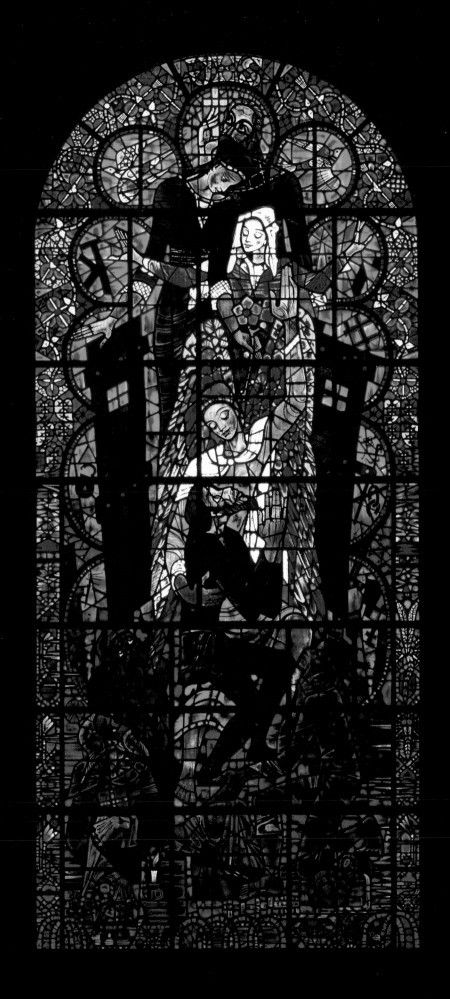

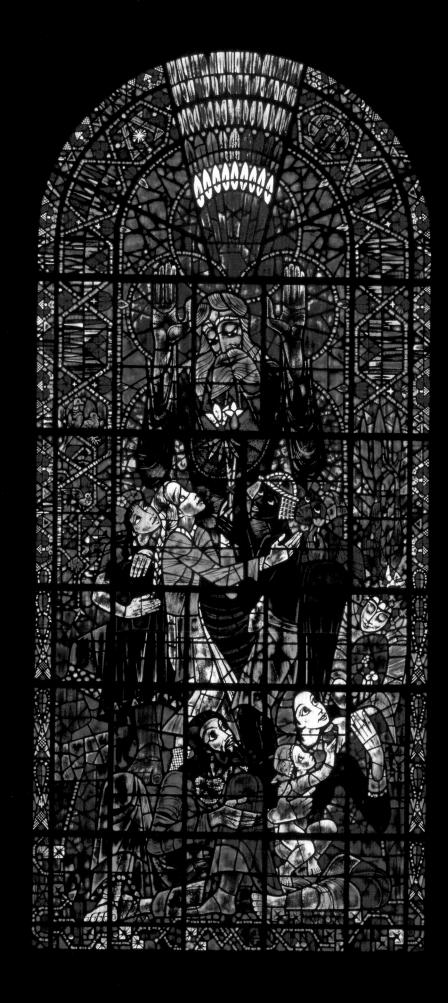

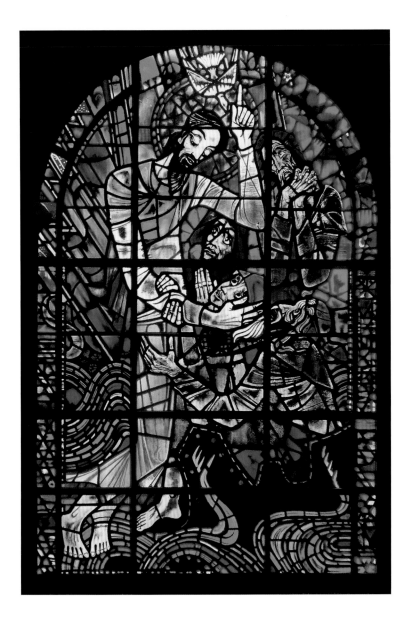

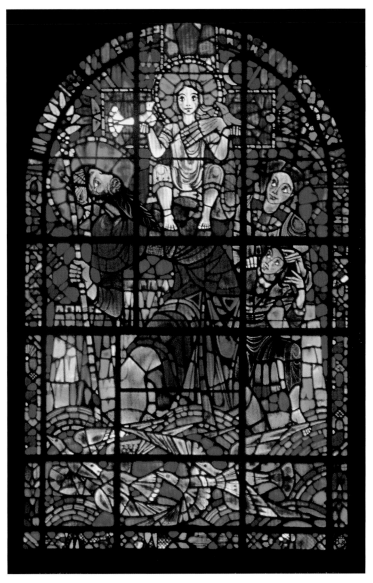

The two smaller windows, *Christ Walking on the Waves (Faith)* and *St Christopher (Action)*, both use the theme of water, but it is treated differently in each. On the left, Christ is presented as a fluid angular figure who reflects the movement of the water beneath him as he bends his knees and uses his outreached arm to help the sinking figures below.

On the right, Christ is presented in a frontal pose, with arms outstretched in a motion paralleled by his legs, in the centre of the composition. St Christopher turns back to glimpse His majesty, revealed in a large glowing halo that is framed by a cross in the background.

Restoring and Conserving the Stained Glass

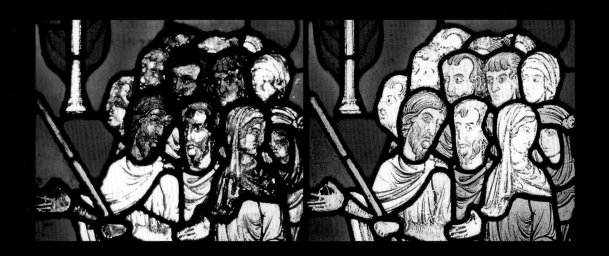

The story of glass restoration began at Canterbury earlier than in most other cathedrals, at a time when craftsmen were only just starting to recapture the lost techniques of medieval glass painting. Hence it is perhaps not surprising that stained-glass restoration in Canterbury was instigated by an architect rather than a glass painter, when George Austin Senior was appointed Surveyor to the Fabric in 1819. The significance of this event cannot be overestimated, as Austin's appointment brought about a stained-glass restoration campaign that lasted no less than 133 years. It was entrusted to four generations of the same family: George Austin Sr until 1848; his son, George Austin Jr, until 1862; Samuel Caldwell Sr, a nephew of George Austin Jr, until 1906; and his son, Samuel Caldwell Jr, until 1952.

The Cathedral's architectural structure had always been George Austin Sr's main concern, but soon after his appointment he also developed a closer interest in its medieval glass. His obituary, which appeared in *The Gentleman's Magazine* in 1849, explained that, when he took to the paintbrush, 'the imitation was so curiously correct that many artists, when asked to point out the new glass, have failed to fix on the right lights'; this astonished his contemporaries, as he had 'no previous knowledge of the art of glass painting'. Today it is impossible to authenticate these statements, as his efforts toward restoration have been obscured by subsequent work and the lack of any kind of methodical documentation.

A number of nineteenth-century illustrations are therefore of particular interest. In 1841 James Joyce produced his album of Canterbury drawings for the glass painter Thomas Willement. Later in the 1840s O. Hudson made several watercolour tracings, most of which are now held by the Victoria and Albert Museum in London. Toward the end of the nineteenth century an album was collated for the stained-glass firm of Clayton and Bell – it was dated 1895 but probably made earlier, as permission for its creation was granted in 1871. Finally, there are the drawings made to illustrate Emily Williams' *Notes on the Painted Glass in*

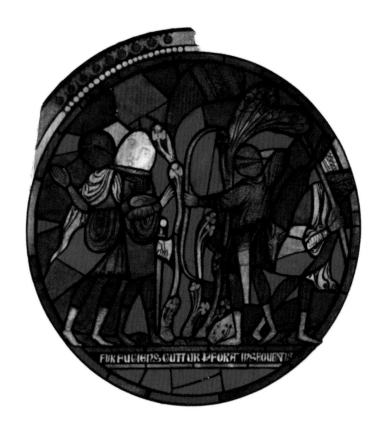

Canterbury Cathedral of 1897. These illustrations had a mainly practical function, namely to enable their recipients to study the windows through an intermediary, as a source-book for their own designs. It is important to understand that the majority of these drawings are interpretations rather than accurate records of the windows. They are nevertheless useful indicators of the condition of the windows at the end of the nineteenth century.

Despite the loss of evidence, it is not a secret that Austin's attitude to historic material – tending toward replacement instead of preservation – was not our own. It can be assumed that he, like his successors, used to remove decayed or fractured pieces and replace them with substitute glass. The methods at his disposal were therefore manifold: to select a new piece of unpainted glass to blend in with the old; to paint such a piece in the style of the original glass; to select an extraneous medieval fragment and insert it as a stop-gap, while ignoring any paint it may have had on it; or to select an old

Above, left to right: a panel from the Cure of Adam the Forester series (s. II, 16) is shown here in a drawing (1841) by James Joyce, a drawing (1897) for Emily Williams' book and its present condition. Taken together, these illustrate the impact of Austin's and Caldwell's creative restoration.

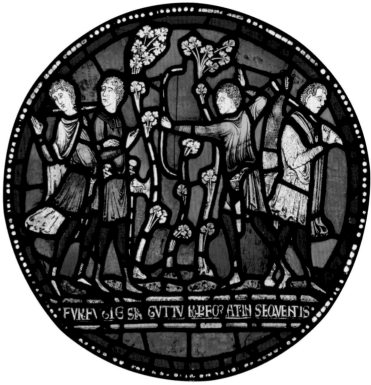

piece, etch it clean and paint it to conform with the style and the design of the original.

These methods remained the same throughout the nineteenth century and the first half of the twentieth century, although the attitude of Austin's three successors differed considerably according to their training, skills and characters, as well as advances in technology and the prevailing Zeitgeist. Of the four restorers, George Austin Jr was most alert to the importance of the original glass and intervened the least with its settings. He became Cathedral Glazier in 1848, taking over from his father, and remained in charge until 1862. His formative years were marked by the revival of glass painting, and he used those resurrected skills to restore the glass in what he thought to be the Gothic style, by imitating in fact the classicising features of the late Romanesque windows in the north quire aisle. When copying originals, he lent

them a more academic style (see the head of Semei, page 212).

In 1855 it was agreed that Austin Jr would re-glaze the entire nave at the rate of one large and two small windows per year, according to an iconographic programme to be decided upon by him in cooperation with Archdeacon Harrison. Most of the aisle glazing he produced was destroyed during the Blitz of 1942, but the series of *Angels of the Lower Order* in the clerestory is still extant, giving testimony of Austin's own design work.

In contrast to his approach in the nave, Austin Jr did not invent scenes when substituting lost glass in the eastern part of the Cathedral, as exemplified in the Miracle Windows of the Trinity Chapel. Knowledge of the stories behind the miracles had diminished over the centuries, and it seems that the texts on which the miracle series was based were not available to Austin Jr. He there-

Above: George Austin Jr (1821–91)

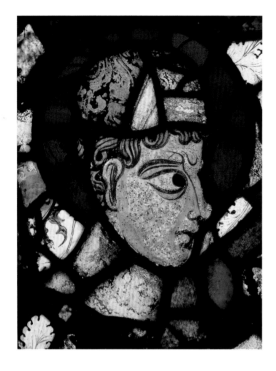
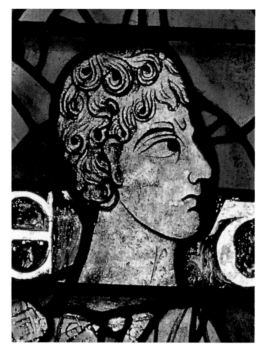

Left to right: The original head of Semei, now in the Victoria and Albert Museum, London, and Austin's replacement (W., C 2), which is a reinterpretation in a new idiom rather than a faithful copy of the original style.

fore made copies of existing panels, disguising this duplication by modifying the colours. On occasions he also fused a false patina, made of a mixture of putty powder and ground glass, to the outer surface. This artificial ageing is fairly easy to detect, as it tends to cover the panels evenly, while most of the medieval glass, in contrast, develops a lively and colourful patina.

Austin Jr was faced with the problem of the availability of appropriate replacement glass. Most colours were too hard in tone to harmonise with the original, and he preferred to renew a whole panel rather than mix old glass with new. For example, in 1854 he removed the two surviving panels of the *Jesse Tree* in the Corona Window, replaced them with copies and filled the remainder of the window with new stained glass. The original panels, which would only have appeared sombre alongside the new glass, were kept in store for some 50 years and eventually disposed of by Caldwell Jr, but returned by bequest to the Corona Chapel in 1953 (see page 100).

During the Second World War much of Austin Jr's new glass suffered severe blast damage and was subsequently replaced with plain glazing. Unlike his father's work, however, enough survives to represent the Gothic Revival at Canterbury, proving Austin Jr's high standard of craftsmanship and his approach to ancient glass. He kept even small pieces of old glass in store, not for his own use but for later generations, which was remarkably far-sighted for a man of the mid-nineteenth century.

Later in the nineteenth century the attitude toward ancient glass began to change. Imperfections in its manufacture and even signs of age such as corrosion and patina were increasingly valued for the appeal they bestowed on the windows. Austin's nephew, Samuel Caldwell Sr, who was in charge of restoration from 1862 until 1906, was strongly influenced by this change in attitude and began to sort fragments of ancient glass by colour. For their re-use, he developed methods of cleaning, re-painting and firing. He applied these techniques extensively, with the exception of Becket Miracle Window 3 (n. V) in the Trinity Chapel, where he replaced a large number of original pieces.

Samuel Caldwell Sr worked as the Cathedral's

restorer for 44 years. Today it is problematic to characterise his work for two reasons. Firstly, in 1878 his son Samuel Caldwell Jr joined the workshop, and it is impossible to distinguish their hands during the period leading up to the elder's retirement in 1906. Secondly, much of Caldwell Sr's work was replaced again by his son between the two world wars.

Samuel Caldwell Jr remained in charge until 1952. In his 74 years at the Cathedral, he handled all the medieval glass at least once, which makes him the most important restorer in the history of the glass. Working with his father, he at first continued the use of original but repainted glass. It was easier, however, to paint on new glass and make it appear medieval, and Caldwell Jr increasingly resorted to this method. Artificial ageing was a common procedure at the time, and there would have been no grounds for pretence. Caldwell Jr nevertheless frequently claimed to have re-introduced genuine pieces from Austin's boxes, which was occasionally true, but usually the pieces supplied were new and Caldwell's statements disingenuous.

Caldwell Jr was very particular over every replacement he made. Each piece of new glass was meticulously chosen and cut to shape, but it was subsequently snipped off with pliers at the raw edges to simulate one of the hallmarks of medieval pieces – the jagged, or 'grozed', edge. The thickness of the pieces was occasionally reduced in order to brighten them up by etching away some of the glass with hydrofluoric acid, which created an evenly matted inner surface. Localised etching was then applied externally to replicate pitting, but these artificial pits preserved a slightly rounded edge. In his attempt to perfectly replicate genuine corrosion, Caldwell 'improved' his methods further and abraded the glass, thus sharpening the edges of the pits. He also left a narrow raised strip around the grozed edges, as if the flanges of the lead had prevented them from diminishing. The final application of a false patina made the forgery nearly perfect.

Unlike Austin Jr, who for the Miracle Windows preferred copying from existing panels, Caldwell Jr used all the skills and resources at his disposal to

fill gaps with scenes of his own design when, for example, he substituted lost glass in the Trinity Chapel after the First World War. To the layman, his work here is convincing, and it needs a trained eye to tell ancient from new. Only on one occasion, in the North Oculus Window (N. XVII), did Caldwell Jr re-use ancient fragments indiscriminately without re-painting, in places even without adhering to a colour scheme. During the restoration of this window he removed all plain glazed panels of the outer zone and supplied figures which are largely made up of incoherent fragments. He kept to the main figurative pattern but was not concerned about colours or paint lines. He

Above: Samuel Caldwell Jr (1862–1963).

Below, left: one of the heads created by Caldwell Jr from incoherent fragments for the North Oculus Window (N. XVII).

Below, right: Panel depicting Thomas Becket & Henry II (n. VII), made up by Caldwell after 1919.

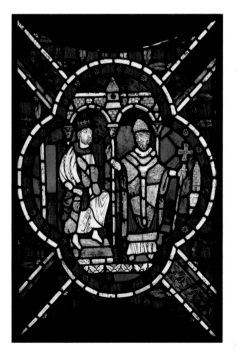

felt able to do this because of the position of the window and its resulting distance from the eye. Obvious success has vindicated Caldwell's decision, and, although missing areas would certainly not be reconstructed in this fashion today, the methods he applied to the Oculus Window were undoubtedly the first step toward modern principles of conservation.

Samuel Caldwell retired in 1952 at the age of 90. His workshop was taken over by George Easton, his assistant for many decades, whose contribution to the restoration of the glass is commemorated with an inscription in one of the north windows of the western crypt (n. VIII). Easton was predominantly responsible for the maintenance of the windows but also oversaw the introduction in the south quire aisle in 1960 of the glass purchased by the Dean and Chapter from the estate of W. Randolph Hearst (see page 24). It was not until 1972 that a new conservation studio was established, following a survey carried out by the stained-glass artist Patrick Reyntiens, which had identified the need for the preservation of the medieval glass before it was lost forever.

In 1972 stained-glass conservation was still in its infancy. Many techniques and materials were still to be developed and tested, but it was acknowledged from the outset that the rigorous approach of the nineteenth century should be abandoned and minimal intervention practised instead. For the glass at Canterbury, restoration would be permitted only in the true sense of the word, namely returning a design that is known rather than resorting to what is now termed creative restoration. When thoroughly researched and carried out professionally, creative restoration may deliver good results, not only aesthetically. Nevertheless, it interferes considerably with the authenticity of the glass and thus can easily destroy its value as a historic work of art.

Because of the work of the Austins and Caldwells, the question of creative restoration hardly ever arises at Canterbury Cathedral. The Cathedral's stained-glass conservation studio, an autonomous department of the Dean and Chapter,

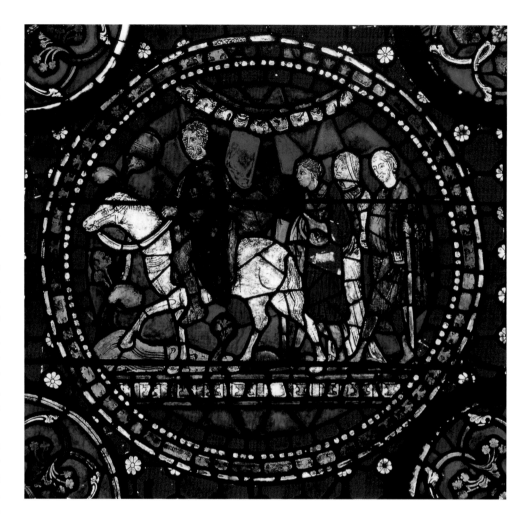

can therefore concentrate exclusively on the four major steps that comprise modern conservation: documenting the pre- and post-conservation condition both of the windows and their panels; careful cleaning of the panels; consolidating and stabilising their components; and protecting them against further damage.

For a long time documentation was the poor cousin of conservation, even though the restoration history of Canterbury Cathedral, like that of so many other buildings, had provided ample evidence of the importance of adequate record keeping. In 1854 'a particular description of what has been done by Mr. George Austin to the old windows of the church' was shown at a Chapter meeting, and it was agreed to ask him to keep a record

Above: Pilgrims on the Road to Canterbury (s. IV), one of Caldwell's deceptive recreations in the Trinity Chapel.

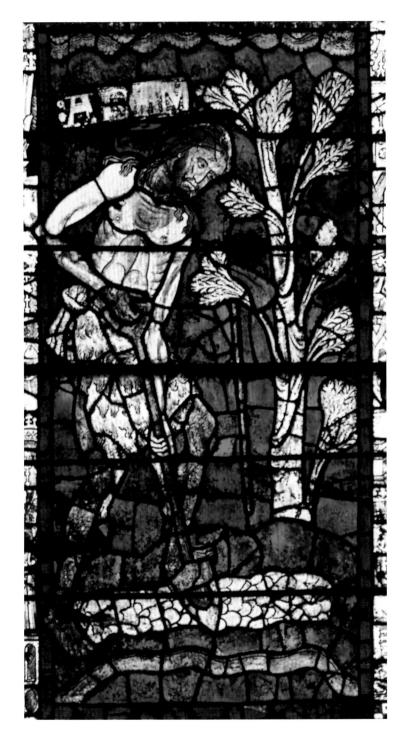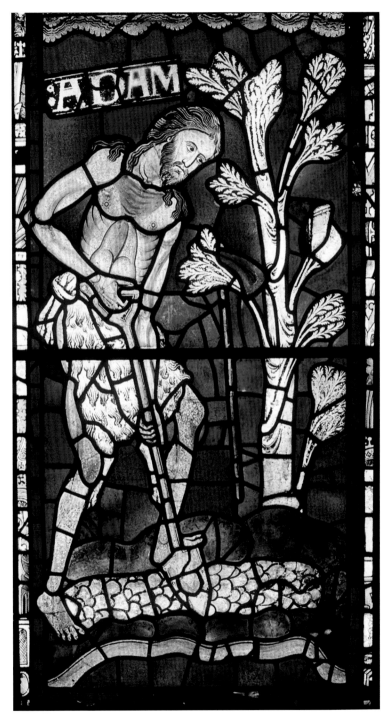

Above: Adam Delving (W., d 3),
before (left) and after (right)
conservation.

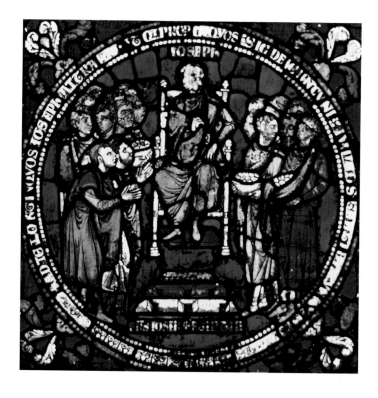

of his work. No such account has survived. If one had, it would have provided vital information about the condition of the glass in the first half of the nineteenth century and the reasons why restorers of the time felt able to work so liberally on the Cathedral's inheritance.

The outcome of Victorian and post-Victorian restoration work has shown quite clearly that it is impossible to foresee what future generations might want to learn from the glass. Efforts are therefore made to record all aspects of present-day conservation work and materials. This is done first and foremost with photography as an unbiased record, which is then augmented by conservation diagrams and written accounts as equally important sources of information.

Following their removal from the window frame, all stained-glass panels are therefore immediately photographed, in transmitted and reflected light, as black and white prints, colour transparencies and increasingly in digital form, to record

This page, clockwise from left: Joseph and his Brothers (n. XV, 29), as recorded in a conservation diagram, and its condition before and after conservation.

Opposite page, left to right: Moses Leading the Israelites (n. XV, 34), before (top) and after (bottom) conservation; Christ Amongst the Doctors (n. XIV, 29), before (top) and after (bottom) conservation.

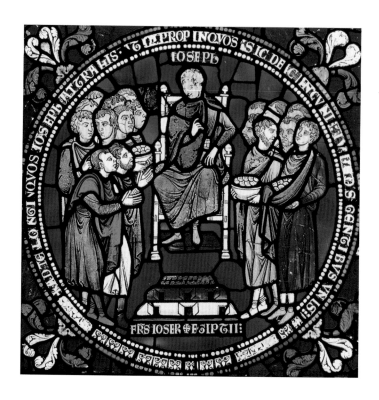

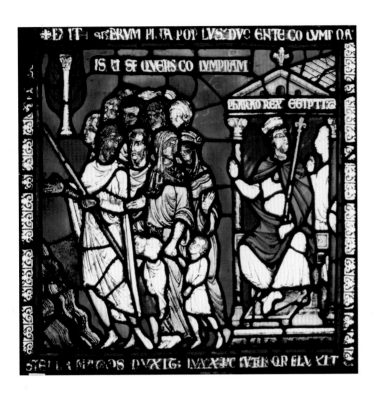

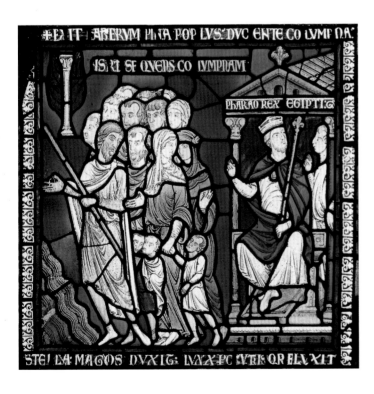

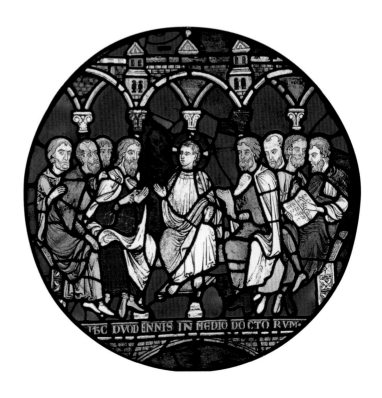

Above: cleaning medieval glass with de-ionised water and cotton wool swabs (top) and under the microscope (bottom).

Right: stages in the manufacture of protective glazing – cutting glass (top), leading up (centre) and soldering (bottom).

their condition before conservation. Thereafter, rubbings of the lead patterns of each panel are made, and these form the basis of conservation charts that record particular conservation measures and conditions, such as the amount of fractures in the glass.

Whilst all these initial steps can be undertaken by a team of conservators, from the next step onward, ideally only one conservator should be responsible for the treatment of a given panel. First of all, the conservator produces a written report on the condition of the panel. This covers, as accurately as possible, the amount of surface dirt on the glass and its fractures, micro-cracks, corrosion layers or any other form of decay, such as pitting or decomposition. Concerning the lead matrix, the conservator's report documents corrosion, structural stability and fractures in the lead cames or at solder joints. The report also covers the condition of the paint pigments – whether they are stable or unstable, loose or lost. This report determines the actual degree of all the conservation measures to follow, which may differ considerably from panel to panel.

Once familiar with the particulars of the panel, the conservator can begin by carefully cleaning the glass, which initially involves the gentle rolling of a wet cotton wool bud over the surface of each single piece. Dependent on the condition of the paint pigments, this procedure can be carried out with the naked eye, but in more delicate areas the use of a microscope becomes imperative. The next step may then involve the removal of more tenacious surface accretions with a scalpel, a glass fibre brush or ultimately with abrasive equipment – all tools requiring the patience and skill of an experienced conservator. Cleaning is thus a time-consuming and painstaking process, due to the cautious approach required to avoid causing damage to the glass surface and the pigments. Despite such necessary restraint, this kind of cleaning improves significantly the translucency of the glass, bringing the colours closer to their original luminosity.

Cleaning also reveals further the condition of the glass, paint pigments and lead, and it should be followed by any localised consolidation where required. In terms of the glass, this means that single cracks will be stabilised *in situ* with an acrylic or epoxy resin, which is highly diluted so that it can penetrate the fracture. Multiple cracks are repaired by removing the glass fragments from the leadwork, by edge-bonding them with a resin or a silicone and by backplating the re-assembled piece to give it additional strength before reinserting it into the leadwork.

Left: installing a stained-glass panel by fitting it into the sub-frame (left and centre) and fixing the saddle bars (right). The clear protective glazing can be seen behind the stained-glass panel.

Until the beginning of the 1990s, it was common in Canterbury to routinely replace the lead, ignoring the fact that this material is also of historic as well as aesthetic importance. Since then the leadwork has been retained and consolidated whenever possible, meaning that only in exceptional circumstances are panels partially dismantled and re-leaded – for example, when material fatigue would otherwise endanger their stability. Because restoration and conservation have been ongoing processes since 1819, however, it is true that all the glass at Canterbury has been releaded at least twice, which means that no medieval lead has survived *in situ* in the Cathedral.

Loose paint pigments can be consolidated with an acrylic resin, but when it comes to areas where the pigments have vanished, this loss has to be accepted as a result of centuries of decay. For technical reasons, it is impossible to re-paint and re-fire the glass, and even if it was safe to do so, re-painting represents an irreversible intervention that destroys the historical value of the glass and is therefore unacceptable. Only in a few instances, such as the bold lettering of inscriptions, can lost paint lines be restored by painting them on to a separate piece of clear glass, which is then attached to the reverse side of the original as a backplate, making the inscription intelligible again in a reversible manner, without affecting the historic integrity of the glass.

After completion of conservation, further photography and a final report form the end of the studio work. To return a panel to its window without protection, however, would be to re-start yet again the cycle of decay. Exposure of the glass to wind, rain, condensation, frost and heat would eventually result in its destruction. It is therefore imperative to separate the two functions that a stained-glass window fulfils, namely to function simultaneously as a weather shield and a work of art. At Canterbury, this is achieved by creating a protective environment for the historic glass through the introduction of an isothermal glazing system – a secondary layer of lead-light panels, copied from each respective original panel and glazed in kiln-distorted clear glass. This new layer is installed in the original glazing groove, while the historic panels are housed in a sub-frame a few centimetres inward of their original location. The space between the protective and the historic panels is ventilated from the interior of the Cathedral, thereby keeping the historic glass close to room temperaturee. The accumulation of moisture on the glass in the form of condensation or rain, which is the main catalyst for corrosion, is thus averted, as is sudden movement due to wind pressure. Protected in this way, the stained glass of the Cathedral will remain a source of inspiration and enjoyment for many generations of worshippers and visitors to come.

Bibliography

Early Canterbury Sources

Chaucer, Geoffrey, *The Canterbury Tales: Fifteenth-Century Continuations and Additions,* edited by John M. Bowers, Kalamazoo, 1992

Gervase of Canterbury, *Tractatus de combustione et reparatione Cantuariensis Eccelesiae,* translated by R. Willis in, *Architectural History of Canterbury Cathedral,* London, 1845, pp.36–62

Gostling, William, *A Walk in and About the City of Canterbury,* Canterbury, 2nd edition, 1777

Hasted, E., *The History and Topographical Survey of the County of Kent,* Canterbury, 2nd edition, 12 vols, 1797–1801

Somner, William, *The Antiquities of Canterbury,* London, 1640

Stained Glass – Canterbury

Brown, Sarah, *Stained Glass in Canterbury Cathedral,* London, 1991

Caviness, Madeline H., 'A Panel of Thirteenth-Century Stained Glass From Canterbury in America', *Antiquaries Journal,* 45, 1965, pp.192–99

Caviness, Madeline H., 'Canterbury Stained Glass', *Arts in Virginia,* 13, 1973, pp.4–15

Caviness, Madeline H., 'The Canterbury Jesse Window' in *The Year 1200, 3, A Symposium: New York, Metropolitan Museum of Art,* New York, 1975, pp.373–98

Caviness, Madeline H., *The Early Glass of Canterbury Cathedral circa 1175–1220,* Princeton, 1977

Caviness, Madeline H., 'Canterbury Cathedral clerestory: the glazing programme in relation to the campaign of construction' in *Medieval Art and Architecture at Canterbury before 1220* (British Archaeological Association Conference Transactions, 5, 1979), 1982, pp.46–55

Caviness, Madeline, H., *The Windows of Canterbury Cathedral, Corpus Vitrearum Medii Aevi, Great Britain, vol. 2, Christ Church Canterbury,* London, 1981

Caviness, Madeline, H., 'Romanesque belles verrières in Canterbury' in *Romanesque and Gothic: Essays for George Zarnecki,* edited by N. Stratford, Woodbridge, 1987, pp.35–38

Evetts, L. C., 'Genealogical Windows at Canterbury Cathedral', *The Burlington Magazine,* 78, 1941, pp.95–98 and 112–18

Heaton, C., 'The Origin of the Early Stained Glass in Canterbury Cathedral, *The Burlington Magazine,* 11, 1907, pp.172–76

Ingram Hill, D., *The Stained Glass of Canterbury Cathedral,* Canterbury, c. 1960

Ingram Hill, D., 'The iconoclasts in Canterbury Cathedral' *Canterbury Cathedral Chronicle,* 68, 1974, pp.20–22

Loftie, William J., 'Early Glass in Canterbury Cathedral', *Archaeological Journal,* 33, 1876, pp.1–14

Mason, Arthur J., *A Guide to the Ancient Glass in Canterbury Cathedral,* Canterbury, 1925

Oakeshott, Walter, 'The ancient glass of Canterbury, by Bernard Rackham' (Book Review), *The Antiquaries Journal,* 31, 1951, pp.86–89.

Rackham, Bernard, 'The Early Stained Glass of Canterbury Cathedral', *The Burlington Magazine,* 52, 1928, pp.34–46

Rackham, Bernard, 'Ancient Stained and Painted Glass', *The Canterbury Cathedral Chronicle,* 30, 1939, pp.22–33

Rackham, Bernard, *The Ancient Glass of Canterbury Cathedral,* Canterbury, 1949

Rackham, Bernard, *The Stained Glass windows of Canterbury Cathedral,* Canterbury, 1957

Williams, Emily, *Notes on the Painted Glass in Canterbury Cathedral,* (with a preface by the Very Rev. F. W Farrar) Aberdeen, 1897

Stained Glass – General

Archer, Michael, *An Introduction to English Stained Glass,* London, 1985

Ayre, Kerry, *Medieval English Figurative Roundels, (Corpus Vitrearum Great Britain, Summary Catalogue 6),* London, 2002

Baker, John & Lammer, Alfred, *English Stained Glass,* London, 1960

Brown, Sarah, *Stained Glass An illustrated History,* London, 1992, pp.7–25 and pp.172–73.

Brown, Sarah, & O'Connor, David, *Medieval Craftsmen Glass-Painters,* London, 1991

Brown, Sarah & Strobl, Sebastian, *A Fragile Inheritance.* London, 2002

Caviness, Madeline H., ' "De convenienta et cohaerentia antiqui et novi operis": Medieval conservation, restoration, pastiche and forgery' in *Intuition und Kunstwissenschaft. Festschrift für Hanns Swarzenski,* Berlin, 1973, pp.205–21

Caviness, Madeline H., 'Rediscovered Glass of about 1200 from the Abbey of Saint-Yved at Braine', *Corpus Vitrearum, Selected Papers from the XIth International Colloquium of the Corpus Vitrearum New York, 1–6 June 1982,* New York 1985, pp.34–49

Caviness, Madeline H., 'Biblical Stories in Windows: Were They Bibles for the Poor?' in *The Bible in the Middle Ages: Its Influence on Literature and Art, Medieval & Renaissance Texts & Studies,* 89, edited by Bernard S. Levy, Binghampton, New York, 1992, pp.103–7

Caviness, Madeline, H., *Paintings on Glass: Studies in Romanesque and Gothic Monumental Art (Variourm Collected Studies, 573),* Aldershot, 1997

Cole, William, *A Catalogue of Netherlandish and North-European Roundels in Britain, (Corpus Vitrearum Great Britain, Summary Catalogue 1),* Oxford, 1993

Cormack, Peter, *The Stained Glass Work of Christopher Whall, 1849–1924,* Boston Public Library, 1999

Coulton, G. G., *Stained Glass of the XIIth and XIIIth Centuries from French Cathedrals,* London, Paris and Berne, 1947

Day, Lewis F., *Windows, A Book about Stained and Painted Glass,* London, 1909

Evans, D., *A Bibliography of Stained Glass,* Cambridge, 1982

Franks, Augustus. W., *Ornamental Glazing Quarries Collected and Arranged from Ancient Examples,* London, 1849

French, Thomas, *York Minster, the Great East Window (Coprus Vitrearum Medii Aevi, Great Britain, Summary Catalogue 2),* Oxford, 1995

French, Thomas, *York Minster, The St. William Window, (Corpus Vitrearum Great Britain, Summary Catalogue 5),* Oxford, 1999

French, Thomas & O'Connor, David, *York Minster, A Catalogue of Medieval Stained Glass (Corpus Vitrearum Medii Aevi, Great Britain 3, Fascicule 1: The West Windows of the Nave),* London, 1987

Grodecki Louis, *Le Vitrail Roman,* Fribourg, 1977

Grodecki Louis & Brisac, Catherine, *Gothic Stained Glass 1200–1300,* London, 1985

Harrison, Martin, *Victorian Stained Glass,* London, 1980

Hebgin-Barnes, Penny, *The Medieval Stained Glass of the County of Lincolnshire (Corpus Vitrearum Medii Aevi, Great Britain, Summary Catalogue, 3),* Oxford, 1996

Lasteyrie, Ferdinand de, *Histoire de la peinture sur verre,* Paris, 1857

Le Couteur, John D., *English Medieval Painted Glass,* London, 1926

Marks, Richard, *Stained Glass of the Collegiate Church of the Holy Trinity Tattershall, (Lincs),* New York and London, 1984

Marks, Richard, *Stained Glass in England During the Middle Ages,* London, 1993

Marks, Richard, *The Medieval Stained Glass of Northamptonshire (Corpus Vitrearum Medii Aevi, Great Britain, Summary Catalogue 4),* Oxford, 1998

Moore, Andrew, *Contemporary Stained Glass,* London, 1989

Morgan, Nigel, J., *The Medieval Glass of Lincoln Cathedral (Corpus Vitrearum Medii Aevi, Great Britain, Occasional Papers 3),* London, 1983

Nelson, Philip, *Ancient Painted Glass in England 1170–1500,* London, 1913

Newton, Peter A., *The County of Oxford (Coprus Vitrarum Medii Aevi, Great Britain 1),* London, 1979

Newton, R. G. & Davison, S., *Conservation of Glass.* London, 1989

O'Connor, David E. & Haselock, Jeremy, 'The Stained and Painted Glass' in *A History of York Minster,* edited by G. E. Aylmer and Reginald Cant, Oxford, 1977, pp.313–94, p.272

Rackham, Bernard, 'English Importations of Foreign Stained Glass in the Early Nineteenth Century', *Journal of the Society of Master Glass-Painters,* 2, 1927, pp.86–94

Raguin, Virginia C., *Stained Glass from its Origins to the Present,* London, 2003

Sewter, Charles, *The Stained Glass of William Morris and His Circle,* 2 vols, New Haven and London, 1974

Wayment, Hilary, *The Windows of King's College Chapel, Cambridge, (Corpus Vitrearum Great Britain, Supplementary Volume I),* London, 1972

Wayment, Hilary, *The Stained Glass of the Church of St. Mary Fairford, Gloucestershire, Society of Antiquaries of London, Occasional Paper,* New series, 5, 1984

Westlake, N. H. J., *A History of Design in Stained Glass*, 4 vols, London, 1881

Whall, Christopher, *Stained Glass Work*, London, 1905

Winston, Charles, *Memoirs Illustrative of the Art of Glass Painting*, London, 1865

Woodforde, Christopher, *English Stained and Painted Glass*, Oxford, 1954

St Thomas Becket

Abbott, Edwin A., *St. Thomas of Canterbury. His Death and Miracles*, 2 vols, London, 1898

Benedict of Peterborough and William, *Miraculi Sancti Thomae […]*, Materials for the History of Thomas Becket, Rolls Series 67, 7 vols, edited by J. C. Roberts, London, 1875–85

Blick, Sarah, 'Comparing Pilgrim Souvenirs and the Trinity Chapel Windows at Canterbury. An Exploration of Context, Copying, and the Recovery of Lost Stained Glass', *Mirator Syyskuu*, 2001, pp.1–27 [E-Journal]

Borenius, Tancred, *St. Thomas Becket in Art*, London, 1932

History and Architecture

Babington, Margaret A., *The Romance of Canterbury Cathedral*, London, 1932

Britton, J., *The History and Antiquities of the Metropolitan Cathedrals of Canterbury and York* (The Cathedrals Antiquities I), London, 1836

Collinson, Patrick; Ramsay, Nigel & Sparks, Margaret, eds, *A History of Canterbury Cathedral*, Oxford, 1995

Crook, John, *The Architectural Setting of the Cult of Saints in the Early Christian West c.300–c.1200*, Oxford, 2000

Draper, Peter, & Coldstream, Nicola, eds, *Medieval Art & Architecture at Canterbury before 1200* (British Archaeological Association Conference Transactions, 5, 1979), 1982

Gibson, Margaret, 'Normans and Angevins, 1070–1220' in *A History of Canterbury Cathedral*, edited by Patrick Collinson, Nigel Ramsay and Margaret Sparks, Oxford 1995, pp.38–68, esp. pp.63–67

Warner, Stephen, A., *Canterbury Cathedral*, SPCK, London, 1923

Wilson, Christopher, *The Gothic Cathedral. The Architecture of the Great Church*, London, 1990, pp. 84–90

Woodman, Francis, *The Architectural History of Canterbury Cathedral*, London, 1981

Woodruff, Charles E. and Danks, William, *Memorials of the cathedral & priory of Christ in Canterbury ... with illustrations by Louis Weirter, R.B.A.* London, 1912

Iconography

Auerbach, Erich, 'Figura' in *Scenes from the drama of European Literature. 6 Essays by Erich Auerbach*, translated by Ralph Manheim, New York, 1957, pp.11–76

James, M. R., 'Pictor in Carmine', *Archaeologia*, vol XCIV, 1951, pp.141–66

James M. R., 'The Verses Formerly Inscribed on Twelve Windows in the Choir of Canterbury Cathedral', *Cambridge Antiquarian*, 8vo series, 38, 1901

Kauffmann, C. M., *Biblical Imagery in Medieval England 700–1550*, London, 2003, pp.79–84

Morgan, Nigel J., 'The Iconography of Twelfth –Century Mosan Enamels' in *Rhein und Maas. Kunst und Kultur 800–1400*, exhibition held Cologne 1972, 2 vols, Cologne, 1972–73

Rushforth, G. McNeil, *Medieval Christian Imagery*, Oxford, 1936

Schiller, Gertrude, *Ikonographie der christlichen Kunst*, 7 vols, Gütersloh, 1969–76. Vols 1 & 2 published in English as: *The Iconography of Christian Art*, London, 1971–72

Exhibitions and General Art History

Exhibition, London, *English Romanesque Art 1066–1200*, Hayward Gallery, London, 1984

Exhibition, London, *Age of Chivalry Art in Plantagenet England 1200–1400*, edited by Jonathan Alexander and Paul Binski, Royal Academy of Arts, London 1987

Exhibition, London, *Gothic Art for England 1400–1547*, Victoria and Albert Museum, edited by Richard Marks and Paul Williamson, assisted by Eleanor Townsend, London, 2003

Exhibition, New York, *The Year 1200, A Symposium: New York, Metropolitan Museum of Art 1970*, 3 vols, New York, 1970–74

Exhibition, New York, *Radiance and Reflection: Medieval Art from the Reymond Pitcairn Collection*, New York, 1982

Exhibition, Oxford, *Ervin Bossanyi: Paintings & Works in Stained Glass*, Ashmolean Museum, Oxford, 1979

Oakeshott, Walter, *Sigena. Romanesque Paintings in Spain and the Winchester Bible Artists*, London, 1972.

Rickert, Margaret, *Painting in Britain: The Middle Ages*, 2nd edn, Harmondsworth, 1965

Röhrig, Floridus, *Der Verduner Altar*, Vienna, 1955

Index

Note: This book has a *General Index*, covering all the major historical topics and events, windows, people, glass-making and restoration techniques, and an index of *Biblical Subjects and Saints*.

In both indexes the italicised page numbers refer to pages containing either illustrations only, or text with illustrations; non-italicised page numbers refer to text only.

GENERAL INDEX

Abstinence 83
Adam the Forester *120–21, 210*
Adoration of the Shepherds Window 24
Alphege, St and Archbishop 7, 12, *42–45*, 162, 184, 192
ancestors of Christ 11, *32–33*
 see also Genealogy of Christ windows
Anglo-Saxon tradition 91
Anne, Princess *182*
Anselm, St and Archbishop 162, 184, 186, 192, *202–03*
anti-types 86
antique models 34
archbishops of Canterbury 184, 190, 192, 200, 202
 see also under names of archbishops
armorial/heraldic glass 22, 164, 176
artificial ageing 212, 214
Augustine, St and Archbishop 162, 184, *186*, 190, 192
Austin, George Jr 24, 132, 210, *211–12*
Austin, George Sr 7, 24, *96*, 188, 210

back painting 1
Baldwin, *Vita Anselmi* 202
Ball, John 34
Barnewell, John 200
Becket Miracle Windows 7, *15–19*, 86, *102–61, 211–12*
 Becket Miracle Window 5 *124–39*
 Becket Miracle Window 6 *140–59*
 North Ambulatory 102, *104–17*
 South Ambulatory 102, 104, *118–23*
Becket, Thomas 162, 176, 184, 213
 cult and cures of 12, 16, 17–19, 28, *102–61*
 murder and canonisation 10, 15–16, 42, 193, *194*
 as saint 12, *126–27, 158*, 176, 186, *195*
Bede 190
belles-verrières (re-set glass) 13

Benedict, Prior of Canterbury 17, 46, 102, 126, 150, 154
Benson, Edward, Archbishop 190, 192
Bertha, Queen 190, 192
Bossanyi, Ervin 7, 24, 188, *204–07*
Bourchier, Archbishop 176
boyhood *26, 71*
Bridget, Princess *182*
Burgh, John 22, 164
Burgh, William 22
Burne-Jones, Edward, *The Briar Rose, I 196*

Caldwell, Samuel Jr 210, *213–14*
Caldwell, Samuel Sr 24, 76, 170, 188, *212–13*
camels (of Queen of Sheba) *15, 27*
Candlemas 62
Canute, King 21, 23, 162, *163, 166*
carpenter's trestle table *27, 118*
Catherine, Princess *182*
Caviness, Madeline 12, 19
Cecily, Princess *176, 183*
Chapterhouse Windows *190–95*
Charlemagne 24
Chartres Cathedral 19–20, 33, 102, 140
Chillenden, Prior 22, 164
Christopher Whall Window *196–99*
ciboria 46, 104
Clayton and Bell 202, 204, 210
cleaning techniques 218
Comper, Sir J. Ninian 7, 24, 188, 200
conservation *see* glass painting techniques; restoration and conservation
Corona Chapel 6, 102
Corona Redemption Window 15, 19, *86–99*, 140, 212
Cranmer, Thomas 190, 192
'creative' restoration 210, *213–14*
cripple with blocks *27, 135*
crows *27, 77*
Culmer, Richard ('Blue Dick') 7, 23–24, 176
cures, attributed to Thomas Becket 12, 16, 17–19, 28, *102–61*

Daughters of Godbald of Boxley *132*
'diaper' (repeat) patterns 124, *125*
Dunstan, St and Archbishop 7, 12, *42–45*, 162, 184, *185*

Eadmer, *Vita Anselmi* 202
Eadwine Psalter 91
Eadwy, King 45
Easton, Hugh 7, 24, 188, 214
educational value of windows 14–15, 46
Edward IV 7, 23, 24, 162, *180*

Edward the Confessor, St 23, *162, 166*
Edward Prince of Wales *179*
Eilward of Westoning 27, *134–37*
Elizabeth II 7, 188, 200
Elizabeth Woodville 23, 24, 162, 176, *181, 182*
Elizabeth of York *183*
Ervin Bossanyi Windows 7, *204–07*
Ethelbert, King 190, 192
Ethelreda of Canterbury *116–17*
ex voto (offering) 18, 110, 112, 128, 150
exile from Canterbury 15, 104
 work completed before 86, 104
 work completed after 124, 140

figura 96
fire of 1174:
 and re-building 7, 10, 32, 34, 102
 rebuilding completed (1180) 42
fishing net 28, *74, 75*
Fitz-Eisulf Master 19, 86, 102, 104, 140
'flashed' reds 21, 76
Flemish influences 23, 126, 184, 186
Fogg Medallion Master 102
France:
 French glass re-set (1960s) 24, 214
 influences of 19–20, 33, 36, 100, 102, 140, 162
 William of Sens 10, 42, 102
Freemasons of Kent Window *200–01*

Genealogy of Christ windows 7, *11, 13,* 24, *32–41, 93, 165*
Geoffrey of Winchester *122–23*
George VI 200
Gervase of Canterbury 10, 12, 42
glass painting techniques 10, 20–21, 178, 183
 'flashed' reds 21, 76
 re-painting 29, 219
 see also restoration and conservation
Glossa Ordinaria 33, 84
Godwin of Boxgrove *128–29*
Gostling, William 24, 166, 168, 170
Great Canterbury Psalter 48
Gregory, St 186, *188*
'grozed' (jagged) edges 213

Harrison, Archdeacon 211
Hearst, Randolph W. 24, 214
Hemmings and Company 7, 188
Henry II 16, 192, *194*, 213
Henry VIII 190, 192
Henry of Fordwich 18, *112–14*
holy water 28, *107*
horses 28, *50–51, 133, 144–45*
Hudson, O. 210
Hugh of Jervaux *138–39*

iconoclasm 7, 23–24, 176
illuminated manuscripts 19, 22, 23, *100*
 compared with glass designs 34, 39, 41, 102
 see also under titles of manuscripts

Jesse Master 15, 19, 100
Jordan Fitz-Eisulf 18, 19, 102, 140, *154–61*
Joyce, James (drawings of 1841) 210
Julian the Apostate 76, 78, *79*
Juliana Puintel's offering 18, *115*
Juliana of Rochester 19, *142–43*

kings of England 7, 22–23, 162, *166–71*, 190, 192, 200, 202
 see also under names of kings and queens

Lanfranc, Archbishop 190, 192, 202
Langton, Stephen 88, 190
Laud, William 190, 192
leadwork replacement 20, 219
lectern 28, *113*
Lenten themes 64, 70
Life of St Alphege Window *44–45*

Marriage 83
Mary of Rouen *17–18, 150–53*
Master of the Gothic Majesty 34
Master of Jordan Fitz-Eisulf 19, 86, 102, 104, 140
Master of the Parable of the Sower 76, 86, 100, 140
Master of the Public Life of Christ 64, 70
Maurice, Emperor 78, *79*
Methuselah Master 19, 34, 48, 64, *35, 40*
moralising themes 14–15, 46, 76
Mosan enamel/metal work 19, 34, 46, 86
musicians 22

Nicholas of Verdun 39
North Occulus Window 32, 33, 100, *213–14*
Northwest Transept Window *200–01*

Occulus Windows 32, 33, 100, *213–14*
Osbern, Prior of Christ Church 44

pallium 90
Peace Window 24, 204, *206*

petal design 124, *125*, 140
Petronella Master 19, *36*, 102, 104, 124
Petronella of Polesworth 19, *106–09*
Philip Scot and the Frogs *148–49*
pilgrims *214*
plague in the House of Jordan Fitz-
 Eisulf *18*, 19, 102, 140, *154–61*
ploughed field with thorns *28*, *79*
'pot-metal' glass 20, *21*
Prior, Edward 196
protective glazing 218, *219*
psalters *22*, 48, 91, *100*

quadrilobe design 86
queens of England 188, 190, *192*, 200
 see also kings
quire clerestory 32, 162

re-founding of Canterbury (597) 190
re-glazing 13, 24, 29, 180, 182, 210–13
re-painting 29, *219*
records of the Canterbury glass 13–14,
 46, 84, 202
 and conservation 214, 216, 219
 eighteenth century 22, 23, 24, 164
Redemption Window (Corona) 15, 19,
 86–99, 140, *212*
restoration and conservation 7, 20–21,
 210–19
 artificial ageing 212, 214
 cleaning techniques *218*
 'grozed' (jagged) edges *213*
 leadwork replacement 20, *219*
 protective glazing 218, *219*
 re-glazing 13, 24, 29, 180, 182, 210–13
 re-painting 29, *219*
 see also glass painting techniques
Reyntiens, Patrick *214*
Richard I, Great Seal of *19*, 100
Richard II *7*, *22–23*, 162, 164
Richard Duke of York 176, *178*
Richard of Sunieve *144–47*
riches *29*, *79*
Robert of Cricklade *16*, 18, *110–11*
Robert of Lilford *12*
Rodbertulus of Rochester *148–49*
Roger of Valognes *130–31*
Royal Window *23*, 162, *176–83*, 188

St Albans's Psalter *91*
St Andrew's Chapel 188
St Anselm's Window 188, *202–03*
St Remi Cathedral *36*, 102
St Thomas Chapel *see* Becket Miracle
 Windows; Trinity (St Thomas')
 Chapel
saints *42–45*, 162, *172–75*, *184–87*
Salt Fishmongers' Company 200
Salvation Window 24, 204, *205*

Savage, Richard 164
Schnebbelie, Jacob *178*, *182*, *183*
Second World War damage 24, *188*,
 204, 211
Sens Cathedral 19, *20*, 100, 102, 140
Sheppard, Dean H. R. L. 24
shrine of St Thomas *7*, *15*, *29*, 102, 124,
 126
siege of Canterbury *44*, *45*
silver stain *21*
Simon of Sudbury, Archbishop 190,
 192
Six Ages of Man 64, *71*, *72*, *73*
Six Ages of the World 64, *70*, *72*
slab glass *196*
soldiers:
 Danish *27*, *42–45*
 guards at the door *28*, *94*
Somner, William, *Antiquities of*
 Canterbury 164
South Oculus Window 24, *33*
Southeast Transept Windows *204–07*
Southwest Transept Window *11*, 24,
 32, *196–200*
St Thomas' Chapel *see* Trinity Chapel
Stammers, Henry J. *7*, 188, 202
stickwork *178*
stippling *183*
stop gaps 29, 210
Strobl, Dr Sebastian 7
Suger, Abbot of St Denis 10, 13

Tau cross *96*
Tertullian 100
Thomas Glazier, of Oxford 169
Tillotson, John, Archbishop 190, *192*
tomb *fenestra* (openings) *17*, 102, 104
Transept Windows *11*, 24, 32, *196–200*,
 204–07
tray of food *29*, *145*
Tree of Jesse Window *15*, *100–01*
Trinity (St Thomas') Chapel *12*, 102
 ambulatory windows *15*, *102*,
 104–23, 213
 see also Becket Miracle Windows;
 shrine of St Thomas
Typological Windows *17*, *46–85*
 second *48–63*
 third *64–69*
 fourth *70–75*
 sixth *76–85*
typology 13–15, 86

Vaux Psalter *22*
Victoria, Queen 190, *192*
Virginity *82–83*
virtuous states *83*

wall paintings 48, 102, 104

Walter of Lisors *133*
Ward and Hughes 200
Wars of the Roses 176
Webb, Christopher *7*, 24, 188
West Window *7*, 22, 24, 32, 162, *164–75*,
 188
Whall, Christopher *7*, 24, 188, *196–99*
Wilfrid of Ripon, St *184*
Willement, Thomas 210
William of Canterbury *17*, *126*, 102
William of Kellet *118–19*
William of Sens 10, 42, 102
William the Englishman 10, 42, 102
Williams, Emily, *Notes of the Painted Glass*
 in Canterbury Cathedral 210
Wilson, William 24
Wilton Diptych *23*, 162, 164, 166
Winchester Bible 19, 34, 48
wine vases *29*, *73*

BIBLICAL SUBJECTS AND SAINTS

Aaron, consecrated by Moses 88
Abraham:
 sacrifice of Isaac *96*
 and the 'Six Ages' *72*
Adam 19, *20*, *35*, *72*, *215*
Adam's Spade *26*, *35*, *215*
adoration:
 of the Magi *55–57*
 of the Shepherds 24
Agony in the Garden 196
Ahaz's sundial *29*, *41*, 91, *93*
Alphege of Canterbury, St *7*, 12, *42–45*,
 162, 184, 192
Aminadab 19, *36–37*, 104
Andrew, St 187
angels 174, 211
Annunciation 46, 200
Anselm of Canterbury, St 162, 184, 186,
 192, *202–03*
apostles 162, 184
ark:
 of the Covenant *26*, *62*, *63*
 of Noah *27*, 64, *68–69*
Ascension *90*, *91*, 92
Augustine of Canterbury, St 162, 184,
 186, 190, 192
Augustine of Hippo, St *70*, 83, *185*

Balaam on his ass *50*, *51*
Baptism 68
 of Christ 64

Cana, miracle at 64, 70, *72–73*
Christ:
 among the Doctors 64, *66–67*,
 216, *217*

ancestors of *11*, *32–33*
 baptism of 64
 feet of Christ *91*
 genealogy of *7*, 12, 35, 13, 188, *see also*
 Tree of Jesse
 in Glory 204, *206*
 in judgement 88, *89*
 leading the Gentiles *15*, 52, *53*
 pharisees turn away from *76*
 presentation of *62*, *63*
 and the 'Six Ages' *70*, *72*
 walking on the water *207*
Christopher, St 204, *207*
Coronation of the Virgin 33
Crucifixion 86, *96–99*

Daniel:
 judges the Elders 64, *67*
 and the parable of the sower *78*
David, with his harp *28*, *72*
Dennis, St *184*
dove *27*, *68*, *69*
Dunstan of Canterbury, St *7*, 12,
 42–45, 162, 184, *185*

Ecclesia 83, *84–85*
Elijah, ascent of *90*, *91*, 92
Enoch 19, *33*, 91, *92*
Entombment *94*, 95

feeding of the five thousand *76*, 172

grapes of Eschol *28*, 46, *96*, *99*

halo, of Christ *27*, *76*
Herod and the Magi *15*, *52–53*
Hezekiah (Ezekias) *41*, 93

Isaac, Abraham's sacrifice of *96*
Isaiah 19, *51*, *93*, 100

James the Major, St *173*, *187*
Jechoniah, and the 'Six Ages' *72*
Jeroboam, Blood Sacrifice of *26*, *61*
Jerome, St *184*, *185*
Jesse Tree 100, *101*, *212*
Jethro, and Moses 64, *66*, *67*, *88*
Job, and the parable of the sower *78*
John the Evangelist, St *21*, *22*, *175*
Jonah and the whale 13, *86*, 95
Joseph and his brothers *55–57*, *216*
Josiah, King 100

Last Judgement 13

Lot's wife *59–60*, 61

Magi:
 adoration of *56–57*
 the Dream of *60–61*
 and Herod 15, *52–53*
 Journey of *50–51*
 typological images 14
Martin of Tours, St 184, *185*
Matthias, St *175*
Maurice, St 24
Methuselah *32, 34*
miracle, at Cana 64, 70, *72–73*
miraculous draught of fishes 64, 70, *74–75*
Moses:
 consecrates Aaron *88*
 and the Grapes of Eschol 96
 and Jethro 64, *66, 67, 88*
 leading the Israelites *52–53*, 96, *216, 217*

Nahsson (Naasson) 19, *38–39*, 104
Nathaniel, the calling of 64, 70
Nativity 196
Noah 19, *40, 72*, 78
 the ark 27, 64, *68–69*
 the three sons of 83, *84–85*

parables:
 of the leaven 83
 of the sower 27, *76–80*
Passion 46
Paul, St *174*, 187
Pentecost 86, *88*
Peter, St 64, 75, 187
pharisees, turn away from Christ 76
Philip, St *172*
presentation in the Temple *62–63*
prophets 61, *162, 173*, 184

Resurrection 13, 46, 86, 95, 196

sacrifice:
 Abraham's, of Isaac *96*
 of Jeroboam *26*, 61
Samson, and Delilah 28, *94*
Samuel, presentation of *62*
Semei, head of *211, 212*
Seven Joys of the Virgin 176
Sheba, Queen of 14, *15*, 27, *55–57*
Shepherds, adoration of 24
Simon, St *172*
Sodom and Gomorrah 20, *21*, 27, *60, 61*
Solomon, King 14, *15, 55–57*

sower, parable of 27, *76–80*
sundial of Ahaz *29, 41, 91, 93*

Thomas Becket, St *see* General Index
three measures of meal 83, *84*
three righteous men 78
Tree of Jesse 100, *101*, 212

Virgin Mary 33, 100, 176

Wilfrid of Ripon, St *184*
'Witnesses' of the Apocalypse 92

This revised edition published in 2014 by
Scala Arts & Heritage Publishers Ltd
10 Lion Yard, Tremadoc Road
London SW4 7NQ
www.scalapublishers.com

In association with
Cathedral Enterprises Ltd
25 Burgate, Canterbury, Kent CT1 2HA
www.cathedral-enterprises.co.uk

ISBN 978-1-85759-966-4

The publishers would like to thank Rachel Koopmans for identifying that the windows reproduced here on pages 150–151 depict Mary of Rouen, not Matilda of Cologne, and for contributing the new entry text. They are also grateful to Léonie Seliger, Director of Stained Glass Conservation at Canterbury Cathedral since 2005, for her assistance with this revised edition.

Page 3: *Walter of Lisors* (see page 133).

Page 4: *Gathering*, a new window installed in the North Walk of the Great Cloister, was dedicated by the Dean in June 2014. It was designed by Scottish artist Emma Lindsay and made at the Cathedral Studios by Grace Ayson.

First published in 2004 in hardback and paperback editions

Edited by Esme West
Designed by Andrew Shoolbred
Diagrams by David West
Printed in Turkey

Photography © The Stained Glass Studio at Canterbury Cathedral, except for the following pages:

3, 8 b/c/e/f/g, 12 a, 15, 16, 20 b, 30 b/c/d/e/g, 32–33 a–f, 34, 36–40, 42–43, 45 a, 47, 50–51 a/c, 52–53 b, 54–59, 60–61 b, 66–74, 76, 78–79 a/c, 81–86, 88–95, 97–99, 101–02, 106–07, 109–17, 124–37, 138–39 a/c, 140–41, 148–149, 163, 165–71, 178–83 © Sonia Halliday or Sonia Halliday & Laura Lushingham

6, 80, 96, 155, 158–59c, 188, 204–06 © Angelo Hornak

11, 44, 49, 65, 87, 103, 177, 202–03 © Cathedral Enterprises Ltd

19 © Micki Slingsby

22 b © Lambeth Palace Library

23, 162 © The National Gallery, London

100 © Society of Antiquaries

176 © Glasgow Museums: The Burrell Collection

196 © The Faringdon Collection, Buscot, Oxen, UK/Bridgeman Art Library

197–98 © Dominic Levet

212a © V&A Images